Adobe®
Illustrator® CC

by David Karlins

for
dummies®
A Wiley Brand

Adobe® Illustrator® CC For Dummies®

Published by: **John Wiley & Sons, Inc.,** 111 River Street, Hoboken, NJ 07030-5774, www.wiley.com

Copyright © 2020 by John Wiley & Sons, Inc., Hoboken, New Jersey

Published simultaneously in Canada

For general information on our other products and services, please contact our Customer Care Department within the U.S. at 877-762-2974, outside the U.S. at 317-572-3993, or fax 317-572-4002. For technical support, please visit https://hub.wiley.com/community/support/dummies.

Wiley publishes in a variety of print and electronic formats and by print-on-demand. Some material included with standard print versions of this book may not be included in e-books or in print-on-demand. If this book refers to media such as a CD or DVD that is not included in the version you purchased, you may download this material at http://booksupport.wiley.com. For more information about Wiley products, visit www.wiley.com.

Library of Congress Control Number: 2019956417

ISBN 978-1-119-64153-7 (pbk); ISBN 978-1-119-64154-4 (ebk); ISBN 978-1-119-64155-1 (ebk)

Manufactured in the United States of America

V10016460_122019

Contents at a Glance

Introduction .. 1

Part 1: Creating, Navigating, and Saving Projects 5

CHAPTER 1: Navigating Illustrator's Interface 7

CHAPTER 2: Creating, Saving, Exporting, and Printing Files. 15

CHAPTER 3: Placing and Tracing Artwork 31

CHAPTER 4: Drawing Lines and Shapes .. 43

CHAPTER 5: Selecting and Arranging Objects 69

CHAPTER 6: Organizing Documents with Layers. 89

Part 2: Drawing and Editing Paths101

CHAPTER 7: Wielding the Pen and Anchor Point Tools 103

CHAPTER 8: Creating Artwork with the Pencil, Curvature, and Blob Tools 117

CHAPTER 9: Painting with Brushes ... 133

CHAPTER 10: Improving Workflow with Symbols 157

Part 3: Applying Color, Patterns, and Effects 169

CHAPTER 11: Designing in Living Color 171

CHAPTER 12: Bringing Graphics to Life with Gradients, Blends,
and Transparency .. 197

CHAPTER 13: Designing with Patterns. 221

CHAPTER 14: Styling with Effects .. 237

Part 4: Designing with Type 253

CHAPTER 15: Formatting Area Type. ... 255

CHAPTER 16: Getting Artistic with Point Type 275

**Part 5: Handing off Graphics for Print
and Screen Design** .. 287

CHAPTER 17: Exporting Raster Files. ... 289

CHAPTER 18: Unleashing the Power of SVGs 305

Part 6: The Part of Tens 335

CHAPTER 19: Top Ten Illustrator Resources. 337

CHAPTER 20: Top Ten Productivity Tips 345

Index .. 355

Table of Contents

INTRODUCTION .1

About This Book. .1
Foolish Assumptions. .2
Icons Used in This Book .2
Beyond the Book .3
Where to Go from Here .3

PART 1: CREATING, NAVIGATING,
AND SAVING PROJECTS .5

CHAPTER 1: **Navigating Illustrator's Interface** .7

Surveying the Illustrator Universe. .8
Launching Illustrator. .8
Using and Customizing Toolbars .10
Accessing and Arranging Panels .11
Using the Control Panel or the Properties Panel12
Choosing between the Control and Properties panels13
Options on the Control and Properties panels.13

CHAPTER 2: **Creating, Saving, Exporting, and Printing Files**15

Creating Documents .16
Making basic choices for a document .16
Using presets .17
Defining color mode, artboard size, and raster resolution.18
Deploying Artboards. .20
Defining artboards .20
Using artboards for a multidimensional project.23
Exporting, Saving, and Printing .27
Saving Illustrator files .27
Exporting files .29
Using artboards and assets for output .29
Communicating with your printer. .30

CHAPTER 3: **Placing and Tracing Artwork** .31

Placing Artwork .32
Embedding and linking files. .32
Placing text in a shape or path .34
Cropping rasters .35
Using clipping masks. .35
Importing Sketches from Adobe Illustrator Draw.37
Tracing Raster Images. .38

CHAPTER 4: **Drawing Lines and Shapes**43

Building Graphics with Basic Shapes44
Generating shapes45
Clicking to generate shapes.............................46
Drawing shapes interactively............................51
Applying Shape Properties from the Control Panel52
Reshaping Shapes ..54
Building Complex Shapes....................................58
Creating a compound path58
Using Pathfinder to combine shapes59
Drawing Shapes with Perspective............................63
Applying Isometric Effects to Shapes66

CHAPTER 5: **Selecting and Arranging Objects**.....................69

Selecting in Illustrator...................................69
Selecting with tools....................................70
Using the Select menu75
Grouping and Isolating Objects.............................77
Editing objects as groups78
Editing objects within groups...........................79
Aligning and Spacing Objects...............................82
Locating objects with rulers, guides, and grids..........82
Aligning with SmartGuides...............................85
Using the Align panel85
Arranging Objects Front-to-Back............................87

CHAPTER 6: **Organizing Documents with Layers**...................89

Using a Template Layer90
Organizing and Arranging Objects in Layers.................92
Organizing Content within and between Layers...............96
Locating objects in the Layers panel....................96
Arranging objects within and between layers.............97
Styling with Layers..97
Targeting layers98
Changing the appearance of objects in layers99
Applying Layers in Real-World Challenges...................99

PART 2: DRAWING AND EDITING PATHS....................101

CHAPTER 7: **Wielding the Pen and Anchor Point Tools**..........103

Editing Anchors ..104
Selecting and moving anchors...........................104
Converting open paths to closed paths and vice versa........106
Editing Curves with the Anchor Point Tool107

Drawing with the Pen Tool. .109
Creating curved, combination, and straight
anchors with the Pen tool .109
Adding and deleting anchors. .111
Wielding the Pen tool with shortcuts .112
Honing Pen tool skills with a waveform.113

CHAPTER 8: **Creating Artwork with the Pencil,**
Curvature, and Blob Tools .117
Drawing with the Pencil Tool. .118
Setting pencil curve smoothness .118
Managing the many modes of the Pencil tool.120
Setting Pencil tool options .121
Ironing Out Wrinkles with the Smooth Tool122
Drawing and Editing Curves with the Curvature Tool122
Drawing curves .123
Editing curves. .123
Drawing Filled Paths with the Blob Brush Tool.124
Erasing with the Eraser Tool .127
Creating Shapes with the Shaper and Shape Builder Tools127
Creating shapes with the Shaper tool .128
Combining shapes with Shape Builder.128
Animating with Puppet Warp. .129
Fine-Tuning beyond Drawing Tools .131

CHAPTER 9: **Painting with Brushes** .133
Unleashing Your Creativity with Brushes. .133
Painting with the Paintbrush .135
Applying Brushes to Paths. .136
Working with the Brushes panel. .136
Navigating the Brush libraries. .137
Creating DIY Brushes .139
Editing existing bristle brushes to create new ones.139
Crafting calligraphic brushes. .144
Applying or designing art brushes .146
Defining scatter brushes .149
Creating pattern brushes. .151
Using Brushes with a Drawing Tablet. .155

CHAPTER 10: **Improving Workflow with Symbols**157
Rationalizing Workflow with Symbols. .158
Using Illustrator's preset symbols. .158
Adding symbols to a document. .159
Managing symbols .162

Getting Creative with Dynamic Symbols .163
 Creating dynamic symbols. .163
 Orchestrating dynamic symbol instances164
Spraying Symbols .166
 Setting Symbol Sprayer options .167
 Managing sets of sprayed symbols. .168

PART 3: APPLYING COLOR, PATTERNS, AND EFFECTS .169

CHAPTER 11: **Designing in Living Color** .171
Understanding Print versus Screen Color .172
 Defining color for print. .172
 Choosing RGB color for screens .175
 Understanding web safe color. .176
 Configuring grayscale .177
Managing the Color of Strokes and Fills. .177
 Apply color from the Tools panel .177
 Apply color from the Control or Properties panel179
Using Color Guides and Color Themes .180
 Getting color advice .180
 Styling with Adobe color themes. .182
Managing Color Swatches .185
 Adding colors to the Swatches panel .186
 Changing the display of swatches. .187
Creating and Merging Live Paint Groups .188
 Creating Live Paint groups. .189
 Coloring Live Paint faces. .190
 Editing Live Paint edges .190
 Controlling Live Paint faces and edges.192

CHAPTER 12: **Bringing Graphics to Life with Gradients, Blends, and Transparency** .197
Merging Colors with Gradients .198
 Applying gradients. .200
 Unleashing linear gradients. .201
 Radiating radial gradients .207
 Transforming gradients with Gradient Annotator208
 Using freeform gradients. .209
Blending for Beauty and Productivity. .212
 Setting blend options .213
 Working with blends .213
Applying Transparency. .214
 Defining and applying transparency. .215
 Clipping with opacity masks. .218

CHAPTER 13: **Designing with Patterns**..................................221

 Applying Patterns ...222

 Applying a pattern to a fill223

 Applying patterns to strokes224

 Applying patterns to text225

 Creating Your Own Patterns226

 Transforming Patterns227

 Scaling a pattern and object together228

 Scaling patterns and objects separately229

 Rotating and moving patterns...........................230

 Moving a pattern within a shape........................230

 Stacking patterns....................................231

 Defining Pattern Options233

CHAPTER 14: **Styling with Effects**.................................237

 Navigating the Universe of Effects237

 Getting your money's worth from effects238

 Using Photoshop effects with care239

 Appreciating SVG filters240

 Choosing and Applying Effects240

 Managing Effects..242

 Using the Appearance panel242

 Expanding effects244

 Saving graphic styles..................................246

 Generating 3D Effects and Mapping Artwork247

 Mapping artwork.....................................247

 Using Adobe Stock images.............................248

 Exploring 3D effects and mapping248

PART 4: DESIGNING WITH TYPE253

CHAPTER 15: **Formatting Area Type**................................255

 Editing Area Type in Illustrator256

 Generating an area type box...........................256

 Getting type from other apps258

 Using Illustrator's proofing tools........................259

 Styling Area Type.......................................260

 Choosing type font and style...........................260

 Sizing, leading, kerning, and tracking type................262

 Sizing headlines to fit263

 Scaling area type263

 Using character styles.................................264

 Formatting Paragraphs...................................266

 Laying Out Area Type in Columns..........................267

Shaping Area Type. .268
 Placing area type in a path. .268
 Wrapping type around an object .270
Flowing Type from Box to Box. .272
Converting Area Type to Point Type and Vice Versa274

CHAPTER 16: **Getting Artistic with Point Type** .275
Understanding How Point Type Works .275
Creating and Editing Point Type .276
Contorting Point Type. .278
 Scaling point type .278
 Rotating point type .279
Interactive Styling with the Touch Type Tool.280
Placing Type on Paths. .281
 Changing baseline shift on aligned type .282
 Moving type on a path .283
 Applying effects to type on a path .284
Sharing Fonts and Outlining Type. .285
 Sharing fonts .285
 Outlining type. .286

**PART 5: HANDING OFF GRAPHICS FOR
PRINT AND SCREEN DESIGN** .287

CHAPTER 17: **Exporting Raster Files**. .289
Exporting in a Hurry .290
Maximizing Illustrator's Export Options. .293
 Understanding the vector to raster journey293
 Orchestrating vector to raster workflow .294
 Defining raster dimensions .295
 Defining raster resolution .295
Navigating Illustrator's Raster Output Options.296
Exporting to Specific Raster Formats .297
 Exporting PNGs .297
 Optimizing JPEGS. .300
 Handing off TIFF artwork to print .301
Relying on Your Team. .303

CHAPTER 18: **Unleashing the Power of SVGs** .305
Understanding the Role of Scalable Vector Graphics306
 Defining an SVG-friendly environment. .308
 Exporting versus saving .311
Preparing Artwork for SVG Output .312
 Simplifying paths for screen output .312
 Reducing the file size with symbols .313

Applying Transparency and Effects to SVGs .314
 Outputting SVGs with transparent backgrounds315
 Applying transparency effects to SVG .318
 Applying SVG filters .321
Creating SVGs with Scalable, Searchable Type324
 Exploiting the value of scalable, searchable type324
 Optimizing type functionality by saving SVGs326
 Adding code snippets to SVG graphics. .328
Exporting or Saving SVGs .329
 Exporting SVGs for screens .330
 Managing raster objects in SVGs. .331
 Saving SVGs for digital development .332

PART 6: THE PART OF TENS .335

CHAPTER 19: **Top Ten Illustrator Resources** .337
This Book's Unofficial Website. .337
Adobe Illustrator Official Documentation .338
Using Illustrator to Create SVG for the Web339
A Unique Resource for Artistic Fashion Designers339
Going Crazy with Illustrator .340
Style Tile Templates .341
Follow Jean-Claude Tremblay @jctremblay .341
Technical Drawing in Illustrator. .342
Online Tutorials from Adobe .342
Illustrator CC Digital Classroom .343

CHAPTER 20: **Top Ten Productivity Tips** .345
Generate Layers. .345
Use Shapes for Guides .346
Generate Guides from Rulers .347
Place Multiple Files .348
Import Photoshop Files .349
Edit Placed Objects .350
Import Word Files .351
Crop a Placed Image .351
Play Actions .352
Use Shortcut Keys .353

INDEX .355

Introduction

n *Adobe Illustrator CC For Dummies,* I draw on my "long strange trip" (to borrow from the Grateful Dead) with Illustrator. I've drawn bus maps in Los Angeles (yes, they have buses in LA), designed infographics, and created architectural renderings for commercial real-estate developers. I'm not an artist, but I've collaborated with fine artists to port their work to giclée prints. I've conducted seminars for commercial printers and artists, and designed logos and icons for app and web navigation. And every day I discover or explore some new way to use Adobe Illustrator in the rapidly evolving world of illustration and design.

Along the way, I've written or co-authored more than a dozen books on Illustrator and other apps in Adobe Creative Suite, and created course materials on Illustrator for Adobe. Still, I'm fully aware that my own experience only scratches the surface of everything Illustrator can do.

I've learned from colleagues, competitors, and experts in different realms of Illustrator. Most of all, I've learned from decades of teaching Illustrator at community colleges, university extension schools, online courses syndicated around the world, and boutique design consulting agencies. More than anything, I've drawn on my teaching experience in putting together this book.

About This Book

Illustrators use Illustrator for an incredibly wide range of projects, but they all experience one thing in common: Illustrator is not easy to get your head around.

Illustrator's massive array of tools is both a treasure chest and a treasure hunt. Even with the substantial online documentation that Adobe provides, finding your way to understanding and wielding Illustrator requires a guide.

That's where this book comes in.

This book is a reference book, not a tutorial, but I've endeavored to weave in a variety of examples and from-the-trenches experiences that I think readers will find helpful.

I spent a lot of time and thought on organizing the material here so that you can find the buried treasure in Illustrator that will unlock your creativity and enhance your ability to solve whatever illustration and design challenges you confront.

I haven't included a lot of links to websites, but I have a few. Some web addresses break across two lines of text. If you're reading this book in print and want to visit one of these web pages, simply key in the web address exactly as it's noted in the text, pretending that the line break doesn't exist. If you're reading this as an e-book, you have it easy: Just click the web address to be taken directly to the web page.

Foolish Assumptions

I've written *Adobe Illustrator CC For Dummies* for three levels of Illustrator users: those who are new to Illustrator, those who have been using it for a while, and those who are experts in some realm of the Illustrator universe but need a guide to other realms.

How do I juggle all three audiences? I don't assume any starting point as far as your knowledge of Illustrator. But I do assume that you're no dummy, so this book is fast-paced, covers a lot of ground in under 400 pages, and emphasizes problem-solving methods in Illustrator over memorizing specific techniques. I also point you towards resources where you can dig deeper into areas that are a particular focus for your work.

Icons Used in This Book

I scatter tips, reminders, and an occasional warning throughout this book.

TIP

When you see a tip, I'm sharing a time-saving or stress-saving technique that might help you complete a project more quickly or easily.

REMEMBER

I use this icon to emphasize meta-concepts and points that are widely applicable in Illustrator.

WARNING

To my knowledge, no one has ever died by choosing an unfortunate and inappropriate tool or menu option in Illustrator. But when the stakes are high, such as when you might ruin your project and not be able to restore it, I issue a warning with this icon.

Beyond the Book

An online cheat sheet provides quick, basic answers to some of the most frequently asked questions about handing off Illustrator files to game coders, animators, and digital designers. Even though the material is drawn from the book, you may find it valuable as a quick guide to Illustrator-to-web problem-solving.

To see the cheat sheet, simply go to `www.dummies.com` and type **Adobe Illustrator CC For Dummies** in the search box.

Where to Go from Here

The chapters are non-sequential, so you can dive in anywhere. That said, I've arranged the chapters so that starting at the beginning and ending at the end is a good pathway for beginners. If you know what you're looking for, go to the table of contents or index. And keep the book handy for the next challenge you encounter.

1

Creating, Navigating, and Saving Projects

IN THIS PART . . .

Getting started with Illustrator, navigating the interface, and creating artwork

Creating, saving, and printing Illustrator documents and objects

Adding artwork from other sources — including your scanner, photos, and sketches from Adobe Draw or other apps

Drawing, arranging, and creating artwork using lines and shapes

Organizing larger projects into layers, and applying styling to entire layers

IN THIS CHAPTER

» Launching and configuring
 Illustrator

» Using and customizing the toolbar

» Accessing and organizing panels

» Using the Control panel and the
 Properties panel

Chapter **1**

Navigating Illustrator's Interface

A dobe Illustrator's interface can seem complicated, confusing, and sometimes redundant. Here's why: It *is* complicated, confusing, and sometimes redundant. But there are good reasons why.

One reason is that people use Illustrator in so many different ways. Illustrator really is a jack-of-all-trades, and so the folks who develop it need to provide alternative pathways to get things done. For example, an artist designing a logo and an engineer sketching an electrical system have different needs and likely different approaches to drawing, and demand different ways to access Illustrator's features.

The second reason why Illustrator's interface is daunting is that there's so much in this application! A quick perusal of this book's Table of Contents will give you a sense of how many different things Illustrator is used for.

Finally, and perhaps ironically, some of the complexity of Illustrator's interface comes from the very complexity of the app. The hard-working and creative team of developers who make Illustrator powerful and contemporary have their finger on the pulse of users like you! And as new generations of illustrators enter the Adobe Illustrator community, the development team endeavors to provide different alternatives to make the interface more inviting and accessible. For example, Illustrator's toolbar now contains more than 80 tools. Displaying all those tools

would make the entire set overwhelming and inaccessible, so Illustrator provides a basic version of the toolbar with a small subset of tools. This approach makes life easier if you need one of those tools but more complex if you need a tool that was left out of the basic box.

All that said, relax! In this chapter, I provide a guide to the key features in Illustrator and how to access them.

Surveying the Illustrator Universe

In the bulk of this book, I focus on documenting how to get things done: for example, how to create, save and print illustrations (Chapter 2); how to draw lines and shapes (Chapter 4); and how to select and assign color (Chapter 11). The book is non-linear, so you're invited to jump to just what you need. If you're like me, you want to find out how to solve a problem, not understand how something works — at least at first. Other people, with more orderly minds I suspect, like to immerse themselves in the how before they get to the what.

If you have started with this chapter, you might be just entering into the Illustrator universe with a rational impulse to find out how to navigate your way around an interface that includes over 80 tools, hundreds of menu options, and at least two distinct but significantly overlapping options for accessing the most commonly used features: the Control panel and the Properties panel. These two panels provide similar sets of options, and which panel you use is really a matter of which one you find more comfortable to work with.

My mission in this opening chapter is not to present encyclopedic documentation of everything in the byzantine Illustrator interface. Instead, I provide a basic guide to where to find what, along with a curated documentation of features you will almost certainly need.

Launching Illustrator

Although people use Illustrator in different ways, a large section of designs travel through a few workflows. When you launch Illustrator, the opening home screen provides access to these frequently traveled express lanes to get you on your way:

» **Learn tab:** The Learn tab, shown in Figure 1-1, provides access to a set of helpful video tutorials. You can watch them in sequence as a continuous learning experience, or choose a topic to help you solve a pressing challenge.

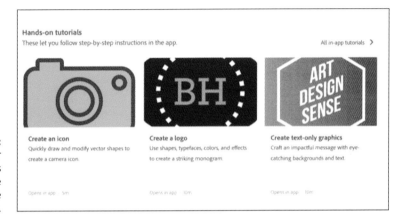

FIGURE 1-1:
Illustrator
tutorials
accessible
from the
home screen.

» **Start a New File Fast section:** Because there are a number of frequently traveled pathways to creating files, the options in the Start a New File Fast section of the home screen allow easy access to basic settings for print and screen projects. These are not templates; they are packaged sets of properties such as units of measurements (points, pixels, inches, and more) and color modes (such as RGB or CMYK). Choosing one of these options can jump-start a project. I zoom in on these options in Chapter 2.

» **Open button:** When you want to open an existing file, Illustrator kindly presents you with a set of template thumbnails — types of projects, such as a letterhead, a poster, a website, or an app prototype. If you can't find the file in the thumbnails, use the Sort and Filter options, shown in Figure 1-2, to search for the file.

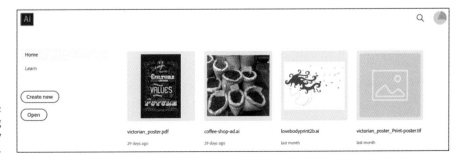

FIGURE 1-2:
Choosing
from recently
opened files.

Using and Customizing Toolbars

After you open or create a document, Illustrator's toolbar is the single most essential element in creating illustrations. Illustrator provides two toolbars, Basic and Advanced. The Basic toolbar is highly customizable.

The Basic toolbar, which is displayed by default when Illustrator is launched, includes a curated set of frequently used tools. The Basic toolbar is highly customizable. To add tools to the Basic toolbar, click the ellipses (edit toolbar)) icon at the bottom of the Basic toolbar. The tools drawer appears. You can display or hide tools using the four Show options at the bottom of the tools drawer. Or you can drag any tool into the Basic toolbar, as shown in Figure 1-3.

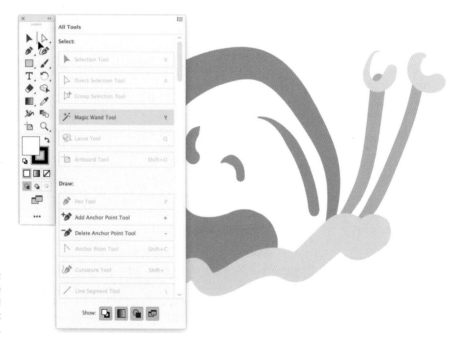

FIGURE 1-3:
Adding the
Magic Wand
to the Basic
toolbar.

The Advanced toolbar includes every tool available in Illustrator. You can toggle from the Basic to the Advanced toolbar by choosing Windows ⇨ Toolbars ⇨ Advanced. You can't change the tools that appear there.

Accessing and Arranging Panels

You use features in panels to tweak, tune, touch up, and transform artwork. Every chapter in this book, and every substantial Illustrator project, involves using features available through panels. But here I want to focus on a couple features of panels above and beyond how any specific panel works.

You can also quickly set up a work environment for typical workflows such as print, web, or typography by choosing Window ⇨ Workspace and then selecting a type of project from the submenu. I'm choosing the Essentials workspace in Figure 1-4.

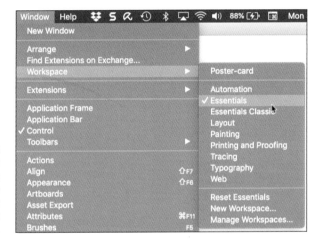

FIGURE 1-4:
Using a workspace to populate the screen with selected sets of panels.

An Illustrator *workspace* is defined by which panels are displayed. You can configure your own workspace by adding and arranging panels, or you can use one of the presets. The contradiction is that the more panels you display, the more features you have quick access to but the less space you have to draw something! So, if you find your workspace cluttered with too many panels, you have a few options:

>> Temporarily hide all panels by tapping the Tab key. A second tap restores the panels.

>> Clear the workspace of extraneous panels and revert to a minimalist workspace with just the Basic toolbar by choosing Window ⇨ Workspace ⇨ Essentials.

>> Dock one panel by dragging it by its tab to another panel. (You can dock it in the top or bottom of a panel or group it in the panel.) In Figure 1-5, I'm dragging the Color Guide panel to the bottom of the Color panel. The image on the right shows the docked Color Guide panel.

FIGURE 1-5:
Docking a
panel.

>> Group panels by dragging the tab of one panel into the title bar of another panel. In Figure 1-6, I grouped the Color and Color Guide panels.

>> Collapse panels (including groups of panels) into icons by clicking the << (double arrows) in the upper-right of the panel or panel group.

FIGURE 1-6:
Grouped panels.

Panels are your friend. But like any friend, they can become a bit too much at times. So when you find your workspace overwhelmed by panels, use any of the tips just listed to reduce clutter and free up space for designing!

Using the Control Panel or the Properties Panel

The two most robust panels in Illustrator are the Control panel and the Properties panel. Both panels have many features that overlap. And both panels are *context-sensitive,* meaning the options they display depend on what you're doing and what objects you select.

For example, in Figure 1-7, I selected a box of type (the word *Control*). Both the Control panel (at the top of the screen) and the Properties panel (on the right) provide access to fill and stroke color, character and paragraph style options, font, font size, and opacity.

FIGURE 1-7:
Option for
styling type
in the Control
and Properties
panels.

The differences, essentially, are that the Properties panel has more options for selected objects and the Control panel takes up less space.

Choosing between the Control and Properties panels

Because many features in the Control and Properties panels overlap, which panel should you use?

I know Illustrator experts who fall out on all sides of this argument: Control panel! Properties panel! Both? My opinion: I think the extra design space that the Properties panel occupies isn't worth its extra features.

Again, the choice is yours, and I explain how to set up and use both panels.

Options on the Control and Properties panels

The Control and Properties panels share the following features:

>> **When text is displayed as a link, you can click the link text to display a related panel or dialog box.** For example, in Figure 1-8, I've accessed the Character panel from the Control panel. That frequently used option (accessing the Character panel) is available in the Control panel but not the Properties panel.

FIGURE 1-8:
Opening a panel from linked text in the Control panel.

» **When nothing is selected, the panels provide options for defining document properties.** In Figure 1-9, I'm changing the unit of measurement for my document in the Properties panel.

One difference between the Control and Properties panels is that you can resize, dock, or group the Properties panel just like other panels, but the Control panel usually sits atop the workspace. However, you can drag the Control panel (by the left edge) down the screen to any other vertical position.

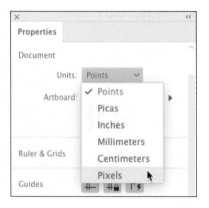

FIGURE 1-9:
Configuring document properties in the Properties panel.

As you explore Illustrator's features in this book or on your own, you'll come to form your own views and feelings about how much to rely on the Properties panel and how much to depend on the Control panel.

Chapter **2**

Creating, Saving, Exporting, and Printing Files

My number one rule for Illustrator projects is this: Work backward. If a project is headed for a print shop, start with a call to the printer to find out what specs you need to meet. If your artwork is to be handed off to a web developer, check in with the developer to find out what kind of resolution he needs. If an animator needs a vector graphic, find out what kind of code she needs.

That said, you don't really create Illustrator graphics backward! You start by defining a document. Then you define *artboards* — the discrete elements in a document that can be easily shared in any combination (you can hand off all of a document's artboards, some of them, or just one to a web developer or print project). And you can gather and share content in other ways, such as selections and library items.

But that said, even in the earliest stages of creating a graphic in Illustrator, it pays — literally in terms of time and energy expended — to work with as clear a picture as possible of where your project will end up. On a website? In a print ad? On a poster? In a digital animation? Each of these outcomes requires a specific color mode, is defined with different units of measurement, and will have other constraints that should be built into the project as early as possible to avoid having to tear up the work and start over.

In this chapter, I sketch out the basic process of identifying your output, and then creating a document; organizing your content into artboards; exporting and saving documents, artboards and selections; and sharing objects that produce the kind of output you need.

Creating Documents

The first step in doing anything in Illustrator is to create a document. But right away you are confronted with important initial choices. Why? Essentially because Illustrator graphics can take two pathways: print and screen. The way colors are defined and objects are measured varies greatly between these two paths.

Am I saying that when you conceive of a project you need to know whether or not the output is aimed at print output or screen output or both? Basically, yes. Although you can change horses in the middle of the stream, you might create unnecessary complications in sizing and coloring objects. It's best to anticipate the output and — to repeat my mantra — work backward from there.

Making basic choices for a document

Shortly I walk you through my curated set of options for creating a document, but all the options boil down to three essential choices: color mode, units of measurement, and dimensions:

- » **Print color or web color:** Projects destined for commercial printing should probably be created with CMYK color. That said, even high-quality personal printers, and some commercial print workflows, accept or prefer RGB color. CMYK (cyan, magenta, yellow, and black) is referred to as *subtractive* color because these four colors are printed on top of each other to create a full range of colors. RGB (red, green, blue) is referred to as *additive* color because red, green, and blue dots of varying intensity are combined on a screen to generate a spectrum of color.

- » **Units of measurement:** You use pixels for web and other increments (such as inches, centimeters, or points) for print projects.

- » **Dimensions (height and width):** Because vector graphics are infinitely scalable, sometimes dimensions are not that relevant. But when illustrations are aimed at a specific device with a set width and height (such as a mobile phone app), viewport (a defined website width), or print output (such as a poster or postcard), you want to define an artboard (or multiple artboards)

that matches those dimensions. I explain how *artboards* work later in this chapter, but the short story is that they are defined spaces in the Illustrator canvas that can be easily shared for print or screens.

Using presets

Illustrator comes loaded with document presets. You access these presets by clicking the Create New button in the opening Illustrator screen, or by choosing File ➪ New. Those presets are grouped into the tabs shown in Figure 2-1: Recent, Saved, Mobile, Web, Print, Film & Video, and Art & Illustration.

FIGURE 2-1:
Document presets grouped in tabs.

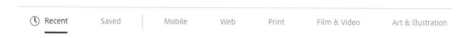

The tabs at the top of the screen provide access to the different categories. After you select a category, the opening screen displays both presets and templates (more developed projects that you can customize).

The View All Presets link pushes the templates down the screen and displays all the available presets. Figure 2-2 shows presets available in the Mobile tab of the New Document dialog, as well as the Preset Details panel on the right, which displays (and can be used to configure) basic color mode, dimension, and print settings.

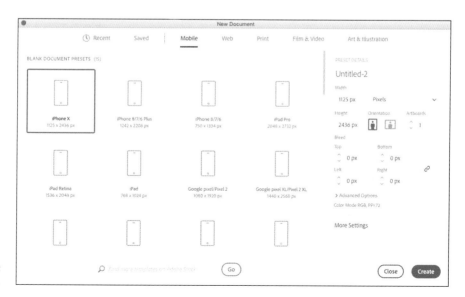

FIGURE 2-2:
Mobile presets.

Presets are handy time-savers. And most of them are pretty self-explanatory: The Recent tab shows presets and custom document configurations you've used recently, and the other presets are organized by output. They provide instant access to color mode, units of measurement, and dimensions for different kinds of projects, as well as more detailed options (such as printer-only features) applicable to specific media.

TIP

I think most readers will find adding profiles to the Saved tab in the New Document dialog to be more hassle than it is worth. But if you have a need to create saved profiles, and you are fluent in navigating hidden system folders, you can save new profiles.

To save a new profile on a Mac, save a blank document with the appropriate settings to the New Document Profiles folder in this path: Users ⇨ Library ⇨ Application Support ⇨ Adobe ⇨ Adobe Illustrator 23 ⇨ [your language] ⇨ New Document Profiles.

To save a new profile in Windows, save a blank document with appropriate settings to the New Document Profiles folder in this page: Users ⇨ AppData ⇨ Roaming ⇨ Adobe ⇨ Adobe Illustrator 23 ⇨ [your language] ⇨ x64 ⇨ New Document Profiles.

My preferred work-around for custom presets is to simply create blank documents with settings I need, and save them as an Illustrator document that I can edit and resave with new filenames.

Defining color mode, artboard size, and raster resolution

Although the presets are nice, they don't match every project you will do. So you need to know how to configure document features by hand.

To define document color mode, units of measurement, dimensions, and other details, click the More Settings button. This opens the More Settings dialog, revealing the full set of options for new documents.

The essential document setting options are as follows:

>> **Name** defines the default filename when you save or export the entire document.

>> **Profile** can shortcut the process of defining document settings by letting you choose or change the kind of document you are creating.

- » **Number of artboards** defines how many artboards of the defined size will be generated. The set of diagrams to the right of the number of artboards defines how the artboards will be arranged. The Spacing drop-down configures the space between each artboard on the canvas, and the Rows/Columns spinner defines the number of rows or columns that will display artboards. I explain how artboards work later in this chapter in the section "Deploying Artboards."

- » **Size** drop-down options can shortcut the process of defining the width and height for your document. The options depend on the profile you selected. For example, if you choose a print profile, sizes include A4, a Letter, or a Tabloid, among others. If you choose Mobile profile, the options include iPad, Apple Watch, and Google pixel.

- » **Width and Height** boxes define the width and height of your project. If you are generating multiple artboards, all the artboards will inherit this width and height. The Orientation options toggle between portrait and landscape orientation.

- » **Units** is where you choose a unit of measurement appropriate to your project: pixels for digital output or points, picas, inches, millimeters, or centimeters for print.

- » **Bleed** is relevant only for files sent directly to print production, such as postcards, posters, or other print media (for example, shirts or mugs). If you're preparing graphics to send directly to a print shop, consult with the printer on what kind of bleed to define, if any. (For an explanation of when and how to apply bleeds, see the "Communicating with your printer" section, later in this chapter.

- » **Color Mode** options are RGB for screen output and CMYK for commercial printing.

- » **Raster Effects** settings define the resolution of bitmap effects (such as Photoshop Effects) applied to your illustration. For an explanation of raster effects, see Chapter 14.

- » **Preview** mode is normally left at the default setting. The Overprint option allows you to preview how commercial print output will look. Consult with your commercial printer on if, when, and how to use this option.

After you configure document settings, click Create Document.

TIP

What if you change your mind about a document setting? You can change settings at any stage of a project by choosing File ⇨ Document Color Settings (for color mode) or File ⇨ Document Setup (for everything else, including units of measurement).

Deploying Artboards

As I briefly noted, the *canvas* is the area of the Illustrator workspace where you create graphics. The canvas is basically everything you see on the screen except the interface (such as the menu, Control panel, and other panels). I walk through the non-canvas sections of the workspace in Chapter 1.

Within the canvas, artboards are discrete, sized spaces that make it easy to export, share, or print sections of the canvas. That's a lot of workflow help!

Here's how I like to think about artboards: They are both coherent and discrete. Too philosophical? Okay, here's the point: Artboards inherit and share many properties of the document they lie within, such as color mode or raster effect resolution. (I explain these options earlier in the chapter in the "Defining color mode, artboard size, and raster resolution" section.) And that's nice because it means you can work on different graphics, including differently sized graphics, with shared properties.

For example, you might have a project where you design a print poster, palm card, and plastic banner for an event. Although these will be different in size, they will likely use the same set of colors and maybe other features such as symbols (which I explain in Chapter 10).

Or you might use multiple artboards of the same size to prepare a prototype of a mobile app that shows different states of user interaction. Here, dozens of artboards might be helpful. Again, this project has common document properties that apply to all artboards, such as RGB color and pixels as the unit of measurement.

To help you get your money's worth out of artboards, I first review some basic rules for creating and using them. Then I walk you through the two scenarios I just identified — print project and app prototype — to help you understand the efficacy of artboards and to expose you to key techniques for deploying artboards.

Defining artboards

You can have 1 to 1,000 artboards per document. I've never used 1,000 artboards in a project, but it's nice to know they're there if I need them. As I explain in the beginning of this chapter, you can set the number of artboards for a document when you first create it, but you can also add and remove artboards after you begin work on a document.

The Artboard tool is part of the Basic toolset (I explain how to manage tools in Chapter 1). You create artboards in a document by selecting the Artboard tool and drawing interactively on the canvas, as shown in Figure 2-3.

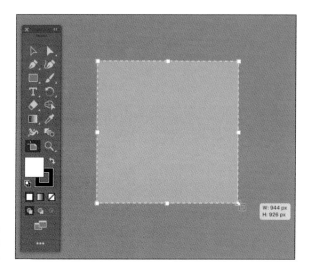

FIGURE 2-3:
Drawing an
artboard.

Or you can generate an artboard by clicking the New Artboard icon in the Artboard pane or the Control (or Properties) panel. The Artboard Options dialog shown in Figure 2-4 opens.

Generating an artboard allows you to name the artboard as you create it, along with defining the dimensions and location digitally.

You can manage artboards in many ways. The following shows you how to define and take advantage of the artboard options I think you'll find helpful in organizing and sharing projects.

To resize or move an artboard inter-actively, follow these steps:

1. **With the Artboard tool, click once inside the artboard.**

2. **Drag to move the artboard, as shown in Figure 2-5.**

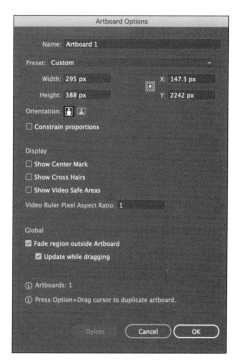

FIGURE 2-4:
Generating an artboard with the Artboard Options dialog.

3. Click and drag on a side or corner (square-shaped) bounding box to resize the artboard, as shown in Figure 2-6.

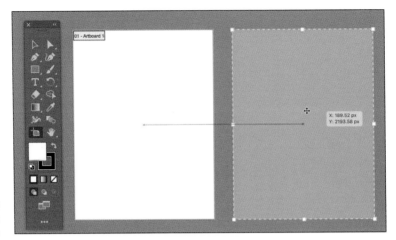

FIGURE 2-5:
Moving an
artboard.

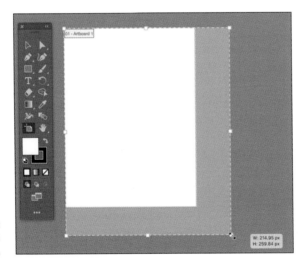

FIGURE 2-6:
Resizing an
artboard.

You can change any artboard property by using the Control or Properties panel:

>> The Presets drop-down provides quick access to commonly used sizes. My favorite feature here is the Fit to Artwork Bounds option, which resizes the selected artboard to shrink in size to where it just fits around all the artwork within it. By sizing an artboard to an exact fit around its content, you avoid exporting or printing blank space in your graphic.

>> The Name box is the easiest way to change the selected artboard name.

>> The Move/Copy Artwork with Artboard option is on by default but can be turned off if you want to move an artboard while leaving the content where it is.

>> The Artboard Options box opens a dialog with options that apply to all selected artboards in a document. I find the Show Center Mark useful when centering content in an artboard. You can use this dialog also to rename multiple selected artboards with sequential numbering. For example, if I rename a bunch of selected artboards DK, I end up with DK-1, DK-2, DK-3, and so on.

>> The X value in the Control panel defines the vertical location; the Y value defines the horizontal location.

>> The Width and Height values resize the artboard. Use the lock icon to lock the height-to-width aspect ratio while you resize.

>> The Rearrange All icon opens up a panel with different options for arranging your artboards in an orderly way on the canvas.

A couple of other artboard essential tips:

>> To hide all objects that are not within an artboard, choose View ⇨ Trim.

>> To delete an artboard, select it with the Artboard tool and click Delete.

Using artboards for a multidimensional project

Let me illustrate a basic but typical multi–artboard workflow: one where you create different versions of the same graphic but with different dimensions. In doing that, I share some techniques and approaches you can apply to your own particular needs.

Suppose that you are tasked with designing an ad that will run in different social media platforms and in different orientations: square, horizontal (landscape), and portrait (vertical). The ad must have the same basic content but fit the following size specs:

>> Square: 1080 pixels

>> Vertical: 1080 pixels wide by 1350 pixels high

>> Horizontal: 1200 pixels by 628 pixels

The following steps are an efficient way to set up the artboards for this project:

1. **Create a new document with one 1080 px square artboard, as shown in Figure 2-7.**

 a. *Choose File ⇨ New, and bypass the New Document dialog by clicking More Settings.* The More Settings dialog appears.

 b. *Name the project Ads.*

 c. *In the Profile drop-down, choose Web.*

 d. *In the Number of Artboards box, enter 3.*

 e. *Set the artboard arrangement to Arrange by Row (the third icon).*

 f. *In the Height and Width boxes, enter 1080.* The Units setting will default to Pixels, and the Color Mode to RGB. These and other defaults are fine.

 g. *Click Create New Document.*

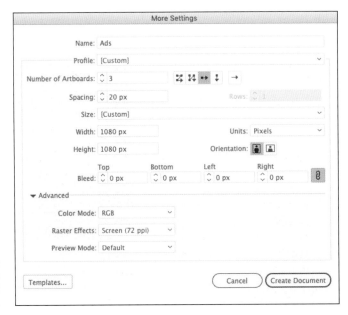

FIGURE 2-7:
Defining a
three-artboard
document.

2. **Name the three artboards Square, Vertical, and Horizontal:**

 a. *If the Artboards panel is not displayed, choose Window ⇨ Artboards.*

 b. *Double-click the name of Artboard 1 and type **Square**. In the same way, rename the second artboard **Vertical** and the third artboard **Horizontal**.*

 c. *Choose View ⇨ Fit All in Window to see all three artboards, as shown in Figure 2-8.*

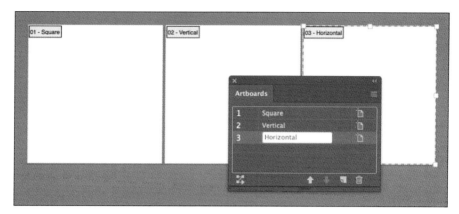

FIGURE 2-8:
Naming
artboards.

3. **Resize the Vertical and Horizontal artboards:**

 a. *In the Artboard panel, double-click the icon to the right of the artboard named Vertical. In the Control panel that appears, change the height to 1350 px and click OK.*

 b. *In a similar way, change the dimensions of the Horizontal artboard to 1200 pixels wide by 628 pixels high.*

4. **Arrange the artboards to create a more coherent display:**

 a. *Click Rearrange All Artboards in the Control panel.* The Rearrange All Artboards dialog opens.

 b. *Keep the Arrange by Row layout and the left-to-right Layout Order settings you defined when you created the document. Leave the spacing set to 20 pixels, and leave Move Artwork with Artboards selected, as shown in Figure 2-9, then click OK.*

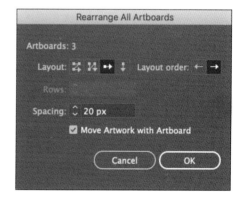

FIGURE 2-9:
Arranging artboards.

 This step keeps the basic layout structure in place, but resets the spacing between the resized artboards so they don't overlap.

5. **Design your ad on one of the artboards.**

 In Figure 2-10, I started with the square ad.

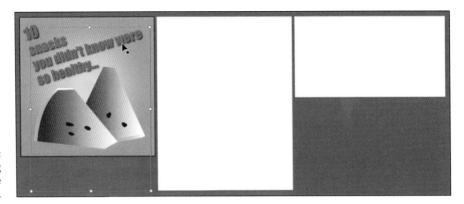

FIGURE 2-10:
Designing
a single
artboard.

6. **Copy the first ad content to the other artboards:**

 a. Use the Selection or Direct Selection tool to select all the content in the first artboard, the one with the content.

 b. Choose Edit ⇨ Cut.

 c. Choose Edit ⇨ Paste on All Artboards.

 d. The Paste on All Artboards technique pays for itself when you're working with dozens or even hundreds of artboards! Of course, the pasted artwork doesn't fit properly in differently sized artboards. Fixing that is the last step.

7. **Edit the design of the horizontal and vertical artboards to make the square content fit, as shown in Figure 2-11.**

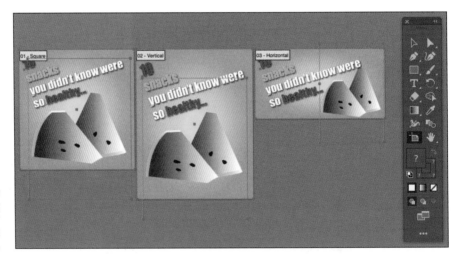

FIGURE 2-11:
Customizing
designs for
different
artboards.

What do you do with a set of artboards? They are automatically saved as part of your Illustrator document. After that, you can export one, some, or all of them for screen or print output. I explain how to do that next.

Exporting, Saving, and Printing

You can export, save, and print several kinds of objects in Illustrator:

>> An entire document

>> One, some, or all artboards in a document

>> Selected objects

>> Assets

You share Illustrator files for a wide range of print and screen output options by *exporting* them to one of a long list of file formats. Exported files can't be edited in Illustrator.

You *save* Illustrator files when you need to edit them in the future.

Sometimes you export files for print or web output, and then save them. Sometimes you can save Illustrator files in formats that you can hand off to print or web designers *and* edit them.

In this section, I first describe how to save files that you can open and edit in Illustrator. Then I explain how to export or print documents, artboards, selections, and assets. Finally, I share some tips on printing and working with commercial printers.

Saving Illustrator files

You can save Illustrator files in any of these formats:

>> **AI,** Illustrator's native format and AIT (Illustrator templates).

>> **EPS,** a widely supported vector format used for sharing files with other vector-editing apps and printers.

>> **Adobe PDF,** a portable vector format accessible to anyone with Acrobat Reader.

>> **SVG or SVG (Compressed)** files for screen output. See Chapter 18 for an in-depth exploration of working with SVG files.

Saving projects as EPS, PDF, or SVG files gives you the option of retaining the ability to edit the files in Illustrator.

Each of the options for saving Illustrator files has distinct options. If you are handing off a file in any of them, check with the team you are handing off to, to find out if there are specific settings they require. I share some tips on saving AI, EPS, and PDF files for print output at the end of this chapter, and explore SVG output for digital projects in Chapter 18.

The following steps apply to saving files as AI, EPS, and PDF formats:

1. **Choose File ➪ Save, File ➪ Save As (to save an existing file with a new name), or File ➪ Save a Copy (to create a duplicate copy of a file).**

2. **Navigate to a location for the file and enter a filename.**

3. **In the Format drop-down, choose one of the available formats (AI, EPS, or PDF).**

 If the file format you want to use (such as PNG or TIFF) is not available in the Format drop-down, the format is available for export but not saving.

TIP

4. **Click Save to open the Options dialog for the file format you selected. The options will differ depending on the format but the following choices are widely available and useful:**

 - If you're saving to AI or EPS format, the Version drop-down defines the version of Illustrator with which you want your file to be compatible. If you are saving to PDF, the Compatibility drop-down defines what versions of PDF will be able to open the file. Legacy formats don't support all features.

 - Font embedding options allow you to embed fonts for users who will receive the file but may not have the required fonts.

 - The Create PDF Compatible File option for saving AI files allows the file to be opened with Adobe Reader as well as apps that support importing Illustrator documents.

 - The Include Linked Files option embeds any linked files in your illustration.

 - The Embed ICC Profiles option is used by some print shops to ensure color integrity. Consult with your print shop on whether and how to use this option.

 - The Use Compression option reduces file size.

 - The Save Each Artboard to a Separate File option is available in Illustrator files with multiple artboards. Along with the resulting set of artboard-based files, a master file is created with all artboards.

If you're simply saving an Illustrator project to access it, to edit it, or to share it with someone who has Illustrator, save the file as an Illustrator file.

Exporting files

Illustrator files (as well as artboards, assets, and selections) can be exported to a variety of print- and web-compatible file formats. These files can't be edited in Illustrator, so you will almost always want to save as well as export projects as Illustrator files.

Web designers may ask you for SVG files, which retain Illustrator editing capability (see Chapter 18). More likely, web designers will ask you for web-compatible PNG or JPG files. I explore export options for those formats in Chapter 17.

Print designers may be able to work with your Illustrator files. Or they might require TIF or other print-only raster images. In those instances, get the specs for the exported files from your print partner.

You export files by choosing File ⇨ Export ⇨ Export for Screens or File ⇨ Export ⇨ Export for As (for print). Options vary depending on the output format. And, again, I'll repeat a mantra that runs through this chapter and any discussion of output in this book: Ask the person to whom you are handing off the file what options he or she prefers.

Using artboards and assets for output

When you save or export Illustrator documents with multiple artboards, you can choose to export or save any set of artboards.

For example, if you're exporting a document to PNG output for screens, the Artboards tab (shown in Figure 2-12) allows you to define which artboards to export.

FIGURE 2-12: Exporting selected artboards.

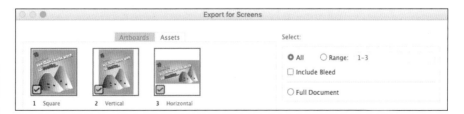

Communicating with your printer

Today, print shops can turn Illustrator artwork into anything, from a poster to a coffee mug, a t-shirt to a message printed on glass. Each project has its own requirements, and the trick is to communicate effectively with your printer from the beginning.

I asked Lydia Ochavo from UpPrinting.com, a widely used online print service, to share advice applicable to just about any print project in Illustrator. Here are some of her tips. Refer to the beginning of this chapter for notes on how to define documents to meet these specs:

>> Print shops provide templates for frequently used output. Download and use them before you begin your project. UpPrinting has templates at www.uprinting.com/print-templates.

>> Although Illustrator vector files are scalable, it's safest to submit files to the printer sized to the actual output size.

>> Most printers require a 1/8" bleed around your artwork. Make sure that all printable content is inside the bleed.

>> Set raster resolution to at least 300 dpi.

>> Use CMYK color mode because professional print shops print only in CMYK.

>> Many print shops prefer PDF format to Illustrator AI files.

>> When you need an exact color match and your printer supports the use of Pantone color, use Pantone colors. Pantone colors are available from Swatch panels in Illustrator. You can use a Pantone color book to preview how a color will print. Those color books are available from your printer.

Chapter 3

Placing and Tracing Artwork

Not everything that ends up in an Illustrator project begins life as an Illustrator object. The genesis of an Illustrator project might start with a raster image, such as a photo. Or an Illustrator project might start with a hastily sketched drawing on an Android or iOS mobile device using Adobe Draw.

Sometimes you'll bring objects into Illustrator as rasters and convert them to vector graphics. Other times you'll bring objects into Illustrator as rasters and they will stay in the project as rasters. Illustrator vector-based graphics are often hybrids, a mix of raster and vector objects.

In this chapter, I explain how to bring all kinds of files into an Illustrator file and describe the essential choices you have when integrating those files into an Illustrator project.

Placing Artwork

In Illustrator, *place* refers to bringing files into an existing document. Placed files can be embedded in a document or linked from an external source and included in an Illustrator document.

When files are linked, changes to the original file are reflected in the Illustrator document. When files are embedded in an Illustrator document, the umbilical cord, so to speak, is cut, and changes made to the original file are not reflected in the Illustrator document.

Embedding and linking files

To embed or link a file in an open Illustrator document, follow these steps:

1. **Choose File ⇨ Place, navigate to the file in the dialog that opens, and click the file, as shown in Figure 3-1.**

 By default, the Link option is selected. If you know you want to embed the file, not link it, deselect the Link option. If you're not sure, leave Link selected (because it's easier to change a linked object to an embedded one than vice versa).

FIGURE 3-1:
Selecting an
object to place.

2. **Select or deselect Link.**

3. **To place the object in your document full size, simply click with the icon that appears. Or click and drag to size the placed object, as shown in Figure 3-2.**

Managing linked files

When a linked file is selected, it appears with a big X on the Illustrator canvas. The file can be transformed, moved, or sized like any object, but as long as it is linked, it can't be edited.

You manage the status of linked files in the Links panel. A number of options for managing the status of a linked file are available, but the most important and widely applicable is updating the connection when a linked file has been changed so that the latest version of the file appears in your Illustrator document.

When a linked file has been updated outside Illustrator (for example, when a photo is touched up in Photoshop, or replaced with a different photo using the same filename), a warning icon appears next to the file in the Links panel. To update the placed content, click the Update Link icon in the Links panel (to refresh the link), as shown in Figure 3-3.

FIGURE 3-2:
Locating and sizing a placed object.

FIGURE 3-3:
Updating a placed object.

Embedding linked files

If you placed a file as a linked file but decide you want to edit it in your Illustrator document, you can easily convert the file from linked to embedded.

REMEMBER

After you break a link and embed a placed file, any changes to the original file will not be reflected in the Illustrator document.

To change a placed object from linked to embedded, select it and choose Embed from the Links panel menu, as shown in Figure 3-4.

FIGURE 3-4:
Converting a
placed object
from linked to
embedded.

Placing text in a shape or path

You can place text files (in TXT or RTF format) from a word processor. The placed text will be embedded, not linked. But it will automatically pour into the selected shape. The following steps place text in a selected shape.

1. **Select the shape into which you are placing text.**

2. **Choose File ⇨ Place and navigate to the text file.**

TIP

When you choose File ⇨ Place and select a text file, the Show Import Options check box becomes active. Ignore it. Whether or not you select that check box, the next dialog that will open is the Microsoft Word Options dialog.

3. **Click Place.**

The Microsoft Word Options dialog opens. Use the options in this dialog if you want to include a table of contents or an index, not import a table of contents or an index, and include (or not include) formatting. Available options depend on the source of the text file.

4. **Click OK to approve your import options.**

5. **Click the edge of the shape to insert the placed text inside the shape, as shown in Figure 3-5.**

Cropping rasters

You can crop placed raster artwork in Illustrator. Cropping a linked raster image breaks the linkage to the original file, so before you can crop a raster image you need to change a linked image to an embedded image. You can do so on the fly with the following steps.

1. **Select the image, right-click, and choose Crop Image from the menu that appears, as shown in Figure 3-6.**

2. **If a dialog appears, reminding you that cropping the image changes the link status to embedded, click OK.**

3. **Use the side and corner cropping handles to crop the image, as shown in Figure 3-7.**

 a. *Hold down the Shift key to maintain the original height-to-width ratio while you crop.*

 b. *Hold down the Alt key (Windows) or Option key (Mac) to maintain the original center point as you crop.*

 c. *Click and drag on the center point to move the crop area.* The area to be cropped appears dimmed.

4. **Press Enter (or Return) to crop to the area you defined in the preceding step.**

Using clipping masks

What if you need to crop a placed image or define an irregular shape that determines what part of the image shows through but

FIGURE 3-5:
Placing text in an octagon.

FIGURE 3-6:
Selecting a placed image to crop.

FIGURE 3-7:
Cropping a linked image.

also maintain the text file's linked status? One solution is to draw and apply a clipping mask.

Clipping masks hide sections of an image without cropping the image. To create and apply a clipping mask, follow these steps:

1. **Draw a shape or path over the image demarcating a crop area, as shown in Figure 3-8.**

 Normally, this shape will be a rectangle, like the one shown in Figure 3-8, but it can be any shape or path.

FIGURE 3-8:
Drawing a
clipping mask.

2. **Select both the rectangle and the placed image by using Shift-click or any other selection technique, and then choose Object⇨Clipping Mask⇨Make.**

 The result looks like a crop, but the placed (and linked) image only appears to be cropped. The entire placed image is still in the Illustrator document.

 If you want to display the entire image in your illustration, you can release the clipping mask by selecting the placed image and choosing Object⇨Clipping Mask⇨Release.

3. **To change the location of the clipped image, choose Object⇨Clipping Mask⇨Edit, and select and move the mask, as shown in Figure 3-9.**

 To edit an existing clipping mask for a selected object, choose Edit⇨Clipping Mark⇨Edit Contents.

TIP

FIGURE 3-9:
Editing a
clipping mask.

Importing Sketches from Adobe Illustrator Draw

For millennia, okay, for a couple decades, digital artists have had to deal with the challenge of transferring sketches to Illustrator. They could draw in their sketchbook and scan the artwork into Illustrator. Ouch! Illustrator has powerful tracing tools, and I show you how to use them in the "Tracing Raster Images" section. But tracing scanned sketches and converting them to vectors is a hassle and usually produces unsatisfactory results.

You can sketch directly in Illustrator with a drawing tablet, such as a Wacom tablet. But what if inspiration strikes while you're out in the field? If you grab your sketchbook, you have to wrestle with scanning the sketch into Illustrator. But if you have a mobile device and a stylus, or even a fingernail, you have all the tools you need to sketch on the spot and access the results in Illustrator.

The first step is to install Adobe Illustrator Draw on your iOS or Android device, using the appropriate app store. The app is free!

When you install Adobe Illustrator Draw, you'll be prompted to sign in with your Adobe ID and password. Doing that links Adobe Illustrator Draw with your Adobe account and your desktop Illustrator app.

After you launch Adobe Illustrator Draw on your digital device, you'll see simple but intuitive drawing tools. I can't squeeze in an overview of those tools here, but you can find documentation at www.adobe.com/products/draw.html. For a quick-and-dirty sketch, just draw on the screen with your fingernail like I did when I confronted the odd creature in Figure 3-10, left. The easiest way to open the file directly in Illustrator on your laptop or desktop is to click the share icon in Draw, and choose Adobe Desktop Apps⟿Illustrator CC, as shown in Figure 3-10, right.

Presto! That's all it takes to open an Adobe Illustrator Draw file in Illustrator.

FIGURE 3-10: Sketching in Adobe Illustrator Draw (left) and setting the sketch to open in Illustrator or Photoshop (right).

Tracing Raster Images

Two basic workflows lead to tracing raster images in Illustrator:

>> You're working with a sketch created in a raster program such as Photoshop or scanned from a drawing, and you need to convert that artwork to a vector image.

>> You're starting with a photo or other raster image, and you want to experiment with artistic effects produced by vectorizing that image.

As much as possible, you want to avoid the first scenario, so that you are working with vectors from the start. Illustrator has powerful tracing capacity, but the results take time and usually require more than a bit of work.

Why is the tracing process so characterized by trial-and-error? Put yourself in Illustrator's shoes: It takes a lot of brain power to convert raster artwork to vectors. Of course Illustrator doesn't have a brain, but it does have powerful processing capacity to "think about" how to transform sets of dots (raster images) into vectors. Thus, tracing a raster image usually involves trial and error to find settings that produce the best result, followed by tweaking with the Pen tool to restore lost or corrupted details.

You can trace rasters in multiple ways. Both the Control and Properties panels have a Trace drop-down list, but I suggest using the Image Trace panel instead. That panel provides the most available and most accessible options. The following steps are used to select and apply an image trace from the Image Trace panel:

1. **With the Image Trace panel displayed (choose Window ⇨ Image Trace if it's not selected), select the raster object to be traced.**

2. **Select the Preview check box in the Image Trace panel.**

 You'll need to experiment with different settings to find the ones that produce the optimal trace, so you'll want to preview the effect of your settings before launching trace.

 You can undo a trace and start over again, but try to avoid that. Tracing takes significant time, and it's more efficient to preview the result of a trace before applying it.

3. **Experiment with trace settings:**

 a. *Choose one of the intuitively named presets from the Preset drop-down list, shown in Figure 3-11.*

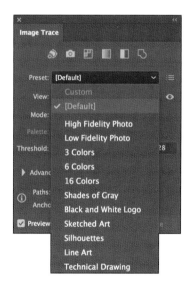

FIGURE 3-11:
Image Trace presets are intuitively named for different types of artwork.

b. Continue choosing presets until you find one that produces something close to your desired result.

c. Use that preset's options to tweak the trace settings by previewing the result. The options are specific to the type of preset you selected. For example, if you choose a color preset, you can edit how many colors will be generated, as shown in Figure 3-12.

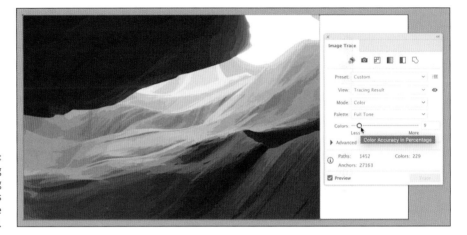

FIGURE 3-12: Customizing and previewing trace settings in the Image Trace panel.

4. **When you achieve the result you want, deselect the Preview check box and then click the Trace button in the Image Trace panel.**

 You can continue to change trace settings after turning off Preview, and you can toggle back into Preview at any time by selecting the Preview check box.

 The Trace button becomes active (not dimmed) when you deselect Preview. Illustrator may warn you that the process will take some time.

5. **Choose Object ⇨ Expand to convert the traced object to paths and to make it possible to edit the vector artwork produced by the trace.**

 Alternately, you can click the Expand button in the Control or Properties panel.

 The result is a set of paths, all ready to edit, as shown in Figure 3-13.

Image tracing is an inexact science. Illustrator has to guess at how to convert a sea of dots into coherent vectors, and the results are never perfect. Expect to put in some time with editing tools (such as the Pen tool, the Anchor Point tool, and the Direct Selection tool) and other techniques to put the finishing touches on the vector graphics produced by your traced artwork.

IN THIS CHAPTER

» Designing graphics with basic shapes

» Building complex shapes

» Creating compound paths

» Drawing shapes with perspective

» Applying isometric effects to shapes

Chapter **4**

Drawing Lines and Shapes

Compelling graphic designs can be put together by artfully arranging simple shapes. In fact, the very simplicity of shapes makes them so widely applicable and effective.

My mission here is not to unleash a shapes-appreciation movement. I'll leave that to Picasso and his acolytes. Seriously, take some time to explore and appreciate Picasso's use of shapes (see, for example, the concise discussion of Cubism at www.pablopicasso.org/).

Okay, let's get here-and-now practical. Contemporary print and digital designers use shapes as the foundation for the following:

» Icons

» Logos

» Symbols

» Print design elements

» Navigation buttons and other elements of app interfaces

» And much more

What do the items in the preceding list have in common? Lots of things, of course, including the fact that every designer needs to be able to create them. But here's another feature they share: They often are built almost entirely with basic shapes.

And Adobe Illustrator is the ultimate tool for creating, transforming, and combining shapes.

Building Graphics with Basic Shapes

Creatively deploying shapes is a key element of modern aesthetics. And in Adobe Illustrator, drawing, generating, combining, and arranging shapes are core elements in contemporary graphic design for print and screen.

Digital interfaces, such as the app interface prototype in Figure 4-1, are usually built from simple shapes.

Play a little "Where's Waldo" with that figure and see how many basic shapes you can identify. See any ellipses (ovals and circles)? A triangle, or two, or three, or four, or five? A hexagon? Rectangles? Lines (horizontal and vertical, of various thicknesses)? How about stars?

Figure 4-1 demonstrates the use of shapes in digital design, but shapes are also ubiquitous in design for print. Arrangements of shapes like those in Figure 4-2 could be used with a wide array of messages in a poster.

FIGURE 4-1:
This app interface prototype screen is built almost exclusively with basic shapes.

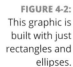

FIGURE 4-2:
This graphic is built with just rectangles and ellipses.

In Figure 4-3, I selected all the paths and anchors so you could see how the illustration is composed of only rectangles, trapezoids (truncated triangles with the top chopped off), and ellipses (combined to make the billowing smoke clouds).

FIGURE 4-3:
Revealed:
rectangles and
ellipses.

By now, I expect you're chomping at the bit to learn not just the basics but more advanced design and workflow techniques to deploy shapes. Even though you've been through some basic training in creating shapes, I think you'll find valuable tips in this lesson.

Let's dive in then, right?

Generating shapes

The tools you need to create shapes are in the Shapes flyout in the toolbar. And if you're going to be working with shapes intensively, you'll likely want to pull those tools off the toolbar for easy access. So let's do that now.

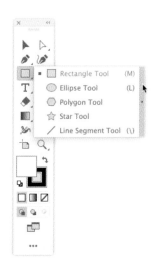

1. **Create a new document by choosing File ⇨ New.**

2. **In the dialog that opens, click any of the presets and click the Create button.**

3. **If the toolbars are not visible, choose Window ⇨ Toolbars ⇨ Basic.**

4. **Click the Shape tool until its flyout appears.**

5. **Click in the vertical bar to the right of the tools (it's dimmed in Figure 4-4).**

FIGURE 4-4:
Pulling the Shape tool's flyout off the toolbar.

After you pull the Shape tool's flyout off the toolbar, you can drag that set of tools around your workspace by clicking and dragging any part of the tool set except the tools themselves, as shown in Figure 4-5.

FIGURE 4-5:
Moving the shape tools flyout around the workspace.

Clicking to generate shapes

When you have a shape tool selected and click in the workspace, a dialog pops up prompting you to *define* a shape. This can be confusing because it's easy to forget that clicking when a shape tool is selected does *not* launch a process of dragging to draw the shape. Instead, it opens a dialog.

This feature is valuable because you can define a shape with a precise size quickly and accurately instead of futzing around trying to draw the shape on the fly. You know you need a 72-pixel square? Click, enter the values 72 and 72, click OK, and you're done!

So let's walk through generating shapes with dialogs.

Generating a rectangle

Let me illustrate the point about a dialog popping up when you click in the Illustrator workspace with a shape tool selected. In Figure 4-6, I selected the Rectangle tool, and clicked once in the workspace.

That action did *not* initiate a process by which I can *draw* a rectangle.

FIGURE 4-6:
The Constrain Width and Height Proportions feature is turned off in the Rectangle dialog.

Instead, it triggered the Rectangle dialog you see in Figure 4-6. Here, I can define a rectangle by entering values in the Width and Height boxes.

When you select the Constrain Width and Height Proportions icon to the right of the values, it locks in the height-to-width aspect ratio. So, for example, if you have this feature enabled and change the value of a width, the value of the height will change proportionally. To use a simple example, suppose you have the Constrain Width and Height Proportions feature selected and start with values of

100 px for both the height and the width. If you then change the height to 200 px, the width will change to 200 px as well.

You toggle this width-height constraint feature on and off by clicking its icon, as I'm doing in Figure 4-6.

After you click OK in the Rectangle dialog, Illustrator generates a rectangle whose upper-left corner is at the spot in the workspace where you originally clicked. In Figure 4-7, I used two intersecting guides to identify the *origin point* — that is, the point where I clicked to begin generating the rectangle. (For instructions in creating guides from rulers, see Chapter 5.)

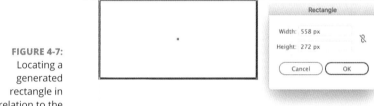

FIGURE 4-7: Locating a generated rectangle in relation to the insertion point.

The function of that origin point varies depending on what kind of shape you're generating. For a rectangle, the origin point defines the upper-left corner. For an ellipse, it locates the upper-left corner of the bounding box around the shape, as shown in Figure 4-8.

FIGURE 4-8: Locating a generated ellipse.

To round a rectangle digitally, click in the Control panel and then click Shape Properties (in Chapter 2, you find out how to view and access context-dependent features in the Control panel). You do not need to select a specific part of the rectangle first. With the Link Corner Radius Values icon selected (that's the default), enter a value for any of the four corner radii, as shown in Figure 4-9.

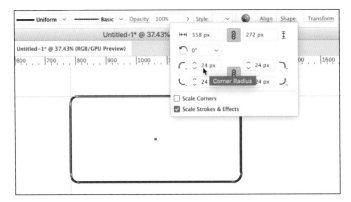

FIGURE 4-9:
Rounding a
rectangle.

You can control corner radii values also interactively by clicking and dragging. I show you how to do that later in this chapter.

TIP

Another technique for drawing rectangles (and other shapes) is to select the Shaper tool and draw a rough shape. Anything close to a rectangle, a triangle, or an ellipse will be converted automatically into a corresponding shape. Drawing with the Shaper tool is similar to drawing with the Pencil tool. I explore the Pencil tool detail in Chapter 8.

Generating an ellipse

Generating an ellipse (an oval or a circle) is similar to generating a rectangle, but with the following two key differences:

» The basic dialog for ellipses has width, height, and constraint options just like the one for rectangles, but the dimensions define the horizontal and vertical diameters of the ellipse.

» As I noted, an ellipse does not have an upper-right corner. So when you generate an ellipse at a point in the workspace, the upper-right corner of the ellipse's bounding box aligns with the point where you clicked before generating the shape.

Generating polygons and stars

When you select the Polygon tool, the dialog allows you to define the number of sides for the polygon and the radius, as shown in Figure 4-10. You can generate polygons with an infinite number of shapes, but when that number starts getting high, your shape is more like an ellipse.

FIGURE 4-10:
Defining an octagon.

More likely, you'll use the Polygon tool for triangles, pentagons, hexagons, and octagons, all of which are used in a wide array of projects ranging from stop signs to app icons.

When you select the Star tool, the dialog allows you to define how many points the star will have, an inner radius (Radius 1), and an outer radius (Radius 2), as shown in Figure 4-11.

FIGURE 4-11:
Defining a five-pointed star, with the outer radius twice the size of the inner radius.

The dialogs for generating polygons, and the one for stars, locate the generated shapes differently than the dialogs for generating rectangles and ellipses. Instead of placing the generated shape with the bounding box anchored in the upper-left corner with the placement point, Illustrator places ellipses and stars using the selected point as the *center* of the shape, as you can see in Figures 4-10 and 4-11.

Generating a line segment

To generate a straight line, click the Line Segment tool, and then click in the work-space. The Line Segment Tool Options dialog allows you to define the length of the line and the angle (with the insertion point serving as the fulcrum, or center, that defines that angle, as shown in Figure 4-12).

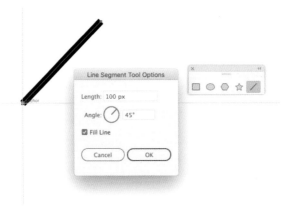

FIGURE 4-12:
Generating a line segment.

A few notes about using generated line segments in designs. The *segment* in the name of this tool is a bit misleading. Don't use this tool to draw *multi*-segment paths. For that, use the Pen tool (see Chapter 7). Line segments are for stand-alone lines.

The Fill Line check box in the Line Segment Tool Options dialog doesn't seem to do much because when you generate a (straight) line segment, there's no curve to fill. But if you're planning to change the segment to a curve, with a fill applied to the resulting space, you'll want to select this box. Let me illustrate: If you adjust the curve of the segment, as shown in Figure 4-13, whether or not a fill is generated within the curve depends on how you defined the line segment. (Adjusting curves with the Anchor Point tool is explained in Chapter 7.)

The Stroke panel options are accessed by choosing Window⇨Stroke and then choosing Show Options from the panel menu. These options allow you to change the caps at the end of the stroke, make a line dashed, or add arrowheads, and more. The arrowheads and dashed lines are ubiquitous in flowcharts and diagrams, and the ability to style caps is useful in design.

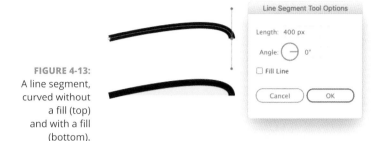

In Figure 4-14, I've applied butt cap, a round cap, and a projecting cap to the three line segments.

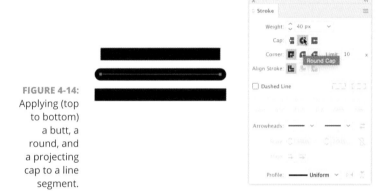

Cataloging obscure line and shape tools

Illustrator has a bunch of additional line and shape tools that — with CC — have appropriately been exiled off the Basic toolbar. They're esoteric (Polar Grid); redundant (Rounded Rectangle, redundant because you can easily round corners on a regular rectangle, as I explain earlier); used occasionally (Arc, Spiral, and Rectangular Grid tools); and inexplicable (Flare).

If you want to experiment with them, click the Edit Toolbar ellipses at the bottom of the toolbar and scroll through to the Draw section.

Drawing shapes interactively

Generating shapes by clicking and defining properties in the Options dialog is often an efficient way to work. You can generate the shapes you need, and then move, copy, and change them to fit your design needs. But at other times, you'll

want the freedom and flexibility of just clicking and dragging to intuitively draw a shape.

Drawing shapes is similar to generating them, except that instead of selecting a shape tool and *clicking*, you select a shape tool and *click and draw*. As you do, the dimensions of your shape are displayed, as shown in Figure 4-15.

Following are some tips for drawing shapes:

W: 369 px
H: 302 px

FIGURE 4-15:
Dimensions are displayed when you draw a rectangle.

>> To constrain dimensions to squares (for rectangles); circles (for ellipses); and no rotation (for polygons and stars), hold down the Shift key while drawing.

>> To draw out from a center point, hold down the Alt key (Windows) or the Option key (Mac). This step is not necessary for polygons and stars because they are always drawn from the center point.

>> You can combine these effects by holding down the Shift key and the Alt key (Windows) or Option key (Mac) at the same time.

>> To interactively change the number of points on a star or sides on a polygon, use the up arrow (to add) or down arrow (to subtract) keys on your keyboard as you draw.

>> Drag clockwise or counterclockwise with your mouse, touchscreen, or drawing pad to rotate as you draw.

Applying Shape Properties from the Control Panel

I walk through the Control panel and how to get your money's worth out of it in Chapter 2, but here are some specific ways you can use the Control panel to configure shapes. The Control panel adapts itself to the context of the selected shape, so the options are different depending on which shape is selected.

Hovering your cursor over a link in the Control panel displays helpful tips. In Figure 4-16, one of those tips alerts you to the fact that you can access an alternate way to define colors for the selected object by clicking while holding down the Shift key.

FIGURE 4-16:
Exploring
shape-friendly
options in the
Control panel.

Here's a list of frequently used Control panel links for handy reference when editing shapes:

>> The Fill and Stroke boxes open from which you can assign colors. Use the Shift key as you click either of these boxes to open an alternative mode for the color panel, instead of the default swatch panel. The flyout menu, shown in Figure 4-17, allows you to choose from additional color mode options. Here, I'm opting to define colors using RGB values.

FIGURE 4-17:
Defining shape colors in RGB.

>> The Stroke link opens the Stroke panel, from which you can select stroke weight (thickness), cap, dashed line properties, arrowheads, and profiles (those profiles provide a set of options for strokes of varying thickness).

>> The Opacity link allows you to set opacity for both the stroke and fill of a selected shape. See Chapter 12 for details on defining transparency and opacity.

>> If you have defined graphic styles, the Style drop-down can be used to apply them to the fill of a selected shape.

- >> The Shape link provides specific options for different kinds of shapes (and the line segment).

- >> The Transform link provides quick access to digitally resizing or moving objects, rotation, and shearing. I discuss these features in Chapter 5.

As if Illustrator weren't complicated enough, the Properties panel provides access to a set of features similar to those in the Control panel. My two cents' worth on the Properties panel? Unless your monitor screen needs additional clutter, you can probably survive without activating this panel.

Reshaping Shapes

In Chapter 5, I dive into transforming any kind of object. There I explain how to use the Scale tool, the Transform panel, and other techniques for large-scale, precise scaling and rotation workflow, including rotating on fixed anchor points.

Some basic, specific techniques common to interactively transforming shapes as you design are worth a quick survey here.

Selecting, moving, and coping shapes

Moving a shape can sometimes be a hassle because you need to avoid selecting an anchor or a path, and instead select the shape itself. Do that by selecting the shape (with the Selection tool), and dragging on the Center icon, shown in Figure 4-18.

FIGURE 4-18:
Moving a
shape.

You can select contiguous shapes by using the Select tool, and drawing a *marquee* (a bounding box) around the shapes you want to transform. With the shapes selected, click and drag *any* of the center icons to move the selected shapes, as shown in Figure 4-19. This technique works for non-contiguous shapes too;

instead of drawing a marquee to select shapes, hold down the Shift key as you select different shapes, and then drag them around the workspace by using any of the center icons.

Hold down the Shift key as you move a shape or selected shapes to lock the movement into horizontal or vertical alignment, or to constrain the angle of rotation to 45 degrees.

Hold down the Alt key (Windows) or the Option key (Mac) as you move selected shapes to copy them as you move them, as shown in Figure 4-20.

Selecting and moving shape anchors and paths

You can reshape a shape (redundant as that might sound) by selecting a path with the Direct Selection tool, and then moving that path, as shown in Figure 4-21. Holding down the Shift key as you drag a path constrains the angle you can drag, which helps maintain the integrity of the shape.

You can also use the Direct Selection tool to select and move anchors, and thus resize and reshape shapes, as shown in Figure 4-22. Here, too, holding down the Shift key as you move an anchor constrains the move to fixed angles.

You can also use Shift-Click to select more than one anchor, or path, and move them all together.

Interactively rescaling shapes

You can change the size of a shape or selected set of shapes by clicking and dragging an anchor. Hold down the Shift key as you resize the shape or selected shapes to maintain the height-to-width aspect ratio, as shown in Figure 4-23. Note that both the original shape sizes and the new shape size are displayed, with the new size outlined in blue.

FIGURE 4-19:
Moving selected shapes.

FIGURE 4-20:
Copying selected shapes.

FIGURE 4-21:
Editing a shape path with the Direct Selection tool.

FIGURE 4-22:
Editing an anchor location with the Direct Selection tool.

FIGURE 4-23:
Resizing
selected
shapes while
maintaining
the height-to-
width ratio.

If you click and drag corner anchors, you can interactively resize both the height and width of a shape or a selection of shapes. If you click and drag a side handle, you can resize either the height or the width (unless you are holding down the Shift key, in which case the height-to-width aspect ratio is locked).

If you hold down the Alt key (Windows) or Option key (Mac) while you resize a shape or shapes, the center point stays locked in position, as shown in Figure 4-24.

FIGURE 4-24:
Interactively
resizing a circle
and two line
segments while
maintaining
the center
point.

Interactively rotating shapes

You can easily and interactively rotate a selected shape. To do so, you need to display the bounding box (the rectangle that encloses the shape). If the bounding box is not visible, choose View ➪ Show Bounding Box.

To rotate a selected shape interactively in the workspace, hover your cursor over one of the corner or side boxes in the bounding box with the Selection tool (*not* the Direct Selection tool) until the rotation icon appears, as shown in Figure 4-25. Click and drag clockwise or counterclockwise to rotate the selected shape or shapes.

With Smart Guides on, Illustrator displays the rotation angle as you rotate. Holding down the Shift key constrains the rotation to increments of 45 degrees. Smart Guides are enabled by default, and I explain how to change settings in Chapter 1.

FIGURE 4-25:
Interactively
rotating
selected
shapes.

Interactively rounding rectangles

Before rounding out my Top Five list of interactive reshaping techniques for shapes (yup, it's five, count 'em), let me show you a quick, easy interactive way to round rectangles. In today's world of digital design, rounded rectangles are more likely to be referred to as *buttons with border radii,* but it's all the same thing.

I noted earlier, in surveying shape tools that you *won't* use, that the Rounded Rectangle tool (still available from the full set of tools) isn't necessary. That's because it's so easy to add a corner radius to regular rectangles. Earlier in the chapter I showed you how to define a corner radius with the Shape properties link in the Control panel, but you can also do it interactively.

So, after all that buildup, here's how to round corners (or define border radii): With the Direct Selection tool, hover your cursor over any corner of a selected rectangle and view the curve icon that appears. Drag the icon, as shown in Figure 4-26, to interactively create a border radius.

R: 6.54 px

FIGURE 4-26:
Defining a
border radius
interactively.

If you want to define the border radius for just one corner of a rectangle, select a corner anchor with the Direct Selection tool. Only one round corner icon will appear.

Building Complex Shapes

Shapes are infinitely editable when you use the Direct Selection tool to click and drag anchors, or delete anchors. I walk you through using the Direct Selection tool in Chapter 5. For now, here's a basic example. To convert a circle to a semicircle, you select one of the anchors, as shown in Figure 4-27, and delete that anchor by simply pressing the Delete key.

FIGURE 4-27: Selecting an anchor in a circle.

The result is the semicircle shown in Figure 4-28.

So that's shape-editing 101, and again, I walk through how to edit paths of every kind, including shapes, with selection tools in Chapter 5. But Illustrator also comes with a very powerful set of tools for combining shapes in all kinds of ways.

Creating a compound path

Because Illustrator shapes are discrete objects, knocking out part of one shape with another shape isn't quite as simple as you might think. For example, to get

the effect of looking through narrow windows at trees, shown in Figure 4-29, I couldn't just draw windows in the gray wall. I had to draw the windows, and then generate a compound path.

To create a compound path from overlapping objects, follow these steps:

1. **Select the object(s) to be transformed into a compound path.**

 For example, in Figure 4-30, I selected the gray rectangle and the white rectangles.

2. **Choose Object ⇨ Compound Path ⇨ Make to knock out the windows, as shown in the example in Figure 4-31.**

3. **Size, move, or transform the resulting object.**

 The resulting compound path can be transformed as a discrete object, as shown in Figure 4-32.

Using Pathfinder to combine shapes

Basically, anything you want to do to combine all or part of overlapping objects can be done with the set of tools in the Pathfinder panel or Pathfinder effects. To take a few widely applied examples:

>> You can combine shapes into a single shape (using the Unite icon).

>> You can knock out the area(s) where they intersect and create a new shape from the intersected region (using the Intersect icon).

>> You can make the areas where they do — and don't — intersect into distinct objects (using the Divide icon).

FIGURE 4-28:
Creating a semicircle by deleting an anchor.

FIGURE 4-29:
A compound path was used to let the trees be visible through slats in the wall.

I mentioned two options: the Path-finder panel and the Pathfinder effects. The former is a set of tools in a panel, and the latter are options from the Effects menu. The set of options available in the Pathfinder effects menu and those available in the Path-finder tools panel are similar, but the two options are used differently.

Pathfinder effects have the advantage of being *effects.* You can select and edit the original (uncombined) objects. And you can use the Appearance panel to modify or remove Path-finder effects just like you can modify or remove other effects that you apply from the Effects menu. I discuss Pathfinder effects more in Chapter 14.

FIGURE 4-30:
Selecting a set of objects to combine into a compound path.

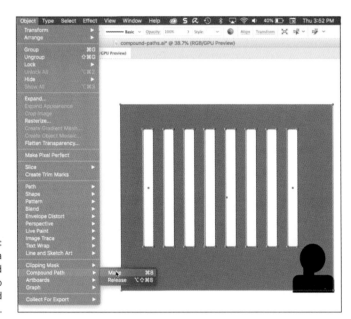

FIGURE 4-31:
Applying a compound path to selected objects.

The big downer, as Jeff Spicoli might put it, with Pathfinder effects from the Effects menu is that they can't be applied to individual shapes. Huh? What good is a set of effects that can't be applied to shapes? Well, Pathfinder effects *can* be applied to *grouped* shapes, text objects, or layers. But the inability to apply them to selected shapes drastically limits their usefulness in many design situations. Figure 4-33 shows what happens, for example, if I try to apply the Exclude effect from the menu to two selected objects.

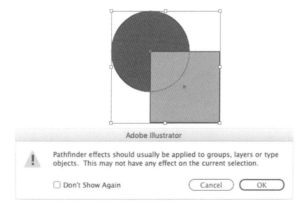

By contrast, when I apply the Exclude effect from the Pathfinder panel to the same two selected objects, I get the result shown in Figure 4-34.

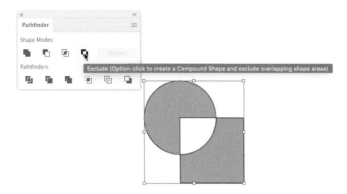

FIGURE 4-34:
Applying
the same
Pathfinder
effect from
the Pathfinder
panel.

Although there are times and places to use Pathfinder effects from the menu, in the interests of avoiding semi-redundancy, and because the objects to which you can apply Pathfinder effects from the Effects menu are so limited, I focus here on applying them from the panel.

It's easier to show how Pathfinder tools work than to try to describe them, so I've put together a set of images in Figure 4-35 that demonstrate the panoply of effects you can generate from the Pathfinder tools when two objects are selected.

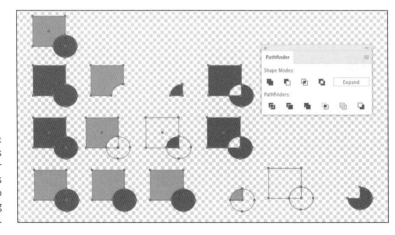

FIGURE 4-35:
The effects
of Pathfinder
panel tools
on two
overlapping
objects.

The four icons in the top row of the Pathfinder panel create paths or compound paths. The bottom row generates new shapes from the overlapping or intersecting parts of the objects.

Note that Figure 4-35 displays the anchors and paths generated by these tools. Why? Because sometimes the unselected objects look alike, but their underlying path structures (and thus what you can do with the result) differ.

For example, the result of applying the Unite tool (second row, first column in Figure 4-35) looks like the result of applying the Divide tool (third row, first column). But you can see that the resulting anchors and paths are different: You can pull apart the objects that resulted from the Divide tool, but you cannot pull apart formerly distinct shapes after you combine them with the Unite tool.

Figure 4-35 illustrates all the Pathfinder panel tools:

>> Row 1 is the original set of two overlapping objects. Note that the magenta circle is *in front of* the orange square. You'll want to keep that in mind as you explore the effect of different Pathfinder tools.

>> Row 2 demonstrates the effect of the Unite, Minus Front, Intersect, and Exclude tools *without* holding down the Alt key (Windows) or Option key (Mac).

>> Row 3 demonstrates the effect of the Unite, Minus Front, Intersect, and Exclude tools *while* holding down the Alt key (Windows) or Option key (Mac).

>> Row 4 demonstrates the effect of the Divide, Trim, Merge, Crop, Outline, and Minus Back tools.

Yet another approach to combining shapes is to use the Shape Builder tool. I explain how that works in Chapter 8.

Drawing Shapes with Perspective

Every art student is taught how to draw with perspective — that is, setting one or two vanishing points and having objects recede in size as they approach that vanishing point. Illustrator provides the Perspective Grid to facilitate drawing with vanishing points. Since it was introduced in Illustrator CS5, it has been a feature that — as Mick Jagger says about the Stones' "Their Satanic Majesties Request" — has received "mixed reviews."

But I'm going to expose you to a quick look at Perspective Grid. Why? Because when you find the right time and place to deploy the Perspective Grid, it's a powerful productivity tool for prototyping architectural renderings and other 3D projects.

I'll demonstrate how the Perspective Grid and Perspective Grid Selection tools work to create a standard two-dimensional grid.

1. **Before you begin to draw, choose View ⇨ Perspective Grid ⇨ Two Point Perspective ⇨ [2p-Normal View], as shown in Figure 4-36.**

FIGURE 4-36:
Defining a
Perspective
Grid.

2. **In the All Tools section of the toolbar, drag the Perspective Grid tool and the Perspective Selection tool into the toolbar, as shown in Figure 4-37.**

3. **With the Perspective Grid tool selected, adjust the horizontal and vertical vanishing points, as shown in Figure 4-38.**

4. **Use the Active Plane Widget to select a plane to edit, as shown in Figure 4-39.**

 The widget appears by default in the upper-left corner of your workspace.

FIGURE 4-37:
Accessing the Perspective Grid tool and
Perspective Selection tool.

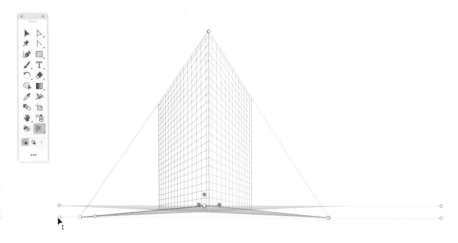

FIGURE 4-38:
Adjusting the
vanishing
points.

5. **With the grid defined and the pane selected, draw a rectangle on the active plane, as shown in Figure 4-40.**

6. **Use the Perspective Grid Selection tool to edit the rectangle, as shown in Figure 4-41.**

I think you can take it from here, adding and tweaking rectangles. A few tips:

>> Define fill and stroke properties as you would for any shape not on the Perspective Grid.

>> If you are creating shapes outside the grid, use the Perspective Grid Selection tool to re-access the grid environment.

>> You can switch between defined planes at any time by using the Active Plane Widget.

FIGURE 4-39:
Selecting a pane to edit.

FIGURE 4-40:
Drawing a rectangle on the Perspective Grid.

>> If you are an experienced 3-D drafter, use the Define Perspective Grid options dialog to customize and fine-tune the perspective type, angles, and horizon height. Access the dialog by choosing View ⇨ Perspective Grid ⇨ Define Grid.

>> You can also customize the display of the grid colors and opacity in the Define Perspective Grid dialog.

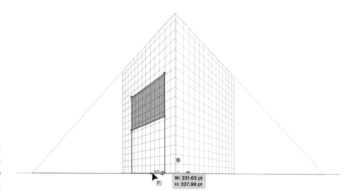

FIGURE 4-41:
Editing a
shape in the
Perspective Grid.

WARNING

>> If you move or edit drawn objects in the Perspective Grid by using the regular Selection or Direct Selection tools, instead of the Perspective Grid Selection tool, you'll lose the snap-to-grid features.

Applying Isometric Effects to Shapes

Isometric effects are a way of applying 3D to shapes, but without the vanishing points that we saw with the Perspective Grid. The drafting table in Figure 4-42 is a fun example of applying isometric effects to shapes.

FIGURE 4-42:
An illustration
composed
of isometric
shapes.

Many techniques and tricks for drawing isometric shapes are available. If you search online, you'll find tutorials for creating them by using special grids (laid out diagonally), breaking up hexagons into isometric shapes, and other approaches.

I'll show you what I think is the quickest and easiest way to create isometric shapes. It is the technique used to create most of the shapes in Figure 4-42.

1. **Start with a rectangle.**

 I won't rehash how to do that; jump to the beginning of the chapter if you need some help.

2. **With the rectangle selected, choose Effect ⇨ 3D ⇨ Extrude & Bevel.**

 The 3D Extrude & Bevel Options dialog opens. Many features are here, accessible from the Map Art and More Options buttons. For an exploration of those options, see Chapter 14. We don't need those options to generate isometric shapes.

3. **In the Position drop-down in the dialog, choose one of the four isometric options, and then click Preview to see how that effect will transform your rectangle.**

 In Figure 4-43, I'm previewing Isometric Right.

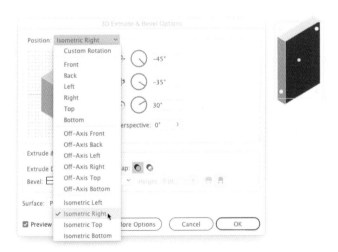

FIGURE 4-43:
Previewing an
isometric effect
on a rectangle.

4. **Experiment with options:**

 - Extrude Depth changes the third dimension in your isometric shape.

 - The two Cap options toggle between a filled in shape and hollow isometric shape.

 - Bevels add a range of effects that you can experiment with by using the Preview option.

5. **After you define the isometric shape, click OK to generate it.**

 You can scale, rotate, and in other ways transform the generated isometric shape. If you want to convert the effect to a set of shapes, choose Object ⇨ Expand Appearance.

 The image you come out of these steps with can be edited like any set of shapes. Rotate it. Resize it. Move it. Make copies of it, and put the resulting shapes together to form more complex sets of isometric shapes. Or edit the paths, as shown in Figure 4-44.

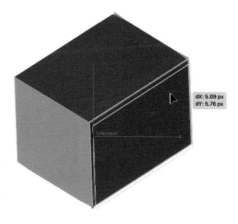

FIGURE 4-44:
Editing an effect expanded as isometric shapes.

IN THIS CHAPTER

» **Making selections with tools and menu options**

» **Making global edits**

» **Grouping and isolating objects**

» **Transforming selected objects**

» **Arranging and aligning objects**

Chapter **5**

Selecting and Arranging Objects

S electing vectors is an art and a science. Why? Because the task involves dissecting a graphic, and figuring out how best to grab objects so you can group and transform them.

In this chapter, I show you how to get your money's worth out of Illustrator's unique selection tools and techniques. Then you discover how to group, transform, arrange, align, and globally edit selected or similar objects.

Selecting in Illustrator

You can select objects in Illustrator in two basic ways:

» Using selection tools

» Using the Select menu

Selection tools are best for interactively grabbing relatively simple sets of objects. The Select menu is best for ferreting out sets of objects that are non-contiguous (not attached to each other), such as paths or shapes with a similar appearance.

Any exploration of selecting objects in Illustrator intersects with exploring how objects are organized, including within groups or layers. I explain when, why, and how to group objects in the section "Grouping and Isolating Objects." Layers are useful for complex projects, and I explain how they work and how to use them in Chapter 6. The Live Paint Selection tool is part of coloring technique, but it's also a selection tool. For an explanation of how to use Live Paint to intuitively apply colors to projects, even when the section of an object you want to color is not an object per se, see Chapter 11. One last cross-reference before we dive into the tools and menu options: I explain how to use selection tools and techniques for type in Chapters 15 and 16.

Having noted these different ways you can make selections in Illustrator, it's time to dive into the two avenues into selection: tools and the Select menu.

Selecting with tools

The power tools in the set of selection tools are Selection and Direct Selection:

>> The Selection tool is the most basic way to select objects and groups and edit those objects and groups.

>> The Direct Select tool allows you to select anchors and paths within objects and edit them.

You can go a long way in life with just those tools. But for more complex selections, the following tools are available:

>> The Group Selection tool makes it easy to select objects within a group.

>> The Lasso tool allows you to draw irregularly shaped marquees around objects and select their anchors or the object(s) entirely.

>> The Magic Wand tool is used to select objects of the same color, stroke weight, stroke color, opacity, or blending mode.

The Selection, Direct Selection, Group Selection, and Lasso tools are available from the Basic toolbar. If the Basic toolbar is not visible, choose Window ⇨ Toolbars ⇨ Basic.

The Selection tool is in the upper-left corner of the Basic toolbar and is easy to access because it is probably the most widely used tool in Illustrator.

The Direct Selection tool flyout reveals the Group Selection and Lasso tools, as shown in Figure 5-1.

The Magic Wand tool is in the Advanced toolbar, but you can add it to the Basic toolbar. Click the three dots at the bottom of the Basic toolbar, and then drag the Magic Wand tool into the Basic toolbar, as shown in Figure 5-2.

TIP

The Perspective Selection tool is another selection tool, but it is applicable only if you're working in a Perspective grid. (For details on working in a Perspective grid, see the section on drawing shapes with perspective in Chapter 4.)

Selecting objects by using the Selection tool

The Selection tool is versatile. At its most basic, you click an object, and the object is selected, ready to be moved, trans-

FIGURE 5-2:
Adding the Magic Wand tool to the Basic toolbar.

formed, or deleted (just press the Delete or Backspace key). Here are some additional techniques:

>> To add objects to the selection, hold down the Shift key and tap the additional objects.

» To select contiguous objects, draw a marquee around them. To select contiguous objects, draw a *marquee* — a rectangular selection area — around them, as demonstrated in Figure 5-3. If the marquee includes just part of an object, the entire object is included in the selection. For example, the marquee shown in Figure 5-3 selects all four rectangles.

» To extend an existing selection, hold down the Shift key and click the additional objects or draw an additional marquee. In Figure 5-4, two non-contiguous sets of objects are selected (the horse's nose and part of the neck), and I'm adding a third set of objects (the mane) by drawing another marquee.

FIGURE 5-3:
Drawing a marquee with the Selection tool.

Selecting paths and anchors with the Direct Selection tool

The Direct Selection tool is used to select anchor points or path segments. Clicking an object with the Direct Selection tool reveals all the anchors in that object. With the anchors revealed, it's easy to click an anchor or path to move or delete it. Figure 5-5 shows a selected path segment being moved.

FIGURE 5-4:
Adding to a selection.

The techniques I noted for making multiple selections with the Selection tool work in similar ways with the Direct Selection tool. You can click and drag to select multiple objects (revealing their anchors and paths). If a marquee that you've drawn with the Direct Selection tool includes part of an object, the entire object will not be selected. In addition, you can hold down the Shift key to add to an existing selection.

FIGURE 5-5:
Using the
Direct
Selection tool
to move a
path.

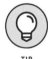

TIP

When using the Direct Selection tool, a marquee needs to cover all objects — not just part of them — for the objects to be selected. With the Group Selection tool and the Selection tool, however, any object partially included in a marquee becomes part of the active set of selected objects.

Selecting within a group

The Group Selection tool allows you to select objects within a group, or to select a single group within a set of grouped objects. A second click with the Group Selection tool selects the entire group.

I explain how grouping works a bit later in this chapter, but the short story is that grouped objects can be selected and edited together. This feature is convenient for grabbing, moving, and editing lots of objects at once. But if you want to convince Illustrator to momentarily forget that grouped objects are stuck together, use the Group Selection tool.

Lassoing objects

You use the Lasso tool to draw irregularly shaped marquees to select objects, anchor points, or path segments. You can hold down the Shift key to add to an existing selection. Figure 5-6 demonstrates using the Lasso tool to select a bunch of objects for editing.

FIGURE 5-6:
Using the
Lasso tool to
select objects.

Wielding the Magic Wand tool

The Magic Wand tool is ported from Photoshop. You use it to select objects of the same color, stroke weight, stroke color, opacity, or blending mode by clicking the object.

In Figure 5-7, I selected all the objects in the horse's head with a magenta fill by clicking one of them.

FIGURE 5-7:
Selecting
objects of
similar fill and
stroke color.

To tweak the tolerance (sensitivity) of the Magic Wand tool or to define what criteria are used to identify objects similar to the one you click, double-click the Magic Wand tool to open the Magic Wand panel.

The higher the tolerance value you set for a property (such as fill color or stroke color), the less fussy the tool will be in selecting like objects. Figure 5-8 shows the default setting of a relatively low tolerance Fill Color setting.

Using the Select menu

Alongside the options I just outlined for interactive selection with tools, you can do mass production selection with the Select menu. The most expansive option is Select ⟳ All, quickly accomplished by pressing Alt+A (Windows) or ⌘+A (Mac). To quickly deselect everything, press Shift+Alt+A (Windows) or Shift+⌘+A (Mac).

FIGURE 5-8:
Defining Magic Wand properties.

You can choose Select ⟳ Inverse to deselect everything that is selected and select everything that was not selected. That's handier than it might seem. For example, if you're editing a set of selected objects and you decide you want to delete everything else, choose this option and hit your Delete (or Backspace) key.

The Select ⟳ Same menu option works like the Magic Wand but on only single attributes (that is, it is more selective than the Magic Wand tool).

Using Select Object to clean up projects

The Select ⟳ Object menu opens up a set of intuitive options. Choosing Select ⟳ Object ⟳ All Text Objects, for example, selects (you guessed it) all text objects.

I want to highlight one option on this menu: Select ⟳ Object ⟳ Stray Points. As you create artwork, it's easy to accidently click with the Pen and generate an anchor. That anchor can distort the size of your document, but you might not see it. Before you save or hand off a project, add Select ⟳ Object ⟳ Stray Points to the end of your workflow so you can hand off a clean document for print or screen projects.

Working in global edit mode

Global edit mode makes selecting and editing similar objects fast and intuitive. Start by selecting an object that matches other objects that you want to batch-edit, then choose Select ⟳ Start Global Edit. You can turn on global edit mode also by clicking the Start Global Edit icon in the Properties panel, shown in Figure 5-9, or clicking the Start Editing Similar Shapes Together icon in the Control panel.

Oddly enough, if you launch global editing from the menu, default settings are applied that intuitively match the properties of your selected object. But if you launch global editing from either the Control panel or the Properties panel, the default settings don't enable any matching, and you have to set match properties.

You can change the global edit match properties with the drop-down next to the Global Edit icon in the Control panel, defining what to match (appearance, size, or both) and where to apply global editing (on all artboards, selected artboards, or the entire canvas, which includes objects not on artboards).

Figure 5-10 shows global editing defined to select objects of the same size and appearance.

WARNING

Make sure you have only one object selected when you launch global editing. Illustrator won't be able to figure out what you want to use as a match criteria if you select more than one object. Also, note that global editing doesn't work on images, text, clipped masks, linked objects, or third-party plug-ins.

FIGURE 5-10:
Applying appearance and size criteria for global edit.

After you enable global editing, any edits you make to the initially selected object apply to all selected objects. Figure 5-11 shows a new color being applied to similar objects by using global edit.

By default, global edit mode will select additional shapes that are similar to the selected shape. To more finely filter the set of objects included in the global edit, check the Appearance option (to restrict selected objects to those with a matching color and shape) and the Size option to restrict selected objects to those of the same shape and size.

Grouping and Isolating Objects

You group objects so you can work on them all at once. Grouped objects can be moved together, transformed, or edited in just about any way. That's handy! No, I take that back, that's essential, because illustrations can frequently involve dozens, hundreds, or even thousands of objects, and you do not want to be moving each of those objects one-by-one.

You can further organize the chaos of an Illustrator project by grouping groups of objects. We don't call those super groups, because that term is reserved for 1970s rock stars who combined their talents in a band, such as Crosby, Stills, Nash, and Young. But the concept is similar.

On the other hand, sometimes working with grouped objects can get in the way of editing an object within a group. So I will show you how to group objects, how to group groups, and then how to dive into a group and edit an object or objects within the group.

Editing objects as groups

You group objects by selecting them and choosing Object⇨Group, or pressing Ctrl+G (Windows) or ⌘+G (Mac). You group groups of objects (don't call them supergroups) by selecting more than one group, and choosing Object⇨Group or by pressing Ctrl+G (Windows) or ⌘+G (Mac). Or you can select objects, right-click, and choose Group from the context menu. You can also group one group with another single object to create another group.

In Figure 5-12, I'm grouping the set of player controls so they can be easily moved around within the prototype design of the app interface.

FIGURE 5-12: Grouping a set of player controls.

Here's a partial but widely applicable list of things you can do to an entire group:

» Edit the group interactively. Select the group with the Selection tool, and then move, rotate, resize, or perform any other transformation to the entire set of grouped objects.

» Edit all the objects in a group with the Transform panel. Select the entire group and choose Window⇨Transform. Use the options in the panel to move, scale, rotate, or shear the grouped objects.

» Recolor all the objects in the group. Select the entire group and use the stroke and fill options in the Control panel or the Properties panel.

>> Group groups to further organize objects. Select two or more groups, and press Ctrl+G (Windows) or ⌘+G (Mac).

>> Transform a group into a symbol. Drag the group into the Symbols panel. (See Chapter 10 for a discussion of when and how to use symbols.)

>> Add an effect to the group, such as a drop shadow or a 3D effect.

Editing objects within groups

To quickly bypass a group and edit within a group, use the Group Selection tool. Normally, this tool is available in the Basic toolbar, as a flyout from the Direct Selection tool, as shown in Figure 5-13.

Figure 5-14 shows the Group Selection tool doing its thing, selecting one object within a group.

FIGURE 5-13:
Choosing the Group Selection tool from the Basic toolbar.

TIP

You can name groups in the Layers panel to help keep track of what's what in your illustration. See Chapter 6 for how and when to use layers, including how to orchestrate the relationship between layers and groups.

FIGURE 5-14:
Selecting one object within a group using the Group Selection tool.

Working with the Group Selection tool

You can use both the Group Selection tool and the Direct Selection tool to select objects within groups. But the Group Selection tool has a handy property that makes it easy to navigate within grouped groups: When you use the Group Selection tool to double-click an object in a group, you select not only the object within the group but also the group that encloses the object.

And each additional click on the object expands the group. So, for example, if I click one of the fast-forward button triangles in Figure 5-15 with the group selection tool, just that object is selected. If I click a second time, both (grouped) triangles are selected. A third click selects the group that encloses the right side of the control bar; and additional clicks with the Group Selection tool select the entire control bar.

FIGURE 5-15: Selecting larger and larger groups with repeated clicks with the Direct Selection tool.

Isolating groups

Another approach to editing within groups is to use isolation mode. This mode is handy when you're working with a bunch of objects within a group, and you don't want to be bothered by, or risk accidently editing, objects outside the group.

Figure 5-16 shows a clown illustration (left) contrasted with the grouped objects that make up the clown's face in isolation mode (right). Note that when the clown's face is isolated, everything else is dimmed and can't be edited.

You can isolate a group in many ways. In fact, it's so easy to isolate a group that my students often do it by accident and find themselves "trapped" inside an isolated group. After you know what isolated groups are and how to get in (and out) of them, you'll avoid that frustration.

FIGURE 5-16:
Isolation mode
applied to the
clown's face on
the right.

You can isolate a group by doing any of the following:

>> Double-click a group with the Selection tool.

>> Click the Isolate Selected Object icon in the Control panel or the Isolate Group icon in the Properties panel.

>> Right-click a group and choose Isolate Selected Group.

You can back out of isolation mode one group at a time by using the breadcrumbs (the gray isolation bar) that appear at the top of the document window, either by clicking a group higher up the hierarchy of groups or by using the left arrow in the set, as shown in Figure 5-17.

FIGURE 5-17:
Backing out of isolation mode one group at a time.

Or you can escape out of isolation mode altogether, intuitively enough, by pressing the Esc key or by double-clicking an empty area on the canvas.

Aligning and Spacing Objects

Adobe Illustrator provides multiple ways to align and space objects in Illustrator. Among them:

>> Grids, guides, and rulers that create snap-to points on the canvas

>> SmartGuides, which provide context-based help in aligning objects

>> The Align panel, which includes options for aligning and spacing selected objects

Which approach is best? That depends on the problem you're solving and your proclivities. Grids and guides (which are based on rulers) are defined before you start drawing. They help keep your illustration within the lines of dimensions or other constraints. You use SmartGuides as you draw. They're intuitive and interactive. And you use the Align panel after you draw to organize selected objects.

Locating objects with rulers, guides, and grids

Rulers in Illustrator are a digital version of a physical ruler. You can set them to measure different units of measurement (points, picas, inches, millimeters, centimeters, or pixels). I find rulers especially handy for technical illustrations, maps, interior design diagrams, architectural renderings, and other projects that require a lot of measurement. In those situations, the workflow is to define and display rulers and then create guides to constrain elements within defined dimensions. I explain how to do that in detail shortly.

Guides are usually vertical or horizontal lines that you can drag from a ruler onto the canvas to create "magnetic" boundaries, making the placement of objects quick, easy, and accurate.

Grids are sets of uniformly spaced vertical and horizontal lines that facilitate placing or drawing objects.

Measuring with rulers and locating with guides

The following are basic techniques for setting them up and controlling rulers:

>> Toggle between viewing and showing rulers by choosing View➪Rulers and then choosing either Show Rulers or Hide Rulers. The keyboard shortcut for toggling between show and hide rulers is Ctrl+R (Windows) or ⌘+R (Mac).

» Change the unit of measurement in rulers by right-clicking a ruler and choosing from the set of units of measurement that appear on the context menu.

» Toggle between rulers that make the origin point (the start of the ruler) the edge of a selected artboard or the entire document by choosing View ➪ Rulers and then choosing Change to Artboard Rulers or Change to Global Rulers, respectively.

With rulers defined, you define the guides by pulling down from a horizontal ruler or pulling right from a vertical ruler. You move guides, as you would a normal object, by using the Selection tool. You can lock, hide, or release guides by right-clicking anywhere on the canvas and choosing one of those options from the context menu.

In Figure 5-18, horizontal and vertical guides are drawn to define a starting point for an illustration, a half inch from the top and a half inch from the left edge of the artboard.

Precisely locating with grids

Grids allow you to precisely place objects on the fly, as you draw. Grids are displayed in Illustrator but not in print or screen output. Grid settings are saved with the document.

If you want to work through an example of deploying grids, see the section in Chapter 7 on honing pen tool skills with a waveform.

FIGURE 5-18:
Defining guides from an artboard-based ruler.

Unfortunately, Illustrator does not have a way to define grid settings for specific documents (or artboards), so each time you need to display and use grids, you do so by changing Illustrator preferences.

The following workflow enables defining, displaying, and snapping to grids as you draw:

1. **Choose Edit ⇨ Preferences ⇨ Guides & Grid (Windows) or illustrator ⇨ Preferences ⇨ Guides & Grid (Mac) to define grid properties.**

2. **In the Grid section of the dialog, choose a grid color and style (lines or dots).**

 Default spacing is set to a gridline every 72 pixels to match legacy low-resolution screens, but you can change that to any value you want, and choose how many subdivisions to create within each grid.

 Normally you'll want to maintain the default Grids in Back setting. In Figure 5-19, I defined a grid with the default settings, except that I changed the color to black.

3. **After you configure grid settings, click OK in the Preferences dialog.**

4. **To force objects to align the grid, enable Snap to Grid if it's not already enabled by choosing View ⇨ Snap to Grid.**

FIGURE 5-19: Defining grid settings.

5. **Draw, move, or transform objects.**

 As you do, they snap to the defined grid lines and subdivisions, as shown in Figure 5-20.

6. **When you no longer want to see or use grids, choose View ⇨ Hide Grid, and View ⇨ Snap to Grid (to deselect that option).**

 If you hide grids without disabling Snap to Grid, snap to grid remains in effect even though you don't see the gridlines.

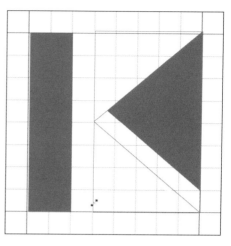

FIGURE 5-20:
Resizing an object within a grid.

Aligning with SmartGuides

SmartGuides are AI times two: They are a key feature of Adobe Illustrator (AI) and are also a form of Artificial Intelligence (AI) in that they appear whenever you create or change objects and help align an object with other objects on the artboard.

In Figure 5-21, for example, Smart-Guides are identifying and help me snap to a location where the center of the square that I am moving is in horizontal alignment with the center of one neighboring hexagon, and in vertical alignment with the center of another neighboring hexagon.

SmartGuides are usually handy but can sometimes get in the way, such as when sketching freehand. You toggle SmartGuides off and on by choosing View ⇨ SmartGuides.

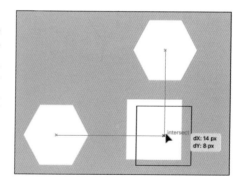

FIGURE 5-21:
Aligning horizontal and vertical center points with SmartGuides.

Using the Align panel

Use the Align panel when you have a set of objects that you have already created, and you need to align them or distribute (space) them evenly.

The alignment options are intuitive. For example, Figure 5-22 shows a sets of navigation buttons (on top) that have been vertical aligned and centered (on bottom).

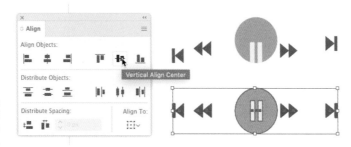

The Align To options define whether you want selected objects aligned within the selection, aligned to a key object (which you define by clicking an object within the selection), or aligned within the artboard.

The following steps guide you through distributing objects.

1. **Select the objects to be distributed.**

2. **With the objects selected and the Align panel open, choose one of the Align To options.**

 In Figure 5-23, I'm choosing to space the objects within the selection, the most common choice. The Align to Artboard option spaces the selected objects evenly within the borders of either the selection itself or the artboard. The Align to Key Object option spaces objects at a fixed amount starting from the key object. If you choose this option, enter a value in the spinner that appears to define the width or height of that space.

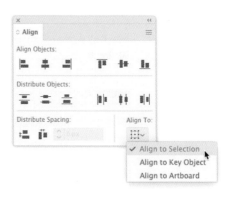

FIGURE 5-23:
Distributing objects within a selection.

3. **Click any of the six Distribute Objects icons to apply the spacing you defined in the previous two steps.**

 In Figure 5-24, Horizontal Distribute Center has been applied to objects distributed relative to the center of the set of objects, within the area defined by the selection.

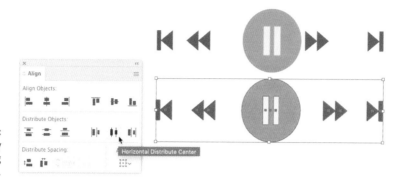

FIGURE 5-24:
Horizontally
distributing
objects.

Arranging Objects Front-to-Back

Illustrator makes it easy to restack objects front-to-back. You can use either of the following techniques to do that:

>> Select the object you want to restack and choose Object ➪ Arrange ➪ Bring to Front or Object ➪ Arrange > Send to Back.

>> To move an object in front of or behind other objects, one step at a time, choose Object ➪ Arrange ➪ Bring Forward or Object ➪ Arrange ➪ Send Backward. In Figure 5-25, the yellow triangle is being moved behind the blue circle but will remain in front of the red square.

TIP

For more powerful techniques for arranging objects in complex projects front-to-back, consider using layers, as explained in Chapter 6.

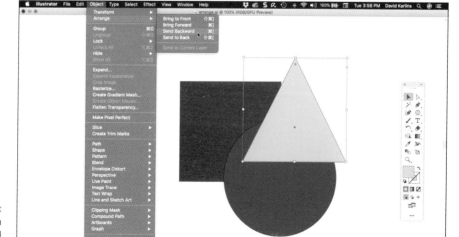

FIGURE 5-25:
Moving an
object behind
another object.

IN THIS CHAPTER

» **Understanding why and how to use layers**

» **Working from a template layer**

» **Defining layer properties**

» **Organizing layers**

» **Styling with layers**

» **Expediting export with layers**

Chapter **6**

Organizing Documents with Layers

L ayers help organize large projects in Illustrator. In this chapter, I explain how to add layers, organize objects with layers, and take advantage of other unique features available in layers.

Before you starting generating additional layers in a document, a caveat: You might not need layers to organize your project. Chapter 5 demonstrates how grouping can organize many projects, how you can select cohorts of similar objects, and how to move objects in front of and behind each other. All that without layers.

If you're coming to Illustrator from a Photoshop background, welcome! Note that many of the techniques I just listed, such as making selections and moving objects in front of and behind each other, require layers when working in Photoshop. But accomplishing those tasks is more easily accessible in Illustrator without layers.

Why start with a caveat that notes when you don't necessarily need layers? Organizing objects in layers adds a layer (sorry) of complexity to a project that you might not need. And ruling out when you don't need layers helps zero in on when and why you do need to organize objects into layers.

So, when *do* you need layers? You should organize your Illustrator document into layers when you

>> Are using a template layer to help create vector artwork from placed sketches and photos.

>> Need to keep track of and organize hundreds, even thousands of objects with layers when your project gets to that scale.

>> Can make your workflow more productive by applying styling to entire layers.

>> Want to be able to move content front-to-back with layers on a larger scale with layers than you can by simply working with groups of objects.

>> Need to avail yourself of export features that are available for objects organized into layers that are, among other things, particularly valuable for exporting animation frames.

>> Want to easily lock/hide layer content to isolate and work on the content of a specific layer (or layers).

>> Are creating alternate text content for a multilanguage document.

Using a Template Layer

One of the most widely used and easiest-to-access features of Illustrator layers is the capability to create a template layer. You might start an illustration project with a sketch or photo, and then use Illustrator tools to draw on top of that original artwork. After the project is finalized, the template layer will not be printed or included in screen output.

The following steps create a template layer:

1. **In an open document (with or without existing content), choose File ⇨ Place, navigate to and select an image you want to trace or use as a basis for a vector object, but do not click Place.**

2. **In the dialog that displays the selected file, click the Template check box, as shown in Figure 6-1, and then click Place.**

FIGURE 6-1:
Selecting an image to use as a template layer.

3. **If the Layers panel is not displayed, choose Window ⇨ Layers to display it and examine the options for the template layer.**

The template layer name is displayed in italics to indicate that it's a template. Template layers do not print. The icon in the first column in the Layers panel, shown in Figure 6-2, toggles between displaying and hiding the layer.

The icon in the second column toggles between locking and unlocking the template layer. Normally, you want the template layer locked so you don't have to worry about corrupting the size

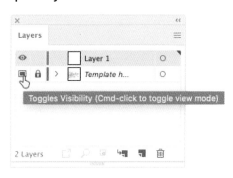

FIGURE 6-2:
Hiding or displaying a template layer.

and location while you work in other layers. But if you need to resize or move a placed file within a layer, you can temporarily unlock the layer.

To rename the layer, or to change the percentage of dimming, double-click the template layer icon to open the Layer options dialog, change the settings, and click OK.

4. **Select a non-template layer, as shown in Figure 6-3, and begin to design your illustration.**

5. **Toggle the template display to hidden to see your project as it emerges.**

If your document is destined for print output, you don't need to hide the template layer before printing because it's hidden by default. If your document is being handed off for screen design, you need to hide the display of the template layer before exporting to PNG format.

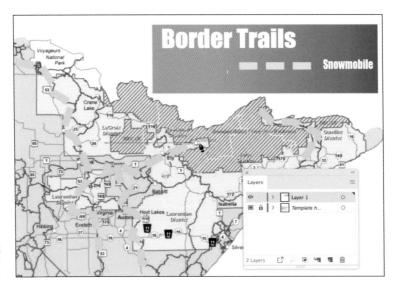

FIGURE 6-3:
Designing
on top of a
template layer.

See Chapter 2 for advice on printing in Illustrator. See Chapter 17 for advice on exporting raster artwork for screens, or Chapter 18 for saving artwork as web-friendly vector images.

Organizing and Arranging Objects in Layers

There's no need to teach you how to create an initial layer. When you create a document in Illustrator, an initial layer is generated automatically. But if you're going to organize and arrange objects in layers (plural), you will need to create additional layers.

You can create that set of additional layers before you start creating an illustration. Or you can add layers at any stage of the process.

An effective way to understand how to use layers to organize and arrange objects is to dive in and experiment. Try that, along with me, in the following steps:

1. **Create a new document in Illustrator, using any preset.**

 To keep things simple, hide the artboard if it's visible (choose View ⇨ Hide Artboards).

 If you want to keep this file handy for future reference, save the file. For help creating a document and saving it, see Chapter 2.

2. **View the Layers panel and create three layers named Triangles, Squares, and Circles:**

a. *If the Layers panel isn't visible, choose Window⇨Layers.*

b. *In the Layers panel, double-click the default layer name (Layer 1) and change the layer name to Triangles, as shown in Figure 6-4.*

c. *Click the Create New Layer icon in the Layers panel, as shown in Figure 6-5, and rename the layer Squares.*

d. *Create a third layer, and name it Circles.*

e. *On the Layers panel menu, choose Panel Options. In the Layers Panel Options dialog, bump up the size of the rows to 60 pixels and then click OK in the dialog.* You're not creating a lot of layers here, so size isn't an issue, and these nice big rows will make it easier to explore how layers work. Your Layers panel should look like the one in Figure 6-6.

FIGURE 6-4:
Renaming a layer.

FIGURE 6-5:
Creating a new layer.

3. **Populate the Circles layers with two intersecting circles and change their stacking order in the Layers panel:**

a. *Click the Circles layer in the Layers panel and draw two intersecting circles with different color fills.* Refer to Chapter 4 for guidance on drawing shapes if necessary.

b. *Expand the Circles layer and examine the circles you drew in the Layers panel.*

c. *Rearrange the order of the circles in the Layers panel by dragging the bottom circle to the top of the Circles layer, as shown in Figure 6-7.*

FIGURE 6-6:
The Layers panel with three layers and 60 px high rows.

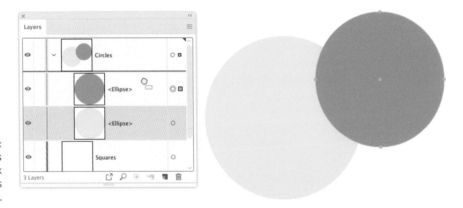

FIGURE 6-7:
Moving circles front-to-back in the Circles layer.

4. **Using the techniques in Step 3, add two squares in the Squares layer, and two triangles in the Triangles layer.**

Your document and Layers panel should look something like the one in Figure 6-8.

5. **Drag the Triangles layer to the top of the Layers panel to move the objects in this layer to the top of the stacking order, as shown in Figure 6-9.**

FIGURE 6-8:
A document
with three
layers.

FIGURE 6-9:
Changing the
stacking order
of layers.

There's a lot more to layers. But the quick set of steps you just worked through demonstrate the most essential features of layers. Following is a summary of the essential things you need to know about layers:

>> Every new document opens with a single layer named Layer 1.

>> If the Layers panel is not visible, choose Window ⇨ Layers to display it.

>> Edit the display of all layers by choosing Panel Options on the Layers panel menu.

>> Create a layer by clicking the Create New Layer icon at the bottom of the Layers panel.

>> Rename a layer by double-clicking its name in the Layers panel.

>> Move objects within a layer or within a document by dragging them up or down in the Layers panel.

Organizing Content within and between Layers

You can move content from one layer to another. This feature can be useful when you want to regroup content in layers so you can more effectively reorder the layers, or if you want to apply styling to a layer and include an object in that layer.

Locating objects in the Layers panel

In complex designs with many objects, it's difficult to determine on which layer an object is located.

To locate an object in the Layers panel, click the object on the Illustrator canvas, and then choose Locate Object on the Layers panel menu. The layer on which the object is located and the object itself are selected in the Layers panel, as indicated by a little red box next to the object in the panel.

In Figure 6-10, I'm locating the purple square in the Layers panel, so I can easily move it within the layer or into another layer.

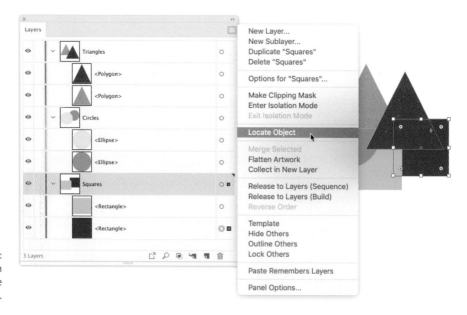

FIGURE 6-10:
Locating an object in the Layers panel.

Arranging objects within and between layers

To move objects within a layer (and, in the process, change their stacking order), click and drag the object icon in the Layers panel.

Similarly, to move an object from one layer to another, drag it from the initial layer to the target layer. In Figure 6-11, I'm dragging the purple square from the Squares layer to the Triangles layer, and placing it on top of the existing objects in the Triangles layer.

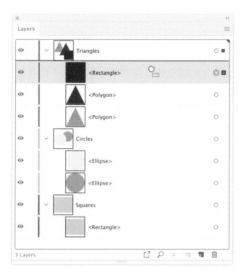 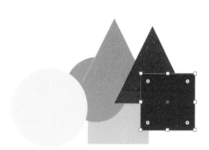

Styling with Layers

You can make wholesale changes to the appearance of all objects in a layer. Among those changes, you can

» Change stroke and fill attributes

» Apply effects (such as Drop Shadow or Pucker & Bloat)

» Apply transparency

Targeting layers

The first step in changing the appearance of all objects in a layer is to make the layer active by clicking its target icon, a little circle in the Layers panel. When you do, little boxes filled with the color associated with the layer appear next to objects in the Layers panel, as shown in Figure 6-12.

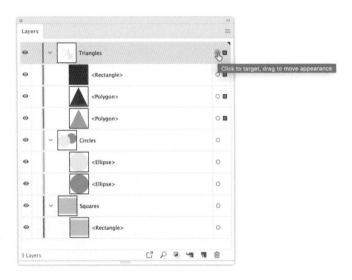

FIGURE 6-12:
Targeting a
layer.

TIP

To keep track of what content is on which layer, change the default colors to colors that reflect the content of the layer. You can change the color associated with a layer by selecting the layer in the Layers panel and choosing Options for (the selected layer) on the Layers panel menu.

Note that you can not only target an entire layer but also target objects within layers, using the target icons associated with those objects. All the changes you can make to the appearance of all objects in an entire layer can be made also to selected objects within a layer.

To target more than one layer, or to target multiple objects within a layer, hold down the Shift key as you click the target icons associated with those layers or objects.

Changing the appearance of objects in layers

With a layer targeted, you can apply styling, such as effects or transparency, to all the objects in the targeted layer. In Figure 6-13, I applied Pucker & Bloat and transparency to all the objects in the top (Triangles) layer in the document.

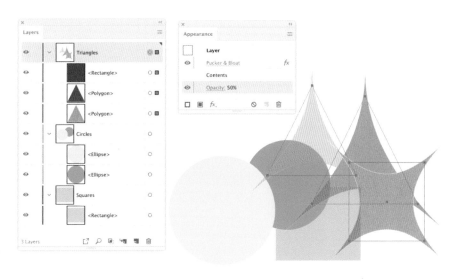

FIGURE 6-13:
Applying
transparency
and Pucker &
Bloat effect
a layer.

See Chapter 14 to learn to define and apply effects, and Chapter 12 for a step-by-step guide to applying transparency.

Applying Layers in Real-World Challenges

To help get your head around how layers are used to organize projects, let me share a couple real-life examples.

In Figure 6-14, the poster has four layers, one for the borders, one for the type (targeted in the figure), one for the string (decorative) elements, and one for the dark background. Any combination of these layers can be hidden, or locked so the designer can focus on type, decoration, borders, or background.

In Figure 6-15, only one of the five layers (the rug) is unlocked, so it can be edited without fear of distorting objects on other layers.

Those two examples demonstrate common ways that layers are used. But different illustrators have come up with all kinds of ways to use layers.

FIGURE 6-14:
A poster with
the Type layer
targeted.

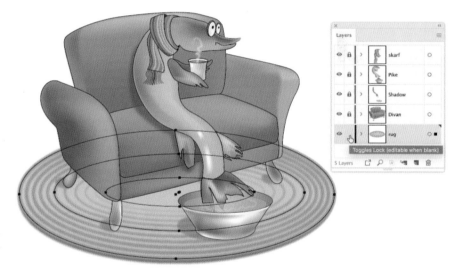

FIGURE 6-15:
Only one layer
is unlocked for
editing.

Some veteran designers eschew using artboards to combine similar graphics in a single file and use layers instead. Layers are sometimes part of the workflow in preparing documents for commercial printing. In Chapter 2, I share advice from a printing expert on how to create separate layers for distinct spot colors in CMYK and Pantone print projects. I sometimes bring illustrations with multiple layers into Photoshop, where I convert those layers into animated GIFs — a low-fi, lean technique for creating animated objects for web and social media ads.

In short, layers are a tool that can be applied to solve all kinds of workflow and design challenges.

2

Drawing and Editing Paths

IN THIS PART . . .

Wielding the Pen tool — Illustrator's most powerful technique for creating and editing vector art

Using the Pencil, Curvature, and Blob tools to intuitively draw shapes, curves, and sketches

Applying an amazing array of stroke styling with brushes

Deploying symbols to make the design process quicker and easier, and to create smaller, more hand-off friendly files

IN THIS CHAPTER

» **Understanding the foundational role of the Pen tool**

» **Drawing curves**

» **Adding, deleting, moving, and connecting anchors**

» **Editing anchors with the Anchor Point tool**

Chapter **7**

Wielding the Pen and Anchor Point Tools

In this chapter, I show you how to use the Pen tool to draw, use the Direct Selection tool to select and move anchors, and use the Anchor Point tool to tweak curves you've created with any tool (even shapes).

These techniques can be used to create a drawing from scratch. More typically, you will deploy them later in the design process, after you use quicker and easier — but less precise — tools to rough out your illustration.

A typical workflow (to the extent that there is such a thing) might start with one of the basic shape tools (see Chapter 4) or with the Pencil, Curvature, or Paintbrush tools (see Chapter 8). Or you might draw a sketch on a mobile device in Adobe Draw — Adobe's free app for sketching vectors on iOS or Android devices — bring that sketch into Illustrator, and then touch it up using the Pen tool with the techniques I cover in this chapter.

The point is, at the end of the day, you need the level of power and detail of the Pen tool, as well as the other path-editing tools you explore in this chapter, to put the finishing touches on most projects. And some drawings, such as the waveform you explore here, are best created from the start by using the Pen tool.

Editing Anchors

We start our journey into editing anchors by demystify vector curves. A *vector curve* breaks down to a collection of anchors and defined path segments. You might, for example, get inspiration from seeing an adorable slug, and quickly sketch it with the Paintbrush tool. That happens. Maybe not every day, but after a rain.

If I use the Selection tool to select the set of objects that make up a sketch of an adorable slug, as I have in Figure 7-1, you can see underlying paths. To emphasize, the Selection tool revealed *paths* but *not anchors*.

FIGURE 7-1:
Revealing
paths by using
the Selection
tool.

But having used the Selection tool to select all the objects, if I then click the Direct Selection tool, the individual anchors that make up those curves are revealed, as you see in Figure 7-2.

You can select these anchors individually, and then use the Direct Selection tool to move or delete each one. And while I chose a sketch of a slug to demonstrate what is revealed with the Direct Selection tool, the technique I just walked you through applies to any drawing.

Selecting and moving anchors

To select an individual anchor, hover your cursor over the anchor until it expands and the word *anchor* appears, and then click. Selected anchors are displayed as solid squares, as shown in Figure 7-3.

FIGURE 7-2:
Exposing
anchors
by using
the Direct
Selection tool.

FIGURE 7-3:
Selecting an
anchor.

To delete a selected anchor, just press Delete. To move a selected anchor, and thus change the shape of a path, click and drag, as shown in Figure 7-4.

When you move anchors, you can hold down the Shift key to constrain the movement to increments of 45 degrees.

WARNING

Use the Direct selection to move a single anchor or selected anchors when you need to reshape an object. But is not advisable to use the Direct

FIGURE 7-4:
Moving an anchor.

Selection tool to change the location, the size, or the height-to-width aspect ratio of an object. You can do those tasks more easily — and with less chance of inadvertently changing the shape of the object — by using the Selection tool.

Converting open paths to closed paths and vice versa

An *open path* is one that has a beginning and end, and the beginning and end points are not connected. An ellipse is not an open path. A line segment is an open path.

To connect the beginning and end of an open path, first select the beginning and end anchors with the Direct Selection tool. You can do that by Shift-clicking each anchor, or by using the Direct Selection tool to draw a marquee, as shown in Figure 7-5.

FIGURE 7-5:
Selecting the beginning and end anchors.

With the anchors selected, click the Connect Selected End Points icon in the Control or the Properties panel, or choose Object ➪ Path ➪ Join from the menu to convert the object into a closed path, as shown in Figure 7-6.

You can also quickly and easily divide an object by cutting a closed path at two selected anchor points. Select the two anchors, and click the Cut Path at Selected Anchor Points tool in the Control or Properties panel. Selecting only one anchor will create an open path.

FIGURE 7-6:
Closing an open path.

You can also quickly and easily connect two discrete (not connected) path segments by selecting one anchor in each path, and clicking the Connect Selected Anchor Points icon in the Properties panel or the Control panel, as shown in Figure 7-7.

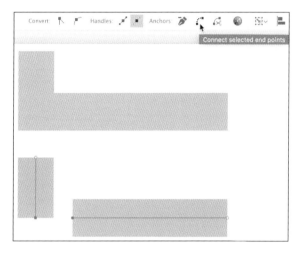

FIGURE 7-7:
Connecting anchors from two separate paths to form a single object.

Editing Curves with the Anchor Point Tool

The Anchor Point tool allows you to alter the nature of anchors by moving *handles,* the tiny circles at the end of thin lines that extend from an curved anchor.

An anchor can be have no, one, or two handles. If an anchor has one or two handles, the position of these handles controls the curvature of the path that is anchored by the selected anchor. I used *anchor* as a noun and a verb on purpose here to emphasize that anchors are *points* but also perform an action (defining location) whereas handles adjust a curve.

Illustrator paths can have three kinds of anchor points: corner anchors, smooth anchors, and combination anchors, which connect a curve and a straight line path.

I noted that anchors can have zero, one, or two handles. Here's how that works: Curved anchors display two *handles,* tiny lines that control the curves. Combination anchors (which combine a straight angle path and a curved path) display a single handle. Corner anchors do not have active handles. Let's explore these.

Figure 7-8, left, shows the simplest kind of anchor, a corner point anchor that connects straight line paths.

FIGURE 7-8:
A corner
anchor
connecting two
straight line
segments (left),
a combination
curved and
straight anchor
(middle), and a
curved anchor
(right).

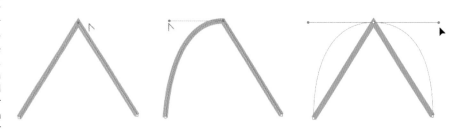

Figure 7-8, middle, shows a combination anchor that is connecting a straight line segment and a curved segment. The combination anchor has one control handle, which is used to control the curve.

Figure 7-8, right, shows a curved anchor with two control handles, one for each curve.

You can use the Anchor Point tool to do the following:

>> Add handles to an anchor by clicking the anchor and dragging away from the anchor. You can edit the resulting curve interactively as you move the handles, as shown in Figure 7-9.

>> Change an anchor to a combination of a curve and an angle by double-clicking one handle.

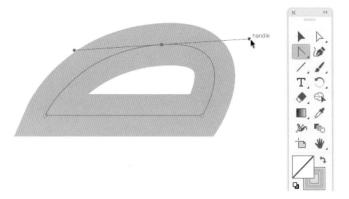

FIGURE 7-9:
Editing a
curved anchor.

>> Change an anchor from a curve to an angle by double-clicking the anchor or both handles.

At any time, you can select a handle with the Anchor Point tool and click and drag to change the curvature of the path anchored by the selected anchor. This is the most powerful way to tweak the exact nature of a curved segment. You can also use icons in the Control or Properties panels to convert an anchor to a corner or smooth point.

Drawing with the Pen Tool

Drawing or editing paths by using the Pen tool is unintuitive. But odds are high that you will still need to be able to wield the mighty Pen tool (and the associated Anchor Point tool) to complete most projects.

Why is that? Good question! Here's an analogy that you might find helpful: Today's web design platforms, such as WordPress, Wix, or Weebly, are WYSIWYG (what you see is what you get) tools. You don't need to know HTML (the basic language that defines web page structure) or CSS (the language that styles websites) to create a web page today. You just click and drag to generate boxes into which you enter content such as text, photos, or video. But if you want to customize colors, do some custom layouts, or change to a font of your choice, you need to push the curtain aside and edit the HTML and CSS that was generated by your WYSIWYG design platform. To continue the analogy, you don't need to *design* websites with HTML and CSS or even be fluent in creating content with those languages. But you need to be conversant enough with HTML and CSS to make basic edits.

Similarly with the Pen tool. You usually don't need to use the Pen tool to create an illustration from scratch. But you *do* need to know how to tweak illustrations by using the Pen tool — and how to deploy the Pen tool as your main design tool when appropriate.

Creating curved, combination, and straight anchors with the Pen tool

The most unintuitive thing about drawing with the Pen tool is that you don't click and drag to create paths. Instead you click once, and then if you hold down the mouse key after setting the anchor and click and drag, you edit the anchor handles on the fly.

This method is easier done than said, so try using the following steps to use the Pen tool to draw a path that includes curved, combination, and straight anchors:

1. **Select the Pen tool and click** *once.*

2. **In the workspace, click and hold down the mouse button, and then drag right (or left), as shown in Figure 7-10, to define the curve of the new anchor.** If you hold down the Shift key as you drag to define the curve, you constrain the curve angle to increments of 45 degrees.

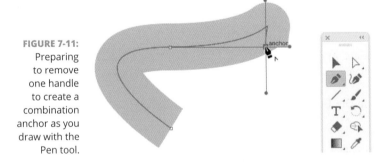

FIGURE 7-10:
Defining a curve as you draw with the Pen tool.

3. **In the workspace, define a combination anchor as follows:**

 a. *Click with the Pen tool to create a new anchor but do not release the mouse button.*

 b. *Drag to define two curve handles.*

 c. *Release the mouse button and hover the cursor over the new anchor you created.* The cursor changes to the Anchor Point tool, as shown in Figure 7-11.

FIGURE 7-11:
Preparing to remove one handle to create a combination anchor as you draw with the Pen tool.

d. *Click to eliminate one of the handles, resulting in a combination anchor.*

e. *Click one last time to create a third anchor.* Because the preceding anchor was a combination anchor, the resulting third anchor is a straight angle anchor, as shown in Figure 7-12.

f. *Press the Esc key to complete the drawing.*

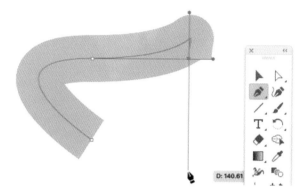

FIGURE 7-12:
Adding a
straight angle
anchor.

Any anchor can be transformed by using the Anchor Point tool.

Adding and deleting anchors

Special Pen tools are available for adding and deleting anchors. They aren't accessible from the basic toolbar, but they have super-intuitive keyboard shortcuts.

In a previous section, you discover how to delete anchors by using the Direct Selection tool. Another option is to use the Delete Anchor Point tool. The easy keyboard shortcut for this tool is the – (minus sign) key on your keyboard.

With the Delete Anchor tool selected, hover it over a path (regardless of what selection key you used last) until an anchor is displayed, as shown in Figure 7-13.

After you use the Delete Anchor cursor to select an anchor, click to remove the anchor.

With a path selected, moving the Pen tool over an anchor changes the tool to the Delete Anchor Point tool. Moving the Pen tool over a selected path (a section between two anchors) transforms the Pen tool into the Add Anchor Point tool.

FIGURE 7-13:
Deleting an
anchor by
using the
Delete Anchor
tool.

Here's another way to add anchors. You can switch to the Add Anchor tool by using the easy-to-remember keyboard shortcut, the + (plus) key. With the Add Anchor tool selected, hover it over any path, as shown in Figure 7-14, and click.

FIGURE 7-14:
Adding an
anchor by
using the Add
Anchor tool.

Wielding the Pen tool with shortcuts

The Pen tool is admittedly a bit unwieldy, so it's nice to have a few handy tips, tricks, and shortcuts at your disposal. Here are some that I think will help you draw and edit paths:

>> To close a path while drawing with the Pen tool, click the first anchor
you created.

A closed path is one with no specific start or end anchor.

>> With the Pen tool selected, hold down the Alt key (Windows) or Option key
(Mac) to toggle to the Anchor Point tool. This technique works as long as the
Alt or Option key is pressed.

>> With the Pen tool selected, you can press the Ctrl key (Windows) or ⌘ key
(Mac) to toggle to the Direct Selection tool. This method works as long as the
Ctrl or ⌘ key is pressed.

>> With the Pen tool selected, you don't have to switch to the Delete Anchor
Point tool or the Direct Selection tool to delete an anchor. If you hover over
an existing anchor with the Pen tool, the – (minus) sign appears next to the
anchor, and the Pen tool converts temporarily to the Delete Anchor Point tool.

>> Before you start creating a new object, tap the Esc key twice to stop drawing
with the Pen tool.

Honing Pen tool skills with a waveform

The emphasis in this chapter is on using the Pen tool (and the Anchor Point and
Direct Selection tools) to tweak, fine-tune, and finish projects after you've created
an illustration by using quicker and easier tools such as shapes, the Pencil tool,
or the Curvature tool. But sometimes the simplest workflow is to create graphics
directly with the Pen tool.

Here's one important reason to use the Pen tool from the start, when you can:
Paths that you draw with the Pen tool are likely to have fewer anchors and paths,
which makes them more rational and easier to edit (because there are fewer
anchors to worry about). Minimizing the number of anchors and paths in an illus-
tration also cuts down file size, which is particularly important when you export
or save files for digital output.

And there some shapes and drawings are just plain easier to create with the Pen
tool. One example is a waveform, as shown in Figure 7-15.

I had to create a batch of waveforms recently for a presentation on compressing
digital audio for the web. I'll spare you the technical details of that specific proj-
ect, but suffice to say that I needed to draw a lot of different waveforms similar to
the one in Figure 7-15.

FIGURE 7-15:
A waveform
created by
using the
Pen tool.

I walk you through how to create waveforms here. In the process, you get to develop your chops drawing with the Pen tool. The following steps create a waveform with evenly spaced, uniform curves:

1. **Define grids, display them, and enable snap to grids with a gridline every 72 pixels and a single subdivision as follows:**

 a. *View the Preferences dialog (Edit ⤳ Preferences in Windows, or Illustrator ⤳ Preferences on a Mac).*

 b. *Select the Guides & Grid tab.*

 c. *Set the Gridline Every value to 72 px and the Subdivisions value to 1, as shown in Figure 7-16, and click OK.*

 d. *On the View menu, if Show Grid is not enabled, select it to display gridlines.*

 e. *Again on the View menu, if Snap to Grid is not enabled, select that option to force anchors to magnetically snap to the grid.*

FIGURE 7-16:
Defining a
wave-friendly
grid.

2. Select the Pen tool. Then in the Control or Properties panel, select no fill, select a colored stroke (your choice), and then define a 6-pixel stroke, as shown in Figure 7-17.

3. Draw the beginning of the first curve 72 px high with a 36 px radius, as follows:

a. *At any intersection in the grid, click once with the Pen tool but do not release the mouse button.*

b. *Continue to hold down the mouse button and drag the cursor two grid squares up and two grid squares to the right, then click and hold.*

c. *Continue to hold down the mouse button, drag to the right one square, and then release the mouse button.* You have just created a curve anchor half the diameter of the wave, as shown in Figure 7-18, left.

4. Complete the first wave, as follows:

a. *Two grid squares to the right of the first anchor and two squares down, click and hold with the Pen tool.*

b. *Still holding down the mouse button, click one square to the right.* You have just defined the anchor curve for the second anchor, as shown in Figure 7-18, right.

FIGURE 7-18:
Using the Pen
tool to draw
the first two
waves in a
waveform.

5. Repeat Step 3 and 4 to continue defining the waveform.

6. Repeat Steps 3 and 4 again to complete the waveform, but when you create the last anchor, just click — don't click and drag. Then press Esc twice to end the path.

The result is shown in Figure 7-19.

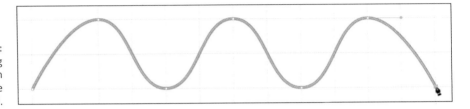

FIGURE 7-19: Completing a waveform by using the Pen tool.

TIP

The steps for drawing the waveform by using the Pen tool involved setting some extreme grid sizes to make it easy to draw precise curves. If you completed those steps, you probably want to revert the screen to normal, smaller grid sizes. You can do that in the Preferences dialog. Select the Guides & Grid tab and set the Subdivisions value to 8.

You can enhance the waveform graphic with a text legend, a gradient background, and some vertical line segments, as I did in Figure 7-15. You learn to create gradients in Chapter 12, artistic text in Chapter 16, and line segments in Chapter 4.

The distinct elements that make up the waveform graphic in Figure 7-15 are revealed in Figure 7-20.

FIGURE 7-20: Adding a legend, a background gradient, and some horizontal and vertical line segments to the illustration.

IN THIS CHAPTER

» Drawing with the Pencil tool

» One-stop-shopping for curves with
the Curvature tool

» Drawing filled paths with the Blob
Brush tool

» Erasing with the Eraser tool

» Creating basic and complex shapes
with the Shaper and Builder tools

» Gracefully transforming artwork
with Puppet Warp

Chapter **8**

Creating Artwork with the Pencil, Curvature, and Blob Tools

U ltimately, all vector graphics consist of anchor points and paths. But when you're on a creative flow, who feels like thinking in terms of underlying technology? Not you, I suspect. Me either. So Illustrator provides other options.

When seized by a creative urge, the fastest way to convey your vision to the screen is often to reach for your mouse, your tablet, or your stylus, and draw with the Pencil tool, the Curvature tool, the Blob Brush tool, or the Shaper tool. I introduce you to these tools and more in this chapter.

Drawing with the Pencil Tool

The Pencil tool is arguably the most intuitive way to draw in Illustrator. It feels as much like drawing with a pencil as can be hoped for in an app. The Pencil tool is even more powerful when you use a drawing tablet. The combination of Pencil tool and tablet enables you to draw strokes with a pressure-sensitive thickness.

The shortcut key for the Pencil tool is the letter *N*. I remember it by visualizing the word *peNcil*. You can access the Pencil tool also from the Paintbrush tool flyout, when using the Essential Workspace, as shown in Figure 8-1.

Setting pencil curve smoothness

If you're acclimating to the Pencil tool, a good way to start is to define and experiment with smoothness settings. The trick is to find a comfortable balance between smoothness (which irons out choppy or jagged paths) and accuracy, so that drawing is intuitive.

Maxing out on the accurate end of the scale creates paths that more closely match the path you draw on the screen (or your tablet). At the other end of the scale, smoothness, you get fewer anchors and a less accurate but smoother path with smoother curves.

Follow these steps to experiment and configure the Pencil tool to work for you:

1. **With the Pencil tool selected, define a stroke thickness and color in the Control or Properties panel.**

 Use any stroke thickness settings you want. Need a suggestion? If you're working with print-appropriate units of measurement, start with a 2-point stroke thickness; for web-appropriate units of measurement, start with 2 px.

 For details on how to set stroke and fill from the Control or Properties panel, see Chapter 1.

2. **Set the fill to no fill.**

3. **Set pencil fidelity to maximum smoothness.**

 Double-click the Pencil tool in the toolbar to open the Pencil Tool Options dialog, and drag the Fidelity slider to select maximum smoothness, as shown in Figure 8-2. Then click OK.

4. **Experiment with the Pencil tool to get a feel for using it with maximum smoothness.**

 Click and drag on the artboard to draw a path and a few curves (see Figure 8-3). The Pencil tool displays a small * (asterisk) when you're drawing a freeform path.

Pencil Tool Options

Fidelity

Accurate ——————————— Smooth

Options
☐ Fill new pencil strokes
☑ Keep selected
☐ Option key toggles to Smooth Tool
☑ Close paths when ends are within: 15 pixels
☑ Edit selected paths
Within: ———○——— 6 pixels

(Reset) (Cancel) (OK)

FIGURE 8-2:
Defining smoothness for the Pencil tool.

5. **Change the settings to maximum accuracy and experiment with the Pencil tool.**

 Double-click the Pencil tool in the toolbar to open the Pencil Tool Options dialog, and drag the Fidelity slider all the way to the left to make the tool function with maximum accuracy.

 Draw curves similar to the ones you just drew. Note that the faster you draw, the smoother the curve.

6. **Choose an accuracy setting that works best for your drawing style and project, and draw away!**

FIGURE 8-3:
Using the Pencil tool to draw smooth curves.

Managing the many modes of the Pencil tool

The Pencil tool is not just good for drawing curves. It's versatile. You can draw straight lines, including constrained straight lines (at fixed angles at 45 degree increments). You can edit existing paths. And can use the Pencil tool to close open paths by connecting the start and end points.

In addition to setting the degree of smoothness in the Pencil Tool Options dialog, the behavior of the Pencil tool is affected by the following:

» How fast you draw with your mouse or stylus

» What keys you press while you draw

» How much pressure you put on your stylus if you're drawing with a tablet

» Other settings in the Pencil Tool Option dialog

» Keyboard, mouse, or stylus options that change the state of the Pencil tool

The Pencil tool behaves differently depending on its mode, which is indicated by the tool's cursor.

It took the Rosetta Stone to begin to decrypt Egyptian hieroglyphics. Decrypting the different cursors that indicate the modes of the Pencil tool isn't as challenging but can be complicated. Following is a list of the most common Pencil cursor states:

» The asterisk is the default Pencil tool cursor and is displayed as you draw unconstrained freeform paths. All you need to do to invoke this state is to start drawing with the Pencil tool.

» The path-continuation cursor indicates that you're adding to the path, picking up where you left off in the drawing. You activate this mode when you move your cursor close to the end anchor in a selected path. I explain how to tweak settings for the distance that triggers path-continuation mode in the next section of this chapter.

» The straight-segments cursor means the Pencil tool draws lines, not curves. It's activated when you hold down the Alt (Windows) or Option (Mac) key.

» The constrained straight-segments cursor constrains straight-line angles to increments of 45 degrees. It's activated when you hold down the Shift key.

» The close-path cursor is a small circle that appears with the cursor when you're about to close a path.

Figure 8-4 illustrates all the modes in this list, left to right: default, path-continuation, straight-segments, constrained straight-segments, and close-path cursors.

FIGURE 8-4:
Five states of
the Pencil tool.

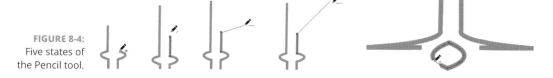

Setting Pencil tool options

To fluently wield the full set of features packed into the Pencil tool, you need to know how settings in the Pencil Tool Options dialog affect the behavior of the pencil in different modes. So let me explain how these options interact with the features of the Pencil tool itemized in the preceding section:

>> **Fill New Pencil Strokes:** Applies a fill as you draw a stroke. However, this option applies only if you have a fill defined (you can do that by using the Control panel or Properties panel).

>> **Keep Selected:** Automatically displays anchors you create when you finish drawing and keep the path selected. This option is useful if you're drawing a single path and want to work on that path in more detail with the Pen tool as soon you finish drawing. You might find the option distracting if you want to complete an entire sketch before tweaking it.

>> **Alt (Windows)/Option (Mac) Key Toggles to Smooth Tool:** Allows you to use that key to toggle to the Smooth tool. I explain how the Smooth tool works later in this chapter.

>> **Close Paths When Ends Are Within** *value*: Defines how close the start and end points of a path have to be before the Pencil tool creates a closed path.

>> **Edit Selected Paths:** Allows you to continue editing an existing path (as opposed to creating a new path that starts where the existing one ends). This option is enabled by default for a good reason: It allows you to keep a drawing together as a single object for easier editing later on the workflow road, instead of ending up with a bunch of discrete objects that are supposed to be combined in an object. The value in Edit Selected Paths Within defines how close your cursor has to be to the start or end point of a path before the Pencil tool connects with an existing path and continues editing it.

Ironing Out Wrinkles with the Smooth Tool

The Smooth tool removes jaggies, zig-zags, and unwanted angles in the sometimes too-messy paths generated by the Pencil tool or any other tool.

The Smooth tool didn't make the cut when Adobe simplified the Basic version of the toolbar, so you have to add it to the Basic toolbar to access it from there. The section on the toolbar in Chapter 1 explains how to add tools to the Basic toolbar.

As noted previously, if you're using the Pencil tool, the Pencil Tool Options dialog lets you enable the Alt (Windows) or Option (Mac) key to function as a toggle from the Pencil tool to the Smooth tool.

You can double-click the Smooth tool to adjust the Fidelity settings: Accurate makes the tool more subtle, and Smooth makes the smoothing go into effect more radically.

With Fidelity cranked all the way up to maximum smoothness, I clicked three times on the shape on the left in Figure 8-5 to transform it into the smoother oval shown on the right.

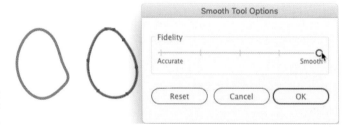

FIGURE 8-5:
Applying the Smooth tool.

Drawing and Editing Curves with the Curvature Tool

The Curvature tool (which bears a slight analogous connection to a similarly named chain of gyms) is tightly focused to help you create and edit curves.

You want angles? You have the Pen or Pencil tool. If your mission is creating, editing, adding, or tweaking curves (including turning curves into corners), the Curvature tool provides one-stop shopping in that it works on any path, regardless of how the path was created.

You use the Curvature tool in basically two ways:

›› You can draw with it.

›› You can transform existing paths with it.

Drawing curves

Here's how to draw with the Curvature tool:

1. **Select the Curvature tool.**

2. **Click once to create an anchor.**

3. **Click a second time to create a second anchor.**

4. **Use your mouse to define the curve of a path between the two anchors:**

 - To create a corner point instead of a curve, press the Alt key (Windows) or Option key (Mac) when clicking to place a second anchor.

 - Continue clicking and defining curves to complete a path.

 - Press Esc or select another tool to finish the path.

 As you move your cursor, the path appears in Rubber Band preview mode, previewing the curve, as shown in Figure 8-6.

FIGURE 8-6:
Previewing a curve with Illustrator's Rubber Band.

Editing curves

You can add anchors to an existing selected path, change curves to straight anchors, delete anchors, and tweak curves with the Curvature tool.

Can't you do all those things with the Direct Selection, Pen, and Anchor Point tools? Yes, you can. But again, the Curvature tool provides one-stop shopping for all things curve.

You can do basic editing of a path without having to leave the Curvature tool:

>> Click an anchor and drag it to move it.

>> Click an anchor and press Delete to delete it (without creating an open path).

>> Click a point and then drag it to move it.

Here's an example of where the Curvature tool earns its money as an editing technique: Double-click the corner or any anchor point of a shape or star to convert the straight anchor to a curve, and then use your mouse to tweak the curve. In Figure 8-7, I transformed the upper-right corner of a rectangle into a curve by double-clicking with the Curvature tool, and tweaked the curve with the Rubber Band preview.

FIGURE 8-7:
Transforming a straight anchor into a curve with the Curvature tool.

Drawing Filled Paths with the Blob Brush Tool

The unique thing about the Blob Brush is that it draws filled shapes, not paths. For example, a designer created some of the lettering in the poster in Figure 8-8 by using the Blob Brush. I then pulled lettering out of the poster and added a yellow fill so you could see that the "strokes" that make up the letters *e*, *s*, *i*, and *g* are actually filled paths.

FIGURE 8-8:
The Blob Brush feels like a stroke-drawing tool but creates filled paths.

Creating those letters by "drawing" with a shape would have been unintuitive. The Blob Brush solves the problem by looking and feeling like a tool that draws paths but actually generates shapes.

You access the Blob Brush tool in the Paintbrush tool flyout of the Basic toolbar. You draw with it as if you were drawing with the Pencil tool.

To define how the Blob Brush functions, double-click it to access the Blub Brush Tool Options dialog. The following tips will help you manage settings there:

» **Keep Selected:** Automatically displays anchors you create when you finish drawing a path (as is the case in the Pencil Tool Options dialog). This option is especially useful because, as emphasized, when you draw "strokes" with the Blob Brush, you're actually creating filled paths, and displaying anchors as you draw makes it easier to tweak the resulting paths. On the other hand, you might find all those anchors distracting as you draw, in which case you'll want to deselect this option.

» **Merge Only with Selection:** Creates discrete blobs, even when they overlap. This option is deselected by default so you can add to a blob with the Blob Brush as you draw. Normally, I find that designers prefer to leave this option deselected so they can return to existing blobs and add to them, maintaining the graphic as a single object. In fact, the ability to merge shapes as you draw is usually an intuitive way to create objects with the Blob Brush. Figure 8-9 shows what happens when I edit two sets of intersecting blob "strokes." The one on the left was edited with the Merge Only with Selection option selected; the one on the right had that option disabled, creating a single object instead of two intersecting ones.

FIGURE 8-9: Merge Only with Selection enabled (left) and disabled (right).

>> **Fidelity:** Controls how precisely your mouse or drawing pad actions are translated into paths. Settings range from no smoothing (Accurate) to maximum smoothing (Smooth).

>> **Size:** Defines the diameter of the "stroke" (really the filled path) that you generate as you draw.

TIP

Defining the size of the Blob Brush can be confusing. Even though drawing with the Blob Brush feels like drawing strokes, you are drawing filled paths. That's why you don't define a stroke color or weight for the Blob Brush (unless you want to add a stroke to the generated fill, and you usually don't because the filled path functions like a stroke). And, to emphasize the point, the color of the "stroke" generated by the Blob Brush is defined in the Control or Properties panel by the selected fill color, not stroke color.

>> **Angle:** Defines how the brush is applied and is only operative if you reduce Roundness.

>> **Roundness:** Reducing below 100% creates an oval-shaped stylus that generates a calligraphic-type "stroke."

>> **Random:** Varies the associated value. For example, with Random selected, a Variation value of 6, and a stroke Size of 36 points, the "stroke" thickness will vary between 30 and 42.

Figure 8-10 shows the Blob Brush Tool Options dialog configured to apply randomness to the size, angle, and roundness for the generated "stroke."

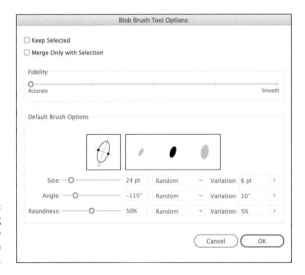

FIGURE 8-10:
Defining options for the Blob Brush tool.

Erasing with the Eraser Tool

The Eraser tool cuts through shapes quickly, cleanly, and intuitively. The Eraser tool can serve also as a drawing tool, cutting a path, so to speak, out of a shape.

Because the Eraser tool is intuitive (and let's face it, not everything in Illustrator is!), and because configuring and wielding it is similar to using features in the Blob Brush I just explained, this section is short. But that doesn't mean the Eraser tool isn't powerful.

You can configure the Eraser tool by double-clicking it to open the Eraser Tool Options dialog. The settings for Angle, Roundness, and Size, as well as the function of random variation in those settings, is similar to those for the Blob Brush.

Figure 8-11 shows the Eraser tool at work cleaning up text created with the Blob Brush.

FIGURE 8-11:
The Eraser tool at work.

Creating Shapes with the Shaper and Shape Builder Tools

Arranging, combining, and transforming basic shapes is a powerful design technique in Illustrator. Chapter 4 explores what you can do with shapes in some depth and focuses on drawing and generating shapes using the Rectangle, Ellipse, Polygon, Star, and Line Segment tools.

But bouncing from one shape tool to another can be tedious. As an alternative, Illustrator's Shaper tool allows you to generate shapes intuitively and on the fly.

Creating shapes with the Shaper tool

The Shaper tool isn't part of the Basic toolbar by default, so you have to add it. Do that by clicking the edit toolbar icon (the ellipses) at the bottom of the toolbar, and then dragging the Shaper tool into the toolbar as shown in Figure 8-12. Alternately, you can press Shift+N to select the Shaper tool.

With the Shaper tool selected, draw something close to an ellipse, a rectangle, or a polygon (such as a triangle or a hexagon). When you release the mouse button, Illustrator meditates for a nanosecond and generates a nice clean shape based on what you drew. So, for example, the crudely drawn rectangle on the left in Figure 8-13 became the nicely drawn triangle on the right. This technique works for rectangles, circles, ellipses, and polygons (including triangles).

FIGURE 8-12:
Adding the Shaper tool to the Basic toolbar.

FIGURE 8-13:
Using the Shaper tool to generate a triangle.

Combining shapes with Shape Builder

The Shape Builder tool is a quick, easy way to combine a bunch of selected, overlapping shapes. Here's how it works:

1. **Select the overlapping shapes that you want to combine.**

2. **Select the Shape Builder tool.**

3. **Click and drag across the selected shapes to combine them into a single path, as shown in Figure 8-14.**

FIGURE 8-14:
Combining
shapes with
the Shape
Builder tool;
the result is
shown on
the right.

The Shape Builder with its default settings is handy for intuitively combining a few intersecting shapes. You can fine-tune how the Shape Builder tool works by double-clicking the tool and adjusting options, but a documentation of those options is beyond the limits of what we can explore here. Instead, when you need more detailed and controlled options for combining intersecting paths, see the section on the Pathfinder panel in Chapter 4.

Animating with Puppet Warp

The Puppet Warp tool helps you gracefully transform artwork so that the changes feel natural. The Puppet Warp tool is particularly effective when used on simple (even stick) figures or cartoon characters.

The process follows:

1. **Select the artwork you want to transform with the Selection tool.**

2. **Select the Puppet Warp tool.**

3. **Use the pins that appear to transform the artwork.**

 Illustrator intuits areas to transform the artwork and adds pins that you can click and drag to transform the art.

 A mesh appears that indicates where you can add pins. That mesh can be distracting. It disappears as you're transforming the graphic, but you can hide it when you don't need it by deselecting the Show Mesh check box in the Properties panel.

 Figure 8-15 shows an original graphic on the left being transformed on the right.

FIGURE 8-15:
Transforming a dancer with the Puppet Warp tool.

4. **Add additional pins by clicking with the Puppet Warp tool:**

 - For the most fluid results, use three or more pins.

 - To select multiple pins, use Shift-click. The selected pins appear with white dots inside the black circles that indicate pins. You can move multiple selected pins together to experiment with the effect that has on your illustration.

 - To remove pins, select them and press Delete.

 - To constrain the transformation of your graphic around a selected pin, press Alt (Windows) or Option (Mac) while dragging that pin.

 In Figure 8-16, I added several pins and made more adjustments to the original artwork.

5. **Rotate pins for effect:**

 a. *Hover your cursor over the circle that appears around a selected pin to display the rotate icon.*

 b. *Drag clockwise or counterclockwise, and explore the effect that action has on the artwork, as shown in Figure 8-17.*

6. **To stop editing with the Puppet Warp tool, select any other tool.**

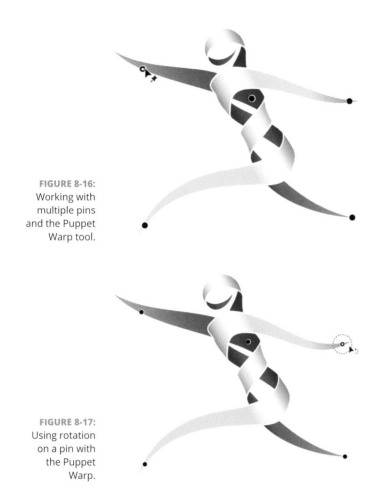

FIGURE 8-16:
Working with
multiple pins
and the Puppet
Warp tool.

FIGURE 8-17:
Using rotation
on a pin with
the Puppet
Warp.

Fine-Tuning beyond Drawing Tools

In this chapter, I introduced many different ways to draw in Illustrator. Many of these techniques overlap or are one of many alternative ways to create artwork. One person's favorite tool or technique is not necessarily the next person's. Different strokes for different folks, to quote Sly Stone.

But as varied, intuitive, and helpful as the drawing tools in this chapter are, I have to circle back to the point I opened the chapter with: Drawing simply to generate points and paths. Thus, the Illustrator drawing workflow often involves a cycle of drawing with the tools in this chapter and then returning to the Pen tool and its cousin the Anchor Point tool to tweak the anchors and paths generated when you drew more intuitively with drawing tools.

So, when you run up against the limits of the detail to which you can edit the paths you create with the Pencil and Curvature tools or other tools for creating objects, keep the Pen tool handy for final touch-up techniques.

IN THIS CHAPTER

» **The role of brushes in Illustrator design**

» **Setting the painter in you free with the Paintbrush tool**

» **Applying brushstrokes to paths**

» **Navigating Illustrator's Brush libraries**

» **Creating custom brushes**

Chapter **9**

Painting with Brushes

You can add a spectacular range of patterns, designs, and flourishes to strokes with Illustrator's set of brushes. And you can paint interactively with brushes applied to the Paintbrush tool. In an informal survey of Illustrator users I conducted while preparing to write this book, faces lit up when designers insisted that I squeeze in a substantial exploration of brushes. Let's face it, Illustrator brushes are fun!

In this chapter, you get introduced to an almost unlimited array of built-in and custom-made brushes. I also show you how to paint interactively on your screen with those brushes, and how to apply brushstrokes to existing artwork.

Unleashing Your Creativity with Brushes

Before I dive into how-to's on using Illustrator brushes, it will be helpful to start by distinguishing between two ways to work with brushes:

>> Create artwork using other tools, such as the Pen, Pencil, or Curvature tools, and then apply brushstrokes.

>> Apply brushstrokes as you create paths with the Paintbrush tool.

In the first method, you create the artwork by using any drawing tool (such as the Pen, Pencil, or Curvature tool). Then select a path, and click a brush in the Brushes panel, choose a brush from the Properties or Control panel, or create a DIY brush (I show you how shortly). The brushstroke is applied to the stroke. Apply a stroke color and weight, and observe the effect, as shown in Figure 9-1.

In the second method, you choose a brush or make your own, and then use the Paintbrush tool to paint on the screen. Figure 9-2 demonstrates loading the Paintbrush tool by choosing a brush, and then painting interactively on the canvas.

That's the short story. Much more is involved in taking full advantage of the palette of brushes and the ways in which you can apply them, so let's dive in more deeply.

Painting with the Paintbrush

Painting with the Paintbrush tool is similar to drawing with the Pencil tool. If the Pencil tool isn't a reference point for you, it might be worth bouncing quickly to the section on the Pencil tool in Chapter 8. The most obvious and dramatic difference between the two tools is that the Paintbrush tool applies the selected brushstroke to a path as you draw but the Pencil tool applies a defined stroke (and fill) but can't, on its own, apply brushstrokes.

When you're drawing with the Paintbrush tool, you release the mouse button when you finish drawing a path. You can also create a closed path with the Paintbrush tool. Hold down the Alt (Windows) or Option (Mac) key as you drag. The Paintbrush tool displays a small circle. When you release the mouse button (without first releasing the Alt or Option key), the path becomes closed.

You double-click the Paintbrush tool to open the Paintbrush Tool Options dialog. The options are similar to those for the Pencil tool, such as how smooth a path you want to draw, and how closely you want the path to adhere to every movement of your stylus or mouse. For more detail, I will save us all a tree and point you back to the Setting Pencil Tool options section of Chapter 8 to get oriented on these features.

And, as with the Pencil tool, Illustrator generates anchors as you draw with the Paintbrush tool. The number of anchor points is determined by the length and complexity of the path and by the Paintbrush tolerance settings. If you choose the Keep Selected option in the Paintbrush Options dialog, you'll see the generated anchors as soon as you draw a brushstroke, as shown in Figure 9-3.

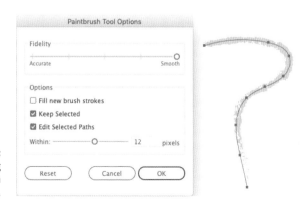

FIGURE 9-3: Revealing anchors in a brush path.

Applying Brushes to Paths

As mentioned, you can apply a paintbrush to a stroke in two ways. One way is to draw directly with the Paintbrush tool. The other way, which I focus on now, is to click a path and then click a brush.

You can use the same technique to replace a brush. For paths that already have a brush applied, select the path and then select a different brush in the Brushes panel to change the applied brush.

Working with the Brushes panel

The bottom of the Brushes panel has six icons. Because these icons access many of the key ways you can define and apply brushes, I'll introduce them to you now, from left-to-right:

>> **Access Brush Libraries:** These are collections of preset brushes that come with Illustrator. You can also create your own brushes (as explained later in the chapter). Here, we focus on exploiting the substantial set of prestyled brushes.

>> **Libraries Panel:** Share objects (including defined brushes) between apps and between users using Creative Cloud Library.

>> **Remove Brush Stroke:** Remove a brushstroke from selected paths, as shown in Figure 9-4.

You remove brushes from a selected path by clicking the Remove Brush Stroke tool in the Brushes panel, not the Delete button. The Delete button deletes the brush from the panel, meaning you have to go dig for it when you need it again.

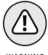

WARNING

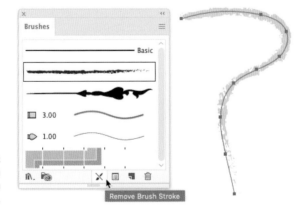

FIGURE 9-4:
Removing a
brush from a
path.

» **Options of Selected Objects:** Different brushes have different options, sometimes very different. I explain how you define brush options for different brushstrokes later in this section.

» **New Brush:** Define your own brushes, either by copying and editing an existing brush or creating one from scratch.

» **Delete Brush:** Access the brush libraries, remove a brushstroke, define options for the selected object, create a new brush, or delete the selected brush.

Navigating the Brush libraries

Now that you know how to draw with the Paintbrush tool and apply brushes to strokes, it's time to explore how to find and create brushes.

Brush libraries, accessible through the icons at the bottom of the Brush panel or the Brush panel menu, are organized by their look and purpose. Arrow brushes, for example, paint with arrows. You can click or drag brushes from any of these libraries (which open in their own panels) into the Brushes panel for easy access in your document, as shown in Figure 9-5.

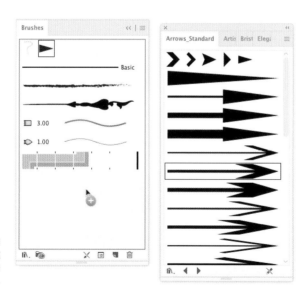

FIGURE 9-5:
Adding brushes to the Brushes panel.

Five types of brushes are available:

- » **Calligraphic brushes** apply strokes that look like ink flow from calligraphy pens.

- » **Scatter brushes** scatter pattern objects along a path.

- » **Art brushes** stretch a single artwork along the entire length of a path.

- » **Bristle brushes** create strokes that look like they were painted with a paintbrush (with visible individual bristles).

- » **Pattern brushes** include up to five tiles that interactively associate with the sides, corners, and endpoints of a stroke.

Note that brush *types* define the way in which a brush is applied to paths whereas brush *libraries* are sets of prestyled brushes.

You can filter the Brushes panel to display any or all of these types of brushes by selecting or deselecting different kinds of brushes from the list that appears when you open the panel menu. In Figure 9-6, the Brushes panel was filtered to display only calligraphic brushes.

FIGURE 9-6:
Filtering the Brushes panel for calligraphic brushes.

Creating DIY Brushes

You can create your own calligraphic, scatter, art, bristle, and pattern brushes. The process for creating any brush has these features in common:

» Create the brush, name it, and save it.

» Then apply the brush to any path(s) or load it onto the Paintbrush tool to paint with it.

» Edit the brush style in the Brushes panel by double-clicking it. When you edit a brush, the changes can be applied to all paths to which the brushstroke has been applied.

Each type of brush has distinctive properties and options. Exploring them all would require a book in itself. Instead, I highlight some of the most exciting properties and widely applicable options for customizing brushes.

TIP

In the following sections, I take you through the process of defining each of the five types of brushes. If you're planning to use only a particular brush or brushes, I suggest that you read through the process for all five brushes. Why? During a discussion of a specific brush, I also introduce techniques applicable to all brushes.

Editing existing bristle brushes to create new ones

The simplest way to create your own brush is to take an existing one and tweak it. Rephrase, as they say in TV legal dramas: The most efficient way to create your own brush is to take an existing one and tweak it.

TIP

If an existing brush is close to what you need or can be a basis for you to creatively experiment, start with that brush.

Exploring the Bristle Brush library

The *bristle brush* lets you create paths that have the look and feel of strokes created with an actual brush. As with every brush, you can either load the Paintbrush tool with a bristle brush or apply bristle brushstrokes to any shape or path.

To explore the library of preset bristle brushes, choose Window ⇨ Brush Libraries ⇨ Bristle Brush ⇨ Bristle Brush Libraries. I know that those last two menu steps seem redundant, but work your way through them and you'll get to the Bristle

Brush library. Alternately, you can get to the Bristle Brush library from the Brushes panel by selecting Open Brush Library ⇨ Bristle Brush ⇨ Bristle Brush Libraries.

The Bristle Brush menu gives you the option of viewing the available brushes in list or thumbnail view. You get a bit better preview of how the brushstroke will look by choosing thumbnail view, shown in Figure 9-7.

FIGURE 9-7:
Surveying
bristle brushes
in thumbnail
view.

The icons on the left side of the brush previews indicate the tip shape of the bristle brush. These shapes include round (more like a pen); flat (more like a brush); and fan (spread out strokes, similar to the effect of pushing down hard on a real paintbrush). Bristle brush types can vary in bristle length, stiffness, paint opacity, and other features. I show you how these are defined shortly.

One way to explore the effect of each of these brushes is to draw a path with any drawing tool, define a stroke weight and color, and then click the different preset bristle brushes one by one. Figure 9-8 demonstrates a bristle brush called Mop.

You can experiment with bristle brushstrokes also by loading the Paintbrush tool with one of the bristle brushes and painting on the canvas, as shown in Figure 9-9.

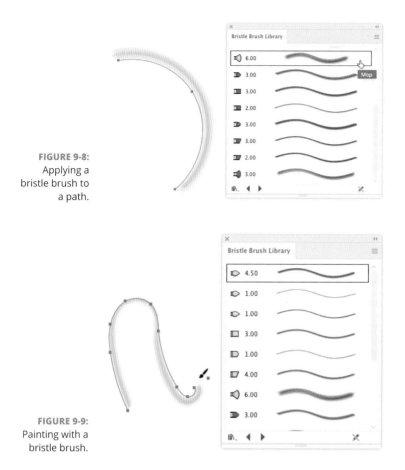

FIGURE 9-8:
Applying a
bristle brush to
a path.

FIGURE 9-9:
Painting with a
bristle brush.

If you have a Wacom Intuos 3 or higher tablet with Art (6D) pen, the bristle brush-strokes applied with the Paintbrush are sensitive to pressure, tilt, and other features built into the tablet and pen.

You can define opacity (transparency) for bristle brushstrokes. And, because bristle brushstrokes are usually defined with space between bristles, that space adds another see-through dimension (along with transparency) when you apply bristle brushstrokes over a background, as shown in Figure 9-10.

Creating a new brush by copying and editing an existing one

Having explored some of the features of the Bristle Brush tool, let me show you how to create your own custom bristle brushes. In the process, I use the bristle brush as an example of how to create a brush by copying and editing another brush.

FIGURE 9-10:
Underlying
objects show
through
transparencies
and gaps
in bristle
brushstrokes.

To create a custom brush based on a preset bristle brush, follow these steps:

1. **Add a bristle brush to the Brushes panel.**

 With one brush selected in the Bristle Brush Library panel, click the panel menu and choose Add to Brushes, as shown in Figure 9-11. If the Brushes panel is not visible, choose Window⇨Brushes to display it.

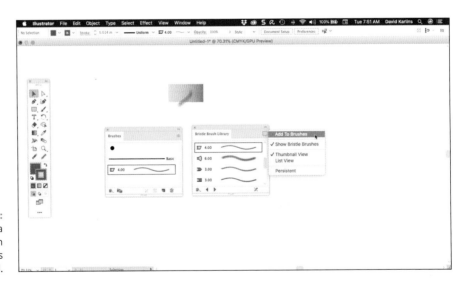

FIGURE 9-11:
Adding a
bristle brush
to the Brushes
panel.

2. **Rename and customize the bristle brush:**

 a. *Double-click the brush in the Brushes panel (not the Bristle Brush Library panel). The Bristle Brush Options dialog opens.*

 b. *In the Name area, enter a new name.*

3. **Experiment with changing the brush properties.**

 The ten options in the Shapes drop-down list access different types of brush designs. When you select one, an illustration of the brush appears below the selection to help you choose which type of brush you want to work with.

 Here's how the different options affect the behavior of a brush:

 - *Size:* Defines the diameter of the brush.

 - *Bristle Length:* Defines the distance from the start to the end of the bristle.

 - *Bristle Density:* Sets the number of bristles in a specified area, ranging from 1% to 100%, calculated in relation to the brush size and bristle length.

 - *Bristle Thickness:* Defines the thickness using a scale ranging from fine (0%) to course (100%).

 - *Paint Opacity:* Defines the degree of transparency of the bristle brushstroke, ranging from 1% (very transparent) to 100% (no transparency). (Parts of underlying objects show through between bristles, but bristle brushstrokes also have definable transparency.)

 - *Stiffness:* Defines the rigidity of bristles, ranging from very flexible (1%) to very stiff (100%).

4. **When the brush preview in the Bristle Brush Options dialog (see Figure 9-12) reflects the look you are aiming for, click OK to save the definition of your new custom brush.**

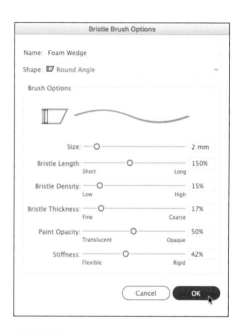

FIGURE 9-12:
Defining a custom brush.

The new defined brush appears in the Brushes panel, as shown in Figure 9-13, ready to apply with the Paintbrush tool or to be applied to any strokes.

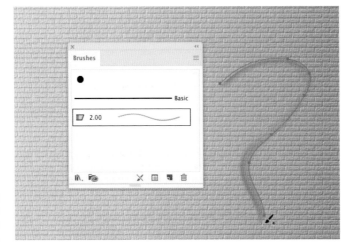

FIGURE 9-13:
Applying a
custom bristle
brushstroke.

Crafting calligraphic brushes

Calligraphy is a form of styling characters (letters, numbers, or punctuation) as designs. In traditions that go back thousands of years, calligraphy is created with a broad-tipped brush.

In Illustrator, *calligraphic brushstrokes* can vary in size, angle, shape, and randomness (variety) in the brushstroke width. Calligraphic brush shapes vary from almost round to very flat, but it is the ovalness that gives calligraphic brushes their unique styling. Calligraphic brushes (like the ones in Figure 9-14) are never round because a completely round calligraphic brush would simply apply a wider band around a stroke.

FIGURE 9-14:
Viewing some
of Illustrator's
calligraphic
brushes.

Many nice preset calligraphic brushes are available in the Artistic_Calligraphic library. To access them from the Brushes panel menu, choose Open Brush Library ⇨ Artistic ⇨ Artistic_Calligraphic.

If you don't find a calligraphic brush that fits your need, you can create your own. To create a custom calligraphic brush, and then tweak it through experimenting, follow these steps:

1. **Begin to define a new calligraphic brush:**

 a. *Choose New Brush from the Brushes panel menu.* The New Brush dialog opens.

 b. *Select New Calligraphic Brush and then click OK.* The Calligraphic Brush Options dialog opens.

2. **Name the brush by entering a descriptive name in the Name box.**

3. **Click OK to save the new brush.**

 Even though you haven't changed anything but the brush name at this point, save the brush now. It appears in the Brushes panel, as shown in Figure 9-15.

4. **With a stroke selected, use the Calligraphic Brush Options dialog to customize the calligraphic brush while observing the effect on a stroke:**

 a. *With a path to which a calligraphic brushstroke has been applied selected, make sure the applied calligraphic brush is selected in the Brushes panel.*

FIGURE 9-15:
A custom calligraphic brush in the Brushes panel.

 b. *Choose Brush Options from the Brushes panel menu.* The Calligraphic Brush Options dialog opens.

 c. *Keep the Preview box selected, as it is by default.* That way, you can see the effect of changes you make on the stroke to which you applied the brush.

5. **In the Angle box, enter a value to define the angle of the brush.**

 You might want to start with a 30 degree angle. As noted, don't define round brushes when you're going for a calligraphy look, but brush roundness can vary from almost round to almost flat.

6. **In the Size box, enter a value to define the diameter of the circle that would enclose the brush if the brush were round.**

7. **Choose Fixed or Random settings:**

 a. *Select either Fixed or Random on the drop-down menus.* The drop-down menu for each option has Fixed and Random options. (Additional options are available if Illustrator has detected that you're using a supported tablet or stylus or both.) Fixed generates a brush with a fixed angle, roundness, or diameter. Random generates a brush with random variations in angle, roundness, or diameter.

 b. *Enter a value in the Variation box to specify the parameters that constrain how brush characteristic can vary.* For example, when the Diameter value is 36 points and the Variation value is 6, as in Figure 9-16, the diameter can range from 30 points to 42 points.

8. **Click OK to save the new calligraphic brush pattern.**

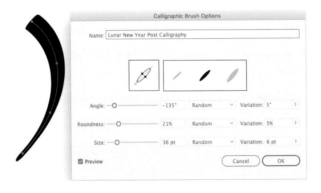

Applying or designing art brushes

Art brushes stretch to the length of the path to which they are applied. For example, if you apply the same flower art brush to different sized strokes, you create different sized flowers, as shown in Figure 9-17.

TIP

Those of you familiar with symbols in Illustrator might note, in looking at Figure 9-17, that the use of an art brush here is similar to the way symbols can be splayed about a canvas and updated globally.

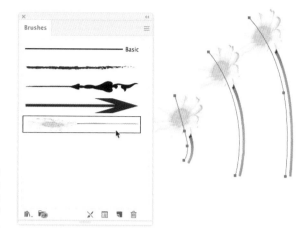

FIGURE 9-17:
An art brush
applied to
differently
sized paths.

The routine for creating an art brush is relatively simple:

1. **Select the object that will become the brush.**

2. **Drag the artwork onto the Brushes panel, as shown in Figure 9-18.**

3. **Choose the New Art Brush option from the dialog that opens and click OK.**

 The Art Brush Options dialog opens with the brush design selected in the preview window.

FIGURE 9-18:
Creating a new
art brush from
an object.

4. **In the Name field, enter a name.**

 The bulk of the work of designing an art brush takes place when creating the object you drag into the Brushes panel. Often the rest of the default options in this dialog, shown in Figure 9-19, work pretty well.

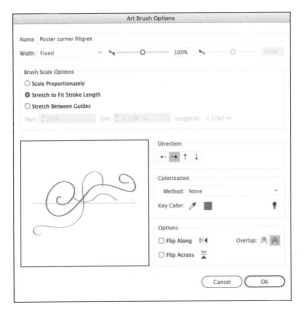

FIGURE 9-19:
Defining an
art brush.

5. **In the Direction area, select the up arrow to make the pattern appear in an intuitive, right-side-up manner as you draw a path up with a drawing tool.**

6. **In the Width area, enter a value to define how large the art will display relative to the stroke path.**

7. **Check out a couple other options in the dialog:**

 - Normally, you'll want to select the Scale Proportionately option to keep the height-to-width ratio unchanged as you rescale the object to which the art brush is applied.

 - One other option to explore is the set of Flip Along and Flip Across check boxes in the Options area. These options allow you to reverse the symbol either horizontally or vertically.

8. **When you're satisfied with the art brush options, click OK.**

 With an art brush defined, select any path and click the brush in the Brushes panel to apply it to the selected path.

Defining scatter brushes

Scatter brushes are intuitively named — they scatter artwork along a path. As with all brushes, you can draw interactively with a scatter brush by using the Paintbrush tool, or you can apply a scatter brush pattern to an existing path.

Defining any brush is easier if you can do so interactively. Simply try different options and observe the effect as the brushstroke is applied to something on the canvas. I show you that trial-and-error method in the "Crafting calligraphic brushes" section, where I walk through the procedure for applying a brushstroke to a path and then tweaking the brush while you watch the changes take effect on a stroke. If you're working with scatter brushes, I suggest looking at that section.

This approach applies in spades to defining scatter brushes. Rather than trying to decipher the algorithms behind the various options for defining this (or really any) brush, it's more intuitive to generate a new brush by using default options, and then test it on a stroke as you edit the options. You apply that workflow again in the following steps to define a new scatter brush:

1. **Start by creating artwork to use as a brush.**

 Small objects patterns are generally best.

2. **Drag artwork onto the Brushes panel.**

 The New Brush dialog appears.

3. **Click OK.**

4. **Choose the New Scatter Brush option.**

 The Scatter Brush Options dialog appears.

5. **In the Scatter Brush Options dialog, enter a name for the brush in the Name area.**

6. **Without changing the default option settings, click OK to generate the brush.**

Next, the work of tweaking the brush begins. Here's how to style brush options that produce the effect you want with your scatter brush:

1. **Draw a path in the canvas and apply the brush.**

2. **Double-click the brush you just created in the Brushes panel.**

 The Scatter Brush Option dialog reopens with a Preview check box.

3. Enable the preview by selecting the Preview check box.

4. Use the sliders and lists in the dialog to modify the pattern while observing the effect:

 - *Size:* Defines the size of the pattern in relation to the size of the original drawing.

 - *Spacing:* Controls the spacing between instances of the artwork.

 - *Scatter slider:* Defines how far apart the scatter brush art will scatter away from the path to which the brush is applied.

 - *Rotation:* Defines how much objects will rotate as the brush is applied to a curved path. Rotation setting can be applied relative to either the path (defined by how you draw) or the page (relative to the document).

5. In the Scatter Brush Options dialog, use the Colorization Method pop-up list to define how coloring is added (or not added) to the original stroke color.

 Click the tips (lightbulb) icon for an explanation of how this works.

6. Observe the effect of different option settings for the brush, applied to a path as shown in Figure 9-20, and when the settings are what you are aiming for, click OK.

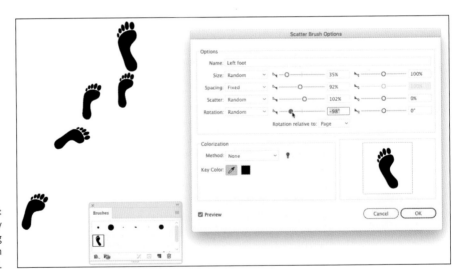

FIGURE 9-20:
Interactively
defining
scatter brush
options.

Creating pattern brushes

Pattern brushes repeat the object on the path. Astute readers who just read the preceding section of this chapter might exclaim, "Wait! I thought that's what scatter brushes do." I hear you. And you're right. What distinguishes pattern brushes is that they more closely adhere to the path they are applied to, and their fine-tuning features make it possible to design complex and detailed effects. I find it helpful to mentally associate pattern brushes with an intricately designed picture frame.

Pattern brushes can get complicated because the process can involve as many as five different object panels for the start, finish, side (center), inside corner, and outside corner panels. Note I said they *can* involve up to five different objects in a single pattern brush. But they don't have to. You can create an interesting pattern brush with just one element.

Keep the following in mind when you design corner and side patterns:

» Brush patterns tile perpendicular to the path, so when a path turns, the patterns turn with the path.

» Corner tiles rotate 90° clockwise when the path changes direction. That means if you design a corner tile that works well in the upper-right corner of a rectangular border, it will adapt appropriately to the other three corners in the rectangle.

Figure 9-21 shows a couple patterns that can be used to create a pattern brush. The top pattern serves as a corner; the bottom pattern will fit on the sides of a shape.

FIGURE 9-21:
Artwork for
a pattern
swatch.

As with all brush design workflow, you can use trial-and-error to tweak your designs.

Follow these steps to create a two-swatch pattern brush that works as a picture frame:

1. **Create two patterns, one for the corners and one for the sides of a rectangle that you can use to frame objects.**

 Keep the artwork as simple as possible.

2. **In the Swatches panel, drag the corner pattern into the panel, as shown in Figure 9-22, and name it Corner.**

 If the Swatches panel is not visible, choose Window ⇨ Swatches.

FIGURE 9-22: Dragging a corner pattern into the Swatches panel.

3. **If you want to rename the swatch, double-click the swatch name in the Swatches panel and type a new name.**

4. **Drag the second graphic, the one to be used for the sides of a frame, and name it Side, as shown in Figure 9-23.**

5. **Create a new pattern brush and name it Frame:**

 a. *On the Brushes panel menu, choose New Brush.*

 b. *In the New Brush dialog, choose New Pattern Brush and click OK.*

 c. *In the Pattern Brush Options dialog, enter Frame in the Name area.*

FIGURE 9-23:
Naming
swatches.

6. **Define the corner tile by using the corner swatch you created:**

 a. *Click the Outer Corner Tile icon.* The icon is on the far left in the set of five pattern swatches.

 b. *Choose the Corner swatch from the set that appears in the drop-down, as shown in Figure 9-24.*

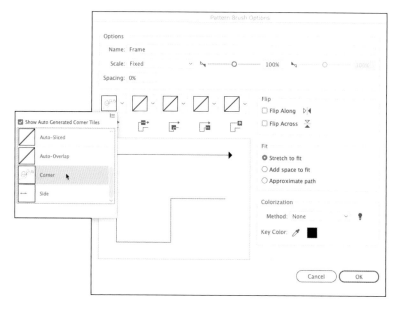

FIGURE 9-24:
Choosing a
corner swatch.

7. Define the side tile by using the side swatch you created.

Use the same process you used in the preceding step.

8. Leave the default settings as is and click OK.

You can tweak settings as you experiment with applying the pattern brush.

9. Test the pattern brush by applying it to the stroke of a rectangle:

 a. *Draw a rectangle.*

 b. *If you want to test your frame with an image or a color background, apply that to the fill of the rectangle.*

 c. *Apply the border using the Properties panel or the Control panel (shown in Figure 9-25).*

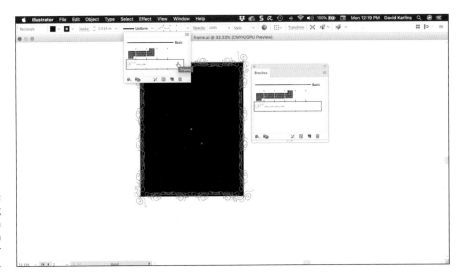

FIGURE 9-25:
Applying a pattern brush to a rectangular frame.

10. With your pattern brushstroke applied to a rectangle, double-click the brush in the Brushes panel to make adjustments:

 a. *Make sure the Preview check box is selected.*

 b. *Experiment first with the three different Fit settings.*

 c. *Also experiment with the Scale slider. In Figure 9-26, I changed the Fit from Stretch to Fit to Add Space to Fit, and scaled the brush down to 75%. That makes the border's effect less cluttered.*

For the kind of pattern I created in this example, most other default settings work well.

FIGURE 9-26:
Tweaking a
pattern brush.

11. **After your preview test matches the look you're aiming for, click OK.**

 You're prompted to apply the changes to strokes to which the pattern brush has been applied.

12. **Click the Apply to Strokes button.**

Using Brushes with a Drawing Tablet

In exploring different brushes in this chapter, I noted that some options for designing and applying brushes are available only in tablets. If you're drawing with a tablet, such as a Wacom tablet, you can select drawing tools like the Pencil, Pen, brush, or shape tools, and draw freehand using your tablet.

Calligraphic brushes, for example, take on special attributes when you use a drawing tablet. When your operating system detects your drawing tablet, Illustrator provides additional pressure and pen stroke options for using your tablet's pen. The most widely supported feature is pressure — the harder you press, the thicker the calligraphic brushstroke.

IN THIS CHAPTER

» Using symbols to rationalize workflow and reduce file size

» Accessing and deploying symbols from libraries

» Creating dynamic symbols

» Applying and editing dynamic symbols

» Spraying symbols

Chapter **10**

Improving Workflow with Symbols

S ymbols are objects that are displayed as instances in a document. A single symbol can be deployed as many instances in an Illustrator document. Each individual instance can be placed, resized, reshaped, and edited in various ways. But each instance retains essential qualities of the original symbol.

So what's in it for you, when it comes to using symbols? Plenty! Regardless of your level of expertise, the kind of graphics you create, or your workflow, symbols save time, make it much easier to orchestrate graphics across large illustrations, can radically reduce file size, and play a special role in sending screen-friendly SVG files to animators and web designers.

In this chapter, I show you how to use symbols to be more productive, and how to hand off lean, small file size illustrations to print and screen developers. Along the way, I introduce you to Illustrator's substantial set of symbol libraries and some powerful techniques for deploying and editing symbols.

Rationalizing Workflow with Symbols

The following are scenarios in which symbols save time, file size, and rationalize workflow:

>> You can use symbols when you're including objects in your illustration that repeat in various iterations. For example, you can use symbols for shrubs in a landscape, for stars in a skyscape, or for fish in the sea. Symbols allow you to quickly generate and tweak multiple objects without having to create each one separately.

>> After you use a symbol to deploy instances in your illustration, you can globally edit all the instances. The process works like Find and Replace in a text document: Illustrator tracks down all the instances of an edited symbol and applies changes that you define.

>> As noted, symbols in print and screen illustrations reduce file size. I've seen the effective application of symbols cut file size by as much as 90 percent.

>> Artwork that you want to map onto a 3D effect must be saved as a symbol. (See the section on generating 3D effects and mapping artwork in Chapter 14 for details.)

>> Symbols can be translated into SVG code when an Illustrator file is saved in SVG format, facilitating animation and interactivity in a website or app.

Using Illustrator's preset symbols

Symbols are associated with Illustrator documents. To access symbols, you place them in the Symbols panel. When you save a document, the set of symbols in the panel is saved with the document.

When you place a symbol in a document, you create a symbol *instance*. That symbol instance is more or less a clone (more or less because it is an editable clone) of the symbol.

The real excitement comes when you create your own symbols, but for prototyping, for quick layouts, or when Illustrator already has a set of applicable symbols, it's expedient to simply grab symbols from one of Illustrator's many symbol libraries.

Adding symbols to a document

The following steps demonstrate how to populate a document with flower symbols. The following steps apply with minor adjustments to deploying symbols from any library.

1. **In an open document, view the Symbols panel and manage how symbols are displayed:**

- If the Symbols panel is not visible, choose Window ⇨ Symbols.

- If the document already has symbols associated with it, those symbols will be displayed in the panel. A set of representative symbols appears by default when you create a document.

- Use options on the panel menu to sort the list of symbols alphabetically, or to view the symbols as thumbnails, a small list, or a large list, as shown in Figure 10-1.

2. **Clean up the Symbols panel:**

a. From the Symbols panel, choose Select All Unused.

b. With the symbols selected, click the delete icon at the bottom of the Symbols panel as shown in Figure 10-2.

FIGURE 10-2:
Deleting unused symbols.

TIP

Don't worry, you're not deleting these symbols from Illustrator. You're just disassociating them from the current document to clean up clutter, get rid of unnecessary content in your saved file, and make room for a more accessible display of symbols you choose to add to the Symbols panel.

3. **Add flower symbols to the Symbols panel:**

 a. *On the Symbols panel menu, choose Open Symbol Library to view all available libraries and then click Flowers. Or click the library (leftmost) icon at the bottom of the Symbols panel and then click Flowers, as shown in Figure 10-3.*

 b. *Click several flower symbols in the Flowers panel to add them to the Symbols panel, as shown in Figure 10-4.*

 c. *Close the Flower panel.*

FIGURE 10-3:
Viewing the Flowers panel.

4. **Create and manipulate flower symbol instances:**

 - Drag symbols out of the Symbols panel onto the canvas. If you drag symbols directly from the Flowers panel (or any other Symbols library), those symbols are automatically added to the Symbols panel.

 - If you copy and paste symbol instances in the canvas, the copies retain the properties of symbols. Or, in other words, you create more symbol instances.

FIGURE 10-4:
Populating the Symbols panel with symbols from the Flowers library.

5. **Edit the display of individual symbol instances.**

- The + symbol in the center of each selected instance is the symbol registration point. The + symbol distinguishes symbol instances from other artwork and is used for transformation.

- Each instance can be individually selected and moved, scaled, rotated, sheared, or reflected.

- You can also apply transparency, apply effects, and modify appearance in the Appearance panel. Figure 10-5 shows two instances of a bird of paradise symbol, sized differently.

- To revert a symbol instance to its unedited state, select and choose Reset Transformation on the Symbols panel menu.

FIGURE 10-5: Sizing and rotating a selected symbol instance.

TIP

The symbols that come with Illustrator are static symbols, which means your ability to manipulate them is limited. You have more flexibility in manipulating individual symbol instances with dynamic symbols. I show you how those work in the next section of this chapter.

6. **Replace a selected batch of symbol instances with instances of another symbol:**

 a. *Select a set of symbols in the canvas.*

 b. *Select a different symbol in the Symbols panel.*

 c. *From the Symbols panel library, choose Replace Symbol, as shown in Figure 10-6.*

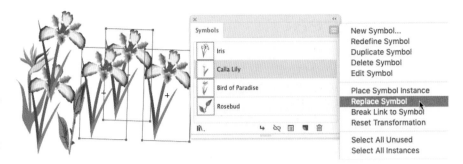

FIGURE 10-6:
Replacing
instances of
one symbol
with instances
of a different
symbol.

Managing symbols

Despite the fact that symbols are a nice mix of uniformity and flexibility, there comes a time when symbol instances aren't flexible enough and get in the way of the creative process. Breaking the link between a symbol and an instance gives you more flexibility and freedom in manipulating the artwork, unconstrained from any symbol definition. And detaching symbol instances from their symbols allows you to edit those instances as objects, without disturbing the display of other artwork.

You can break the linkage between a symbol and an instance in the following ways:

>> From the Symbols panel library, choose Break Link to Symbol.

>> At the bottom of the panel, select the break link to symbol icon.

>> Right-click the instance and choose Break Link to Symbol from the context menu.

>> Click the Break Link button in the Control or Properties panel.

Here are a couple other tips that will help you be more productive with symbols:

>> To quickly select all instances of a symbol, click the symbol in the Symbols panel and choose Select All Instances. Or choose Select ⭢ Same ⭢ Symbol Instance.

>> After you populate a custom symbols panel, you can save it for reuse in other documents by choosing Save Symbol Library on the panel menu.

Getting Creative with Dynamic Symbols

Custom dynamic symbols uncork much greater productivity and creativity options than the static symbols you just examined. The rules and techniques for selecting symbols and deploying symbol instances in the preceding section apply to symbols from an existing symbol library and symbols you create. And they work for both static and dynamic symbols. But custom dynamic symbols are even more powerful:

>> Edits to individual dynamic symbol instances do not affect the master symbol design.

>> Changes to a master design are applied to all instances of the symbol.

In short: When you create and deploy symbols, you'll want to make them dynamic symbols and take advantage of additional instance-editing features.

Creating dynamic symbols

The following steps demonstrate how to create a dynamic symbol. As noted, the techniques for deploying and editing preset static symbol instances examined in the preceding section apply also to custom dynamic symbol instances, so I don't repeat those techniques here:

1. **In an open document, create, name, and set properties for a new dynamic symbol.**

 - If the Symbols panel is not visible, choose Window ⇨ Symbols.

 - If the document already has symbols associated with it, choose Select All Unused and then Delete Symbol to clean up the Symbols panel.

2. **Create new artwork to be used as a symbol, select and drag it into the Symbols panel (see Figure 10-7), and name the new symbol.**

 Avoid text, placed images, or mesh objects because they don't work well as dynamic symbols.

FIGURE 10-7:
Creating a new symbol from artwork in the canvas.

3. **Define symbol options:**

 a. *In the Symbol Options dialog that appears, enter a name in the Name box.*

 b. *If you're preparing symbols for Flash, use the Export Type drop-down, the Registration options, and the Enable Guides for 9-Slice Scaling.* (See documentation in Flash for how these kinds of symbols fit into a Flash workflow.)

 c. *Choose Dynamic Symbol and then click OK to define the symbol.*

 The artwork you dragged into the Symbols panel becomes a symbol instance, appearing as an icon in the Symbols panel with a small + in the lower-right corner, as shown in Figure 10-8.

FIGURE 10-8:
Examining a custom dynamic symbol instance.

Orchestrating dynamic symbol instances

I chose the metaphor of "orchestrating" dynamic symbol instances because all the musicians are (I hope) playing the same tune and even the same part, but different musicians (such as the lead violinist) might be playing a slightly different part within the constraints of what the entire section is doing.

And similarly, dynamic symbol instances are constrained by the definition of the master symbol but can also have individuality, if you want to get psychological about it. The following steps illustrate how this feature works:

1. **Drag multiple instances of a dynamic symbol into your document and name them.**

 You can select individual instances and name them in the Control panel, as shown in Figure 10-9.

2. **Edit part of a dynamic symbol instance:**

 a. *Use the Direct Selection tool to select part of a symbol instance.* You can Shift-click to select multiple sections of multiple instances.

 b. *Modify fill color, stroke color, opacity, and effects.* You use the same techniques when editing a symbol that you use to edit an object.

 c. *Apply new styling to the selected objects within the symbol instances.* In Figure 10-10, I'm applying a new fill color to the candles but not the flames.

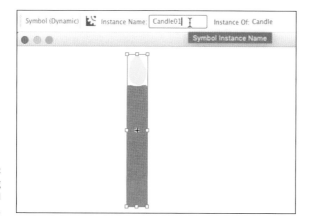

FIGURE 10-9:
Naming
a symbol
instance.

FIGURE 10-10:
Styling selected
candles (but
not flames)
within a group
of instances.

3. **Edit a dynamic symbol:**

a. *Select the symbol in the Symbols panel and choose Edit Symbol on the panel menu to enter symbol editing mode.*

b. *Edit the symbol objects' fill, stroke, rotation, transparency, effects, and other properties.*

c. *Use the left arrow at the top of symbol editing mode to exit the mode, as shown in Figure 10-11. Changes in the master symbol are applied to all instances of the dynamic symbol without changing specific edits to individual dynamic symbol instances.*

Figure 10-11 shows a revolve effect (see Chapter 14 to learn to apply revolve effects) applied to the candle and a gradient applied to the flame (see Chapter 12 for instructions on how to define and apply a radial gradient).

FIGURE 10-11:
Exiting symbol editing mode,
applying edits to a dynamic
symbol.

In Figure 10-12, those changes (the rotation and gradient) have been applied to the symbol but instances where the fill color was changed retained their fill.

FIGURE 10-12:
Edits to a dynamic symbol applied to instances.

Spraying Symbols

Like spraying paint from an aerosol can, you can spray symbols onto an illustration. You spray symbols when you need a lot of symbol instances in a hurry and the exact placement isn't an issue, not when you need precision-placed artwork. Think creating a flock of birds; a blizzard of hail stones; or a swarm of ants. Okay, sorry about that last image; replace that in your mind with a forest of beautiful redwoods.

How do you deploy sprayed symbols? A few definitions (much as I usually try to avoid them) will help guide the way:

>> The Symbol Sprayer tool gets loaded with a symbol, and sprays that symbol on the canvas.

>> The batch of symbol instances created by the Symbol Sprayer tool is a symbol set.

>> Symbolism tools (and there are several) distort and reshape selected instances in a symbol set.

The symbolism tools are not part of the Basic toolbar. To add them, click the edit toolbar icon (ellipses) at the bottom of the toolbar, and drag the Symbol Sprayer or other symbolism tools to the Basic toolbar.

The starter tool in spraying symbols is the Symbol Sprayer tool. Like the symbolism tools, it is not part of the Basic toolbar, but it is easily accessible with the Shift+S keyboard shortcut.

With the Symbol Sprayer tool selected, click a symbol and then scribble on the canvas, as shown in Figure 10-13.

FIGURE 10-13:
Spraying
symbol
instances with
the Symbol
Sprayer.

Setting Symbol Sprayer options

To adjust Symbol Sprayer options, double-click the Symbol Sprayer tool to open the Symbolism Options dialog. Some of the options are intuitive:

» **Diameter:** Defines the area in which the spray is applied — kind of like changing the setting on a showerhead from a wide spray (large diameter) to a fine, high-pressure spray (small diameter).

» **Intensity:** Defines the rate at which the tool generates instances.

» **Symbol Set Density:** Defines how many instances come out of the sprayer, with larger values creating more dense sets of instances. A value of 10 generates the densest concentration of symbols (and a value of 1 the lowest concentration of symbols).

» **Show Brush Size and Intensity:** Change the tool's cursor to display the diameter and intensity of the symbol as you spray symbols on a canvas.

Other options are usually best left at their default settings, but you might want to experiment with them if you're going to be doing massive symbol spraying. The options selected in Figure 10-14 create a very dense symbol set within a relatively small spray area.

The set of adjustments is complicated, but if you find yourself applying a ton of symbols with the Symbol Sprayer tool, you can apply trial-and-error to see how they work with different settings.

FIGURE 10-14:
Defining
Symbol
Sprayer
options.

Managing sets of sprayed symbols

After you spray symbols, you can add to the set of instances by spraying some more. Even if you do some other editing and deselect the set of instances, you can add to it by reselecting it and using the Symbol Sprayer tool some more.

A set of sprayed instances can be moved, rotated, sized, or deleted like other objects. Figure 10-15 shows a set of sprayed symbol instances being resized.

FIGURE 10-15:
Resizing a set
of sprayed
symbols.

Edits made to the master symbol will be applied to symbol instances created with the Symbol Sprayer. However, you can't edit instances created by the Symbol Sprayer, even if you used it to apply dynamic symbols.

3

Applying Color, Patterns, and Effects

IN THIS PART . . .

Defining and applying web-friendly and print-friendly colors

Defining and applying color gradients, blending different objects, and transparency to artwork

Defining and applying patterns

Styling with effects such as drop-shadows, distortion, and 3D effects

IN THIS CHAPTER

» **Understanding how print and screen color work**

» **Applying colors to objects**

» **Organizing colors in panels**

» **Getting theming help from Illustrator CC**

» **Intuitively applying color with Live Paint**

Chapter **11**

Designing in Living Color

llustrator provides a range of tools and features for choosing and applying color to strokes and fills. Some panels help you choose colors based on the colors you're already using. Other panels help you share or create coherent color schemes. You can choose from preset groups of colors, or you can mix your own sets of selected colors. I show you how to do all that in this chapter.

Exciting! Everything you need to inspire and facilitate your creativity.

But hit pause here. Before you starting defining and applying color, it is important, no — I won't soft-pedal this — it is critical to choose an appropriate color mode for your project: print or screens.

In this chapter, I explain the (very) different ways in which screen and print color are defined and how to apply color to strokes and fills. I also introduce you to powerful design features that will assist you in creating aesthetic color schemes for your graphics. Finally, I show you how to use Live Paint to apply color to parts of your artwork that Illustrator would not normally consider objects.

Understanding Print versus Screen Color

Why do I insist that defining color mode is a, if not the, starting point in any design project? Here, as in most chapters, I return to the mantra: Work backward. Color is applied in different ways for screens versus print projects, and the sets of available colors are different as well. If you try to use the wrong color mode for your intended output, you're shoving a left shoe on a right foot, to invoke a crude but cautionary metaphor.

Printers, particularly commercial printers, layer different colors of ink to produce a spectrum of colors. This process is referred to as *subtractive* because, for instance, when cyan is applied on top of yellow, the result is less yellow. Screens, on the other hand, use an *additive* process in which you add colors (red, green, and blue) together with various levels of intensity to project colored light. Those color pixels are backlit and can produce a larger spectrum of color than is possible to create by subtractive mixing of colors on a printed page.

In Chapter 2, I demonstrate how to define a color mode for a new document. Reviewing that won't take long because you simply choose between CMYK or RGB.

Defining color for print

The range of color available in print is smaller than that visible by eye. In other words, just because you can see a color on your screen doesn't mean it will print.

WARNING

To avoid designing with colors that will not reproduce in print, you must choose print-appropriate colors from the beginning of the print design process.

TIP

In the section on printing in Chapter 2, I emphasize communicating with your print professional at the very beginning of designing output for print with color. I repeat, highlight, and emphasize that here because the most important questions you need to ask your print professional are what kinds of colors are available, how do you define them, and how do you best preview how the colors will look in print.

Preparing documents for four-color printing

If your document is destined for print output at a commercial print shop, and the folks at the print shop advised you to give them an Illustrator file with CMYK color (a typical scenario), be sure your document is using CMYK color mode. Check by choosing File ⇨ Document Color Mode ⇨ CMYK, as shown in Figure 11-1.

Four-color print processes create colors by mixing cyan, magenta, yellow, and black — collectively referred to as CMYK (K represents black to prevent confusion with blue).

FIGURE 11-1:
Defining CMYK as a document color mode.

You define CMYK colors in the Color panel (choose Window ⇨ Color to display that panel). As you can see in Figure 11-2, you can either click in the color palette at the bottom of the panel to select a color, or enter values for cyan, magenta, yellow, and black (K) using sliders to define a color.

FIGURE 11-2:
Defining CMYK color.

Some quality inkjet printers enhance the set of printable colors by adding other cartridges such as light cyan, light magenta, or red, green, and blue. But regardless of how many colors are mixed in the print process, it is still necessary to generate a much larger set of colors by layering ink of different colors.

Using spot color or Pantone colors

You can mix CMYK colors by hand, or you can choose from sets of color books that correspond to commercial print colors.

Pantone colors are the most widely applied of these color sets. The workflow for applying Pantone color to a selected object is as follows:

1. **Choose a color or set of colors from a Pantone color book.**

 You can purchase a Pantone book, or many professional print shops will loan you one. Work with your printer to see a sample of your chosen color(s) on the paper or medium (glass, fabric, plastic, or other material).

2. **To configure Illustrator to make your chosen color available, view the Swatch panel for the appropriate color book:**

 a. *Select Window ⇨ Swatches to view the Swatches panel.*

 b. *From the Swatches panel menu, choose Open Swatch Library ⇨ Color Books ⇨ and then select the color book you are using, as shown in Figure 11-3.*

FIGURE 11-3: Adding a Pantone color book to the Swatches panel.

3. **To apply a color from a selected color book, select an object's stroke or fill, and click the color in the Swatches panel, as shown in Figure 11-4.**

 You can target a stroke or a fill by using the boxes at the bottom of the Tools panel.

 I explain how to use, manage, and save swatches later in this chapter.

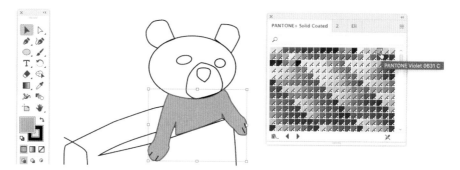

FIGURE 11-4:
Applying a
Pantone
color to a
selected fill.

Choosing RGB color for screens

The spectrum of color visible on a monitor is wider than that available in print. The darkest purple and deepest reds, for example, can't be fully reproduced using techniques that create printed colors. The number of colors that contemporary screens can reproduce with RGB (red, green, blue) color is in the millions, and designers can safely design with the expectation that users will be viewing artwork on monitors that support that range of color. (In the increasingly rare event that users' screens don't support that range of colors, the range of color will degrade gracefully enough to be acceptable in almost every scenario.)

WHY RED, GREEN, AND BLUE?

Mixing red, green, and blue coincides with how the human eye discerns color. Our eyes are made up of receptors that are normally tuned to collect red, green, and blue light. Colors that fall between red, green, and blue are generated in our brains by impulses from the eye that "mix" reds, greens, and blues.

RGB color is defined in values between 0 and 255. So, for example, an RGB setting of 0,255,0 (red=0, blue=225, green=0) produces solid green.

Follow these steps to define and apply an RGB color to a selected object:

1. **Make sure your document is set to use RGB color.**

 Choose File ⇨ Document Color Mode ⇨ RGB.

2. **Select the object to which the color will be applied.**

3. **Define an RGB color in the Color panel:**

 a. *Choose Window ⇨ Color.*

 b. *For red (R), green (G), and blue (B): Enter a value, or use the sliders to define a color, or click a color in the palette at the bottom of the panel.* If you know the hexadecimal color value (six-digit code prefaced with # that is used in HTML and CSS for web design), you can enter that value as a way of defining an RGB color, as shown in Figure 11-5:

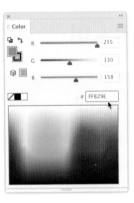

FIGURE 11-5:
Defining an RGB color with a hexadecimal value.

Understanding web safe color

Contemporary screens, defined as 24-bit color, handle millions of colors. But it hasn't always been that way. In earlier eras of digital design, illustrators had to be conscious of a much more limited palette of colors that were guaranteed to be supported in screens.

Today, designers do not need to concern themselves with constraining color selection to what were considered web safe colors in an earlier era of screen design (except in rare circumstances).

Configuring grayscale

Black and white printing generally allows you to apply a range of grayscale shades. You can select and apply grayscale shading by choosing Grayscale on the Color panel menu, as shown in Figure 11-6.

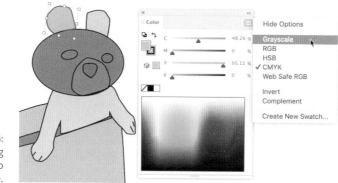

FIGURE 11-6:
Converting a color to grayscale.

Managing the Color of Strokes and Fills

I just described how to apply color from the Swatches and Color panels. But you can apply color to a selected object's stroke or fill (or both) in many ways, including the following:

>> Tools panel

>> Control or Properties panels

>> Swatches panel

I explain some of the most accessible and quickest ways to apply color next.

Apply color from the Tools panel

The Tools panel isn't the most powerful way to access stroke and fill color, but sometimes it's the most convenient, sufficient for accessing color on the quick.

To apply color to a stroke or to apply fill to a selected object (or objects) from the Tools panel, follow these steps:

1. **Double-click either the Stroke or Fill color selection box.**

Doing so displays the Color panel if it's not already displayed. The colors displayed reflect the document's color mode.

Press X to toggle back and forth between stroke and fill.

2. **Click a color in the color picker to apply that color to the selected object's stroke or fill.**

If the Stroke box is selected, the color will be applied to the object's stroke. If the Fill box is selected, the color is applied to the fill.

In Figure 11-7, I'm applying a blue fill and generating CMYK color values.

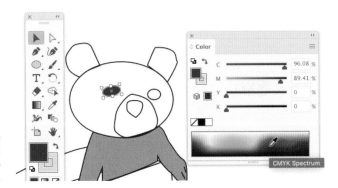

FIGURE 11-7:
Applying a fill color from the toolbox.

3. **Click the Out of Gamut warning icon if necessary to correct colors defined with RGB in a document using CMYK color mode.**

If you define a color with RGB settings in a CMYK document, and the defined color isn't reproducible with CMYK printing, an Out of Gamut warning icon appears. Click the warning icon to change the selected RGB color to the closest CMYK match.

TIP

The Color panel also presents an out of web color warning (cube) icon if you select an RGB color in an RGB color mode document that is not web safe. As I explain earlier in the chapter, web safe color is no longer a significant issue for screen design.

Apply color from the Control or Properties panel

Assigning color to strokes and fills in the Properties panel has the advantage of providing one-stop-shopping for defining other properties of a selected object (or objects) beyond color. You can, for example, define a stroke weight along with the stroke color.

To apply color to a stroke or to apply fill to a selected object (or objects) from the Properties panel, click the Fill or Stroke box in the Appearance section of the panel. A pop-out panel appears, with a color mixer at the bottom and the leftmost icon at the top displaying color as a swatch, as shown in Figure 11-8.

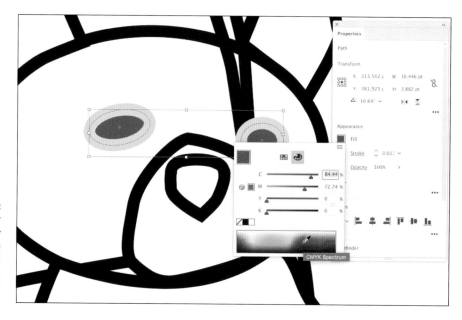

FIGURE 11-8:
Using the color mixer to apply a fill color to two selected objects from the Properties panel.

TIP

Using the Control panel to apply color is my favorite technique because the Control panel includes quick access to so many properties and the panel doesn't fill up much of the workspace.

Click the fill or stroke color buttons in the Control panel to display color swatches, as shown in Figure 11-9.

You can display color mixers instead of color swatches by Shift-clicking the color swatches in the Control panel.

FIGURE 11-9:
Choosing a
color swatch
for selected
strokes from
Control panel.

Using Color Guides and Color Themes

In the preceding section, I illustrate how to choose and apply stroke and fill colors using the color picker in the Color panel that appears in various forms when you apply color from the Tools panel, the Properties panel, or the Control panel.

But what if you need some help choosing colors? Illustrator has a couple panels that can assist you: the Color Guide panel and the Color Themes panel.

Getting color advice

The Color Guide panel generates a set of color swatches that go well with a base color that you define. That set of colors adjusts, chameleon-like, as you add (or delete) colors from your illustration. As you assign new colors, the Color Guide panel changes.

To view the Color Guide panel, choose Window ⇨ Color Guide. The drop-down menu at the top of the panel, shown in Figure 11-10, presents different color groups generated using different *harmony rules* — ways of generating complementary colors to the set of selected colors based on applying different mathematical calculations to numeric representations of colors.

FIGURE 11-10:
Getting color
advice from
the Color
Guide panel.

The Color Guide panel menu provides micro-control over what colors are displayed, as well as options for saving sets of generated colors:

>> Students of color theory will find the Edit Colors menu option in the Color Guide panel helpful. Choosing this option displays a window where you can dynamically adjust the way colors are generated for the Color Guide, as shown in Figure 11-11.

FIGURE 11-11:
The Edit Colors
window.

>> The Save Color Group to Swatch Panel tool adds the set of colors at the top of the Color Guide to the document Swatch panel. This panel is saved along with the document.

>> The Color Guide Options dialog lets you constrain how many colors are generated in the Color Guide, and how closely they match colors used in the open document.

Styling with Adobe color themes

Illustrator's Color Themes panel integrates Adobe Color, the free-to-anyone tool for generating color schemes that is high on my list of free online graphic design tools. If you aren't tuned into Adobe Color, check it out at `https://color.adobe.com`.

Adobe Color gives you access to searchable shared color schemes and makes it easy to create your own color sets, including from uploaded photos. Anyone can use it — and again, it's free! But if you do license Adobe Illustrator CC in any form, you can log into Adobe Color and save color schemes. (To save color schemes, you need a subscription to Adobe CC.)

Adobe Color is both a full-fledged app in its own right and intuitive, so I won't document how it works here. I think you can explore it thoroughly on your own. After you create color schemes in Adobe Color, you can access those themes (as well as create your own or used shared themes) by choosing Window ⇨ Color Themes.

Here are some ways in which you can avail yourself of the creative power of Adobe Color:

>> To use Adobe Color from Illustrator to create new themes, click the Create tab in the Adobe Color Themes panel.

>> To use shared themes, click the Explore tab.

>> To access saved color themes, choose Windows ⇨ Color Themes and choose the My Themes tab.

>> To access a shared theme, click the Explore tab. If you add a theme in Color Themes after you launch Illustrator, refresh the browser window running Adobe to update and add the latest theme(s).

>> To use a somewhat truncated interface to create a new theme, select the Create tab. (However, creating new themes is more easily managed by using the full online version of Adobe Color.)

After you find a theme or themes you want to use for your illustration, use the following techniques to apply colors from a theme in the Explore or My Themes tab to objects in a document:

» To apply a color from a theme to a selected fill, target a fill in the Control panel or Tools panel and then click the color in the Adobe Custom Themes panel (the My Themes tab). In Figure 11-12, I'm applying a fill from my Stuffed Animals theme.

FIGURE 11-12:
Applying a fill
color from a
custom color
theme.

» To apply a color from a theme to a selected stroke, target a stroke in the Control panel or Tools panel and then click the color in the Adobe Custom Themes panel (the My Themes tab). In Figure 11-13, I'm applying a fill from a shared color theme.

» To add colors in the Adobe Color Themes panel to your document's Swatch panel, click the ellipses under a theme to open a pop-up menu and choose Add to Swatches, as shown in Figure 11-14.

» To add a single color (or selected colors) from a theme available in your Illustrator document, click the color to make it active and drag it from the Tools, Properties, or Control panel to the Swatches panel, as shown in Figure 11-15.

FIGURE 11-13:
Applying a
stroke color
from a shared
color theme.

FIGURE 11-14:
Adding a color
theme to the
Swatches
panel for a
document.

FIGURE 11-15:
Adding a single
color from
a theme to
the Swatches
panel for a
document.

Managing Color Swatches

The Swatches panel functions like a painter's palette, holding the colors you need to work with in your document. In the preceding section, I explain how to add colors from Adobe Color Theme to your document's Swatches panel. Now I take a moment, or at least a few pages, to document key functions of the Swatches panel.

Swatches are named colors, tints, gradients, and patterns. In this chapter, I focus on adding colors to the Swatches panel, but the basic rules I explain apply to adding gradients (see Chapter 12) and patterns (see Chapter 13) as well. Color swatches can be grouped to help keep sets of related colors easily accessible.

And, importantly, swatches are saved with the document in which they are created. When you return to a saved document and view the Swatches panel, all the swatches you created in that document are still available.

Adding colors to the Swatches panel

To add a color to the Swatches panel, use any of the following techniques:

» Select a color using the color picker or Color panel and drag the color from the Tools panel, Control panel, Properties panel, or Color panel to the Swatches panel, as shown in Figure 11-16.

FIGURE 11-16:
Adding a color from the Properties panel to the Swatches panel.

» Use the Eyedropper tool to click any color in a placed object (including a photo) to add the color to the Color panel, Properties panel, or color picker in the Tools panel, as shown in Figure 11-17. Then drag the color from the panel to the Swatches panel.

» In the Swatches panel, click the New Swatch icon (it looks like a piece of paper with a folded corner) or select New Swatch on the panel menu. Define and name the color in the New Swatch dialog, as shown in Figure 11-18, and click OK.

FIGURE 11-17:
Selecting a
color from a
placed photo
with the
Eyedropper
tool.

The new color in Figure 11-18, named
Pinkish-12, is converted from a process
color (from a color book) to a global
(defined) CMYK color, and is being saved
to my Stuffed Animals library of colors.

The Global check box converts Pantone
or other process colors to regular CMYK
colors.

The Add to My Library check box adds
the color to a selected color library
available in all your Adobe CC apps. You
can open libraries of swatches in other
Illustrator documents, but Swatch in CC
libraries appear in separate panels and
are not saved with the document in
which they are created.

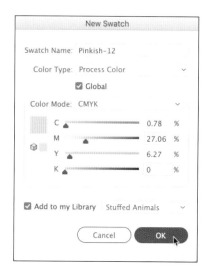

FIGURE 11-18:
Adding a color from a photo to the
Swatches panel.

Changing the display of swatches

The Swatches panel menu provides a set of intuitive options for grouping, dupli-
cating, deleting, selecting, sorting, and displaying swatches.

A few of these options merit a bit of explanation:

>> To clean up the Swatches panel by removing all unused swatches, choose Select All Unused and then Delete Swatches.

>> To find a swatch by name, choose Select Show Find Field on the Swatches panel menu and then start typing the swatch's name in the Find text box at the top of the panel.

>> You can reorder swatches manually (by dragging them in the panel) or by selecting Sort By Name or Sort By Kind on the Swatches panel menu.

>> To access Swatch libraries (collections of preset colors), choose Open Swatch Library and then select the library.

TIP

You can save an open Illustrator document as a swatch library. You retrieve saved swatch libraries by choosing Window ⇨ Swatch Libraries ⇨ Other Library and navigating to and opening the library.

Creating and Merging Live Paint Groups

Here's the problem Live Paint was invented to solve: Often, you'll find that you want to apply paint to an Illustrator path that isn't really a path. Instead, what looks like it should be an easily selectable and fillable region, such as the intersecting area of the two ellipses in Figure 11-19, isn't an object. The two ellipses are objects, but the area where they intersect is not an object to which a fill can be applied without Live Paint.

FIGURE 11-19:
A conventional fill can't be applied to the area where the two ellipses intersect.

The rules for what is fillable (or strokeable, if that's a word) change with Live Paint. In Live Paint, every intersecting path forms an editable path, and the regions formed by these paths can be filled individually — handy features when you're coloring in artwork.

Creating Live Paint groups

Live Paint groups even use different terminology than normal Illustrator paths:

➤ Strokes are called *edges* in Live Paint.

➤ Fillable areas formed by edges are *faces*.

Before you can edit Live Paint edges, or fill in Live Paint faces, you need to convert exiting paths to Live Paint groups. To convert paths to Live Paint groups, follow these steps:

1. **Use a selection tool to select all the paths you want to convert to a Live Paint group.**

 Any selection technique works, but given the nature of Live Paint regions, you'll likely want to use the Selection tool to draw a marquee around objects.

2. **Choose Object ➪ Live Paint ➪ Make, as shown in Figure 11-20.**

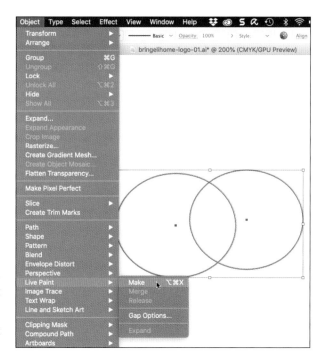

FIGURE 11-20: Converting selected objects into a Live Paint group.

Coloring Live Paint faces

To apply a fill color to a Live Paint face, follow these steps:

1. **Select a color in the Tools, Control, or Properties panel.**

2. **Press K to select the Live Paint Bucket tool.**

3. **Click a Live Paint face to apply the color, as shown in Figure 11-21.**

FIGURE 11-21:
Applying a
color fill to a
Live Paint face.

Live Paint is a little more intuitive when applied to faces (fills) than to edges (strokes).

Editing Live Paint edges

Use the Live Paint Selection tool (Shift+L) to paint Live Paint Group edges. The Live Paint Selection tool is not just for coloring Live Paint edges. This tool treats every line segment formed by intersecting lines as a separate line that can be selected, painted, or deleted.

Selecting Live Paint edges are useful, for instance, if you're editing scanned artwork and need to be able to easily select line segments, or if you find it more intuitive and rational to think of every line segment as a distinct line. You select edges with the Live Paint Selection tool also to apply color to edges.

The Live Paint Selection tool is particularly useful when you want to select a Live Paint edge, but it can be used also to select Live Paint faces. As you hover over a section of a Live Paint group with the Live Paint Selection tool, the tool displays as a black triangle when a face is selected, as shown in Figure 11-22.

Still, the most applicable use of the Live Paint Selection tool is for selecting and coloring Live Paint edges. Figure 11-23 shows an edge selected, with the cursor icon displaying as an unfilled triangle.

To apply a color to a Live Paint edge, follow these steps:

1. **Define a stroke color in the Tools, Properties, or Control panel.**

2. **Press Shift-L to activate the Live Paint Selection tool.**

3. **Click to select a Live Paint edge, and then click a color from the Color or Swatch panel, as shown in Figure 11-24.**

If you delete an edge between two Live Paint faces, the paint (fill color) flows into newly expanded faces.

FIGURE 11-22:
Selecting a Live Paint face with the Live Paint Selection tool.

FIGURE 11-23:
Selecting a Live Paint edge with the Live Paint Selection tool.

FIGURE 11-24:
Using the Live Paint Selection tool to color an edge.

Controlling Live Paint faces and edges

Selecting Live Paint faces and edges takes a bit of practice, so experiment with a simple example such as the intersection ellipses I used here. After you get comfortable with Live Paint, you'll find that it makes it much easier and, yes, more fun to color illustrations.

But there are some additional techniques you will want to be aware of to control the process of creating Live Paint groups and coloring them. I explore those next.

Setting gaps

When you apply fills to faces in Live Paint Groups, the fill sometimes flows into nearby faces. Whether or not the fill will flow through gaps between faces depends on how you set the Live Paint Gap options.

Here's how to define those gaps:

1. **To access features of Live Gaps, choose Object ⇨ Live Paint ⇨ Gap Options.**

 The Gap Options dialog opens, as shown in Figure 11-25. This is where you change gap settings.

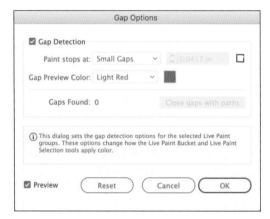

FIGURE 11-25: Defining gap options.

2. **To define what size gaps will constrain fills, select the Gap Detection check box if it is deselected.**

 With the Small Gaps option, fills will flow through any gap that isn't small. The Large Gaps option stops paint from flowing through any gap except large ones. Medium Gaps is in-between.

 To define a custom gap value, choose Custom Gaps and enter a value.

3. **To customize the preview color, choose a color from the Gap Preview Color drop-down.**

 The default color is red.

4. **To use trial-and-error in setting gaps, select a Live Paint group before you define gap options.**

 - If you have a Live Paint group selected, the Gaps Found value will reflect the gaps detected by your settings.

 - If you select Preview, you can see the effect of the gap settings you create applied to a selected Live Paint group. In Figure 11-26, the gap that will be closed is indicated by a thin red line.

5. **After you define the Live Paint Gap settings, click OK.**

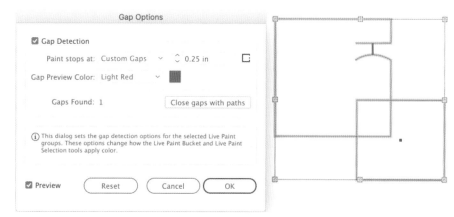

FIGURE 11-26: Previewing gap detection.

Editing Live Paint groups

What if you want to convert a Live Paint group back to normal Illustrator paths to facilitate editing those paths? Good news. You can! To convert a selected Live Paint group to normal Illustrator paths, choose Object ➪ Live Paint ➪ Expand. Bad news: The fill and stroke are permanently separated into distinct objects, which makes editing them as regular Illustrator objects more complicated.

You can also merge selected Live Paint groups. To do that, choose Object ➪ Live Paint ➪ Merge, as shown in Figure 11-27.

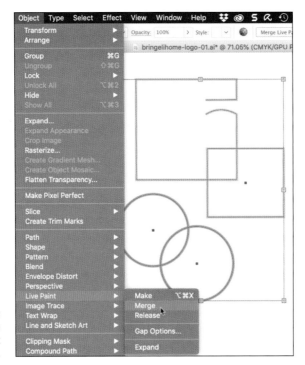

FIGURE 11-27:
Merging two
Live Paint
groups.

To apply fill attributes to many faces at once, click and drag with the Live Paint Bucket across those faces in the Live Paint group, as shown in Figure 11-28.

To apply fill attributes to all faces in a Live Paint group that have the same fill, triple-click one of the faces.

Using Live Paint wisely

You pay a price for converting normal Illustrator paths to Live Paint groups. Transparency, effects, and stacked strokes or stacked fills are lost.

Type, embedded raster images, and brushes do not convert to Live Paint groups. Of course, if you find that you've destroyed an illustration by converting paths to Live Paint groups, you can undo the Live Paint by choosing Ctrl+Z (Windows) or ⌘+Z (Mac).

FIGURE 11-28:
Applying Live Paint color to multiple faces.

Many things that you create or apply in Illustrator don't work in Live Paint groups, including the following:

- » Blends
- » Brushes
- » Effects
- » Gradient meshes
- » Stacked fills and strokes from the Appearance panel
- » Symbols
- » Transparency

Live Paint groups are often easier to apply colors to but less flexible than normal Illustrator paths. So, if you use Live Paint, I suggest a workflow where you do basic editing with Live Paint groups first, and then convert to regular Illustrator paths for other tools and effects if needed.

IN THIS CHAPTER

» **Defining and applying gradients**

» **Using blends for productivity and design**

» **Defining and applying transparency to objects**

» **Styling with opacity blends**

» **Combining transparency and gradients in opacity masks**

Chapter **12**

Bringing Graphics to Life with Gradients, Blends, and Transparency

L et's talk about the real world for a moment. Objects in the real world can't be represented simply with vectors with solid strokes and solid-color, opaque fills. In real life you encounter objects with colors that merge gradually. In Illustrator, you can more closely approximate a real object by using gradients to generate and fine-tune transitions between colors.

In real life, objects that are the source of an illustration (or a product of the imagination) are often part of a larger set of objects. For example, a step is usually part of a staircase. A stone in a creek might be part of a path of stones that cross the creek. In Illustrator, you can use blends to generate sets of objects that transition from one object to another along a defined path.

In real life, not all objects are opaque (hiding everything behind them). Many elements of an illustration, such as a windowpane or thin piece of fabric, reflect real-life objects that are only partially opaque, with an aspect of transparency. Illustrator's transparency features allow you to apply any degree of transparency to objects, from fully opaque to almost completely transparent.

In this chapter, I show you how to use gradients, blends, and transparency to bring illustrations to life.

Merging Colors with Gradients

Gradients merge two or more colors in an object. Gradients can be used to reflect color transitions in real-life objects. Figure 12-1, for example, captures the transition between the white part of a watermelon slice that is no fun to eat, and the sweet, juicy, red part that is almost too much fun to eat.

Gradients can add the appearance or feel of three-dimensional depth to an illustration. In Figure 12-2, I added gradients to add depth to the room with receding light.

FIGURE 12-1:
A gradient applied to a slice of watermelon.

Illustrator CC allows you to generate three types of gradients:

» Linear gradients blend color from one point to another, horizontally, vertically, or diagonally, as shown in Figure 12-3.

» Radial gradients also mix colors from one point to another point but they do so by radiating out from the center of an object. The fill in the setting sun in Figure 12-4 is a radial gradient.

» Freeform gradients are more flexible than either linear or radial gradients, as shown in Figure 12-5. Fluent Illustrator designers will find freeform gradients a more accessible and versatile way to create effects similar to, if not quite as complex, as those created with gradient mesh.

FIGURE 12-2:
A gradient applied to create the illusion of depth.

FIGURE 12-3:
Horizontal, vertical, and diagonal linear gradients (left to right).

FIGURE 12-4:
The setting sun in the illustration uses a radial gradient fill.

FIGURE 12-5:
A freeform
gradient.

Applying gradients

You apply defined gradients to selected objects pretty much the same way you apply color to objects. If you're not familiar with organizing and applying color, a quick visit to Chapter 11 will serve as a helpful prerequisite to working with gradients.

The short version is this: Select an object and then click a gradient in a swatch panel, and the gradient is applied to the selected object.

There's more to the story, of course. Gradients can be tweaked, created from scratch, and applied in many different ways, as I outline in the introduction to this chapter. But let's start with the basics: picking a gradient and applying it to an object.

Applying a gradient from a swatch library

The simplest way to apply a gradient is to use an Illustrator preset gradient. Illustrator provides an impressive set of built-in gradients, and custom gradients (I get to those next) often begin with a preset.

You access Illustrator's robust set of preset gradients by choosing Window ⇨ Swatch Libraries ⇨ Gradients and then clicking one of the many sets of gradient swatches.

When you select an object and choose a gradient from any of the swatch libraries, that gradient is applied to the selection, and the gradient swatch is added to your document's Swatches library. Figure 12-6 shows three gradient swatch libraries, with a gradient (Sky 3) being applied to a selected rectangle, and all applied gradients added to the Swatches panel.

FIGURE 12-6:
Applying a gradient from a swatch panel.

TIP

In Chapter 11, I explain how to configure and use Swatch libraries.

Applying a gradient to a stroke

If you want to apply a gradient to a stroke (and you can!), change the Tools panel color focus to Stroke, and then click the gradient swatch you want to load into the Stroke color box. With the gradient defined as a stroke color, click any object to apply the gradient to that object's stroke, as shown in Figure 12-7.

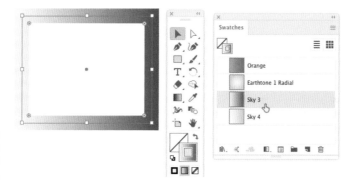

FIGURE 12-7:
Applying a gradient to a stroke.

Unleashing linear gradients

If the dozens of preset gradient swatch libraries don't have the gradient you need, you can edit an existing one or create one from scratch.

If you're customizing an existing gradient, start with these steps:

1. **Select a starter gradient in the Swatches panel.**

If the gradient you're using as a starter gradient is not in the Swatches panel, drag it there from one of the gradient swatch libraries.

2. **Duplicate and rename the starter gradient swatch:**

 a. *Choose Duplicate Swatch from the Swatches panel menu.*

 b. *Double-click the swatch (not the swatch thumbnail) in the Swatch panel to open the Swatch Option dialog.*

 c. *Enter a new swatch name, as shown in Figure 12-8, and click OK to apply the new swatch name.*

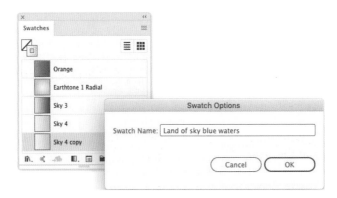

FIGURE 12-8:
Renaming a
swatch.

3. **Open the Gradient panel to edit the gradient.**

 With the new gradient selected in the Swatches panel, view the Gradients panel, as shown in Figure 12-9.

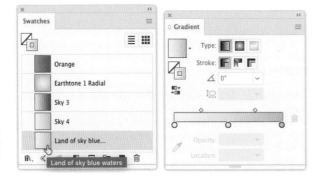

FIGURE 12-9:
Editing
gradient
properties.

You're now ready to edit the properties of the swatch. I explain how to do that next.

To create a gradient, I usually start with an existing gradient and tweak it, as I explain in the preceding section. But you can also create a gradient from scratch. Do that by double-clicking the Gradient tool in the Tools panel (on the Basic toolbar). The Gradient panel opens, ready for you to define a new gradient.

The next step is to choose a gradient type. As I note in the beginning of this chapter, the three types of gradients are linear, radial, and freeform. The process of defining each of these is similar.

Because linear gradients are the most widely applicable, l start by explaining how to define a linear gradient, and how to apply linear gradients interactively with the Gradient tool. Then I point out what's different when you define and apply a radial or freeform gradient.

Linear gradients can be horizontal, vertical, or diagonal — I demonstrate all three options at the beginning of this chapter.

Follow these steps to define any one of the three types of linear gradients:

1. **In the Gradient dialog, click the linear gradient icon (the first one).**

2. **Define the start and finish gradient colors:**

 a. *Click in the gradient slider at the bottom of the panel.*

 b. *Double-click the far-left gradient color stop and choose a color from the color box that opens.*

 c. *Double-click the far right gradient color stop and choose a color from the color box, as shown in Figure 12-10.*

3. **Add color stops:**

 a. *Hover your cursor under the gradient slider until a + appears.*

 b. *Click to define the new color stop.*

 c. *Apply a color to the new stop using the technique in Step 2.*

 Color stops can be placed or moved anywhere on the gradient ramp.

 To delete a gradient stop, drag it out of the Gradient panel.

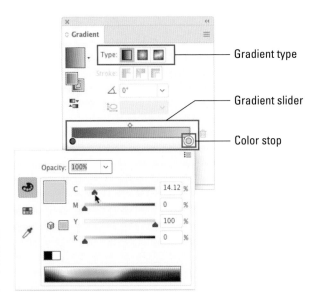

Gradient type

Gradient slider

Color stop

FIGURE 12-10:
Defining
beginning and
ending color
stops.

4. **Adjust the location of the transition between color stops.**

 After you create gradient stops and apply colors to them, adjust the gradient by changing the location of the diamond-shaped midpoints between each color stop, as shown in Figure 12-11.

5. **Rotate the fill:**

 a. *Change the angle setting.*

 b. *Draw a rectangle.* You won't see the effect of changing the rotation of a fill until you apply it, so it's helpful at this stage to draw a rectangle. The gradient will be reflected in the rectangle, as shown in Figure 12-12.

6. **Define transparency.**

 You can define opacity for each selected color stop; lowering the opacity applies some transparency to that color. In Figure 12-13, I dialed down the opacity of the far left color stop to 20%. You can see that when this gradient is applied to the rectangle, the underlying black ellipse shows through the semitransparent section of the gradient.

FIGURE 12-11:
Adjusting the midpoint in a gradient transition.

FIGURE 12-12:
Defining
gradient
rotation angle.

FIGURE 12-13:
Applying
transparency
to a color stop.

7. **Define how the gradient will appear when applied to a stroke:**

a. *Draw a rectangle with a thick stroke on the canvas and keep it selected while you define the gradient stroke style.* Drawing a rectangle helps you to preview how your stroke gradient settings will appear.

b. *In the Tools panel, focus the selection on the stroke.* You can apply a gradient within, along, or across a stroke using the three icons under the set of three stroke icons. These icons are active only if you have selected the stroke focus, not the fill focus.

c. *Experiment with the three options for applying the gradient to a stroke.* Figure 12-14 shows the Apply Gradient within a Stroke option applied.

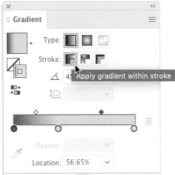

FIGURE 12-14:
Defining a
gradient for
strokes applied
within the
stroke.

8. **To change the location of gradient stops, drag them to a different location on the gradient slider.**

Alternately, you can define a location value of a selected color stop in the Location box at the bottom of the Gradient panel. Color stop locations values are defined in percent, with the beginning of the gradient at 0% and the end at 100%.

9. **Save your defined gradient:**

a. *Drag the gradient swatch in the upper-left corner of the Gradient panel to the Swatches panel, as shown in Figure 12-15.*

b. *Name the new gradient in the Swatches panel.*

When you save your document, the swatches panel is saved with the document, including your defined gradients.

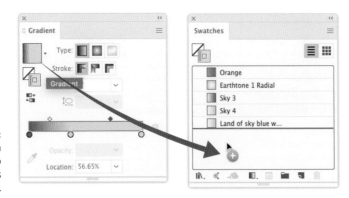

FIGURE 12-15:
Adding a
gradient to
the Swatches
panel.

Radiating radial gradients

Defining a radical gradient in the Gradients panel is similar to defining a linear gradient. The most essential difference is that you select the radial gradient icon in the Gradient panel when you define the gradient, as shown in Figure 12-16.

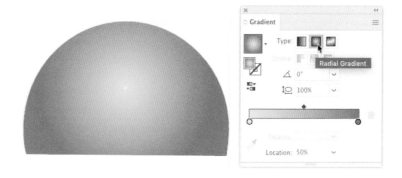

FIGURE 12-16:
Defining a
radial gradient.

Following are a couple radial-specific tips:

>> The default aspect ratio setting of 100% produces a circular gradient. Changing that transforms the gradient into more of an egg-shaped ellipse, as shown in Figure 12-17.

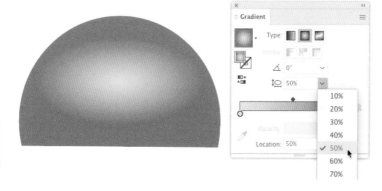

FIGURE 12-17:
Changing a
radial gradient
from a circle to
an ellipse.

>> If you change the aspect ratio to something other than the default, you can rotate the radial gradient using the angle setting, as shown in Figure 12-18.

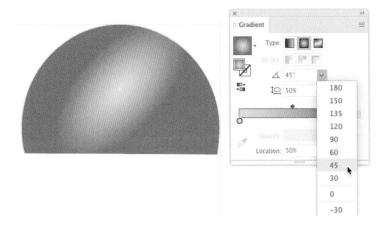

FIGURE 12-18:
Rotating a
radial gradient.

Transforming gradients with Gradient Annotator

Gradient Annotator lets you edit gradients directly on the canvas as they are applied to an object. To activate Gradient Annotator, select an object with a gradient applied to it, and click the Gradient tool.

Wielding Gradient Annotator is pretty intuitive. For linear gradients, Gradient Annotator essentially replicates the options in the Gradients panel for defining a gradient, except that you can apply those options and see the effect instantly. And when you display Gradient Annotator, you also see the Gradient panel, so you can bounce back and forth between changing settings interactively with Gradient Annotator and entering values in the Gradient panel.

Here's how to apply changes to a gradient with Annotator:

>> To change the color of a color stop, double-click the stop and change color settings, as shown in Figure 12-19.

>> To change the rotation angle of a gradient, hover your cursor over the end point of Annotator until the rotation icon appears, as shown in Figure 12-20, and then drag to rotate the gradient.

>> Editing the location and transparency of color stops with Annotator is similar to editing those options in the Transparency panel.

>> In addition to the features for interactively editing linear gradients, Annotator displays a dotted ring for radial gradients. You can rotate that ring to change the rotation of the radial gradient, as shown in Figure 12-21.

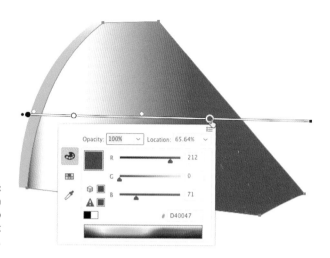

FIGURE 12-19:
Editing a
color stop
with Gradient
Annotator.

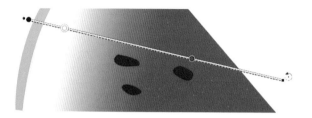

FIGURE 12-20:
Rotating a
linear gradient
interactively.

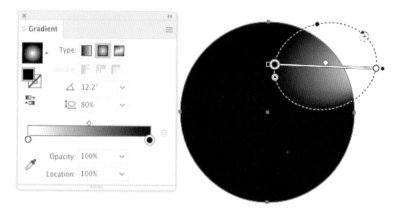

FIGURE 12-21:
Rotating a
radial gradient
interactively —
Gradient
Annotator and
the Gradient
panel are
displayed here.

Using freeform gradients

The linear and radial gradients explored so far in this chapter are defined by and
emanate from a single point. They can flow from one side of a graphic to another,
or from somewhere within an elliptical frame to another point within that ellipti-
cal frame.

For more complex gradients, Illustrator offers two options: the Gradient Mesh tool and freeform gradients. Both options allow you to define gradients using multiple points, not just one point. For a gradient mesh, those multiple sources are bunches of points. For freeform gradients, those sources are either a set of points or a line. I focus on the points option because it's more widely applicable.

WARNING

Before you commit to defining and using a freeform gradient, note that you can't apply a freeform gradient to a stroke, unlike linear and radial gradients. Freeform gradients apply only to object fills.

A freeform points gradient is defined by a set of color stops that function as independent points within the object to which the gradient is applied.

The following steps demonstrate how to create and apply a freeform line gradient:

1. **Apply the default freeform points gradient to an object:**

 a. *Click the Gradient tool and then click an object on the canvas.*

 b. *In the Gradient panel, click Freeform Gradient.* Illustrator's default gradient is applied to the selected object.

 c. *Select points from the set of three types of gradients in the Gradient panel, as shown in Figure 12-22.*

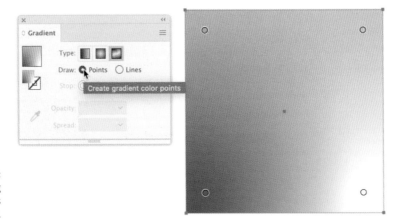

FIGURE 12-22:
Defining
a points
gradient.

2. **Recolor the freeform gradient stops.**

 Double-click a stop to open the color panel and change the color, as shown in Figure 12-23. To assign the same color to multiple stops, Shift-click multiple stops and open the Color panel (choose Window➪Color).

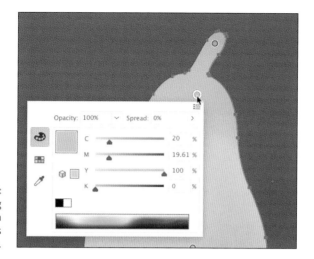

FIGURE 12-23:
Recoloring
stops in
a points
gradient.

3. **Add, move, or delete color stops:**

 • *Add a color stop:* Click anywhere on the selected object.

 • *Move a color stop:* Drag the color stop.

 • *Delete a color stop:* Drag it outside the object area and then click Delete in the Gradient panel or press the Delete key.

4. **Define the size of the gradient point spread for stops.**

 • Spread is the diameter around the color stop where the gradient is applied. The default spread is 0%, and the largest spread is 100%.

 • To define the value of the spread, use the Spread box in the Gradient panel, Control panel, or Properties panel. You can also define spread interactively by dragging on the edge of the slider, shown in Figure 12-24.

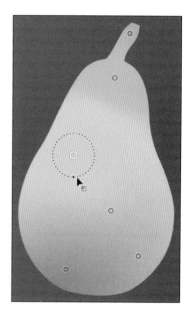

FIGURE 12-24:
Defining spread for color stops for a freeform points gradient.

Freeform gradients tend to be use-once-and-that's-it because they are so specific to the size and shape of the object to which they are applied. You can't save them as swatches. But you can copy them and apply them to other objects using the Eyedropper tool.

Blending for Beauty and Productivity

Illustrator blends are both a design tool and a productivity tool. Blending exploits the fact that because vector graphics are, deep down, just math, we can apply complex math to figure out how transitional objects between two selected objects should look.

Blends can be used to save the work of seemingly endless copying, pasting, and tweaking sets of objects, such as the set of stairs in Figure 12-25.

Or blends can be a design tool when used to create a rough, gradient-like look, as shown in the panda in Figure 12-26.

Blends can be smooth or steps. Smooth blends are file-size and processor heavy. The results of a step blend overlap considerably with the effects available (generally more efficiently) from gradients.

Step blends (as illustrated in Figures 12-25 and 12-26) can save time in generating multiple objects along a path and can be used for interesting effects. For those reasons, I focus on step blends.

FIGURE 12-25:
A step blend applied to generate . . . steps.

FIGURE 12-26:
A step blend applied to generate concentric shapes.

Setting blend options

Before you apply a blend, use the Blend Options dialog box to define the kind of blend you want to apply and how you want to apply it. To access the Blend Options dialog, double-clicking the Blend tool in the Basic toolbar or choose Object ➪ Blend ➪ Blend Options.

The following list explains the defining options for step blends:

>> **Spacing:** Use this drop-down to choose between a smooth blend, or one of two ways to define a step blend: Specified Steps or Specified Distance. As you guessed, Specified Steps lets you define how many steps to generate (not just literally steps as in Figure 12-26, of course, but iterations of the blended objects to be generated). Specified Distance defines how much space to create between generated steps.

>> **Orientation:** The two Orientation options for step blends are Align to Page and Align to Path. With the Align to Page option, objects that start vertical, for example, stay vertical throughout the blend. With the Align to Path option, intermediate objects in a blend will rotate in conformity with the path along which they are generated.

You can redefine these options for an existing blend by selecting the blend and choosing Object ➪ Blend Options.

Working with blends

To apply a blend after you've defined blend options, select two (only two) objects and choose Object ➪ Blend ➪ Make.

To remove a selected blend, choose Object ➪ Blend ➪ Release.

After you generate a blend between two or more paths, you can modify the blend interactively on the artboard. Simply use the Direct Selection tool to move one of the objects used to create the blend, as shown in Figure 12-27.

You can also change the curve of a blend by editing the anchors that define the path, as shown in Figure 12-28.

Sometimes, after letting Illustrator's Blend tool do the work of generating a bunch of objects, you'll want to change the result into discrete, editable objects. You do that by expanding the blend: Select the blend and choose Objects ➪ Blend ➪ Expand. The result is a set of grouped objects that you can edit. After you expand a blend, it loses its blend properties. You can no longer adjust the blend options or edit the path on which the blend is applied.

FIGURE 12-27:
Changing the
length of a
blend path.

FIGURE 12-28:
Bending a
blend.

Applying Transparency

Transparency is a hot topic these days. Political candidates are supposed to be transparent about where their funding comes from. Websites are supposed to be transparent about where their content comes from. Consultants are supposed to disclose where they have invested in a product they recommend. If you're looking for advice on the ethical and legal implications of all this, I have to be completely transparent: You bought the wrong book.

But if you're looking to apply semi-opacity to objects in Illustrator, you have the right book and you're reading the right section.

Transparency is applied in degrees, ranging from 1 percent (almost completely opaque) to 99 percent (almost completely invisible). An object with 0 percent opacity is completely transparent, and an object with 100 percent opacity has no transparency.

Defining and applying transparency

You can define some transparency features from the Control and Properties panels, but to get to one-stop-shopping for all transparency features, choose Window➪Transparency. The Transparency panel that opens can define opacity and transparency for any selected object or objects.

Managing opacity applied to overlapping objects

Note that I wrote "object or objects." You can apply transparency to multiple selected objects. When semitransparent objects overlap, their opacity reflects the sum of the opacity of each object. For example, in Figure 12-29, the two red objects alone are 50 percent opaque but are 75 percent opaque where they overlap.

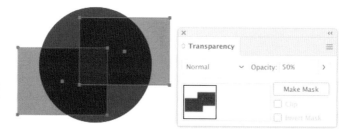

FIGURE 12-29:
Applying transparency to overlapping objects.

Applying transparency to strokes or fills

When you apply transparency from the Transparency panel, the level of opacity you choose is applied to all selected objects. And it is applied to both the stroke and the fill of an object.

To apply transparency settings to only the stroke or fill of an object, select the object to which you want to apply transparency and open the Appearance panel. Then click Stroke or Fill in the panel, and adjust the transparency for each. Figure 12-30 shows 25% transparency assigned to a red fill, and no transparency assigned to the black stroke.

Using transparency blending modes

In addition to normal transparency, Illustrator's Transparency panel provides blending modes that transform colors in the underlying layer. These blending modes work something like sunglasses or a colored piece of glass — tinting, distorting, or enhancing the effect of a transparent overlay.

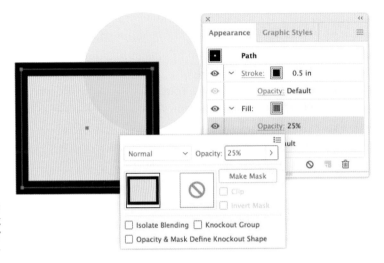

FIGURE 12-30:
Applying
transparency
to just a fill.

The following blending effects are available in the Transparency panel from the blending mode drop-down list (which is displaying Normal in Figure 12-30). You can experiment with them, but here are short explanations of what to expect from each:

» **Normal** provides just transparency, no distortion of color.

» **Multiply** darkens the resulting color.

» **Screen** lightens the resulting color.

» **Overlay** sharpens the contrast of a color (or pattern) filter by intensifying the contrast.

» **Soft Light** lightens the underlying object if the filtering object color is lighter than 50 percent gray. Otherwise, the underlying object is made darker.

» **Hard Light** simulates shining a bright light on the underlying object.

» **Color Dodge** brightens the underlying object.

» **Color Burn** darkens the underlying object.

» **Darken** changes any underlying colors that are lighter than the overlay color to the overlay color.

» **Lighten** lightens underlying colors that are darker than the overlay.

» **Difference** calculates a new color based on the difference between the brightness values of the overlapping colors.

- » **Exclusion** changes color using the same kind of calculation as the Difference effect, but the contrast between the original color and the changed color is muted and less dramatic than the Difference effect.

- » **Hue** retains the color of the top filtering object(s) while assuming the saturation (intensity) and brightness of the bottom object(s).

- » **Saturation** retains the saturation (intensity) of the top filtering object(s) while assuming the brightness and color of the bottom object(s).

- » **Color** retains the hue and saturation of the top filtering object(s) while assuming the brightness of the bottom object(s).

- » **Luminosity** retains the brightness quantity (intensity) of the top filtering object(s) while assuming the saturation (intensity) of the bottom object(s).

In Figure 12-31, I picked four blending modes to compare to normal transparency.

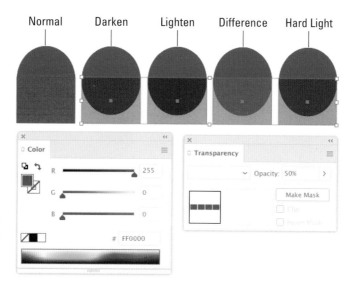

FIGURE 12-31:
Experimenting with transparency modes with 50% opacity.

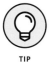

TIP

Many blending modes are defined by calculations based on hue, saturation, or brightness values. As you experiment with different blending modes, you'll develop your ability to anticipate the effect they will have when used as filters.

If your output is destined for hardcopy that will use spot color printing, avoid the Difference, Exclusion, Hue, Saturation, Color, and Luminosity blending modes. They're not supported by spot colors. For more on spot color printing, see Chapter 11 and the discussion of working with print shops in Chapter 2.

Clipping with opacity masks

An opacity mask reveals part of an underlying object through an opacity lens. Let me break that down: Opacity masks combine transparency, explained in the earlier part of this section, and masking.

In this section, you see how opacity masks work, which gives me a chance to describe how transparency and gradients can combine to create some cool results.

The following steps walk through an example of applying a gradient fill as an opacity mask:

1. **Create or open any kind of illustration, simple or complex, or use one you have handy.**

2. **Group all the objects in the illustration.**

3. **Create a circle on top of the illustration, and fill it with a black-to-white gradient fill.**

 a. Use the default gradient fill.

 b. Move the masking object (the circle with the gradient fill) above the illustration, as shown in Figure 12-32.

4. **Use the circle as an opacity mask.**

 Select both the mask object (the circle) and the underlying illustration and choose Make Opacity Mask from the Transparency panel menu, as shown in Figure 12-33, or use the Make Mask button in the panel.

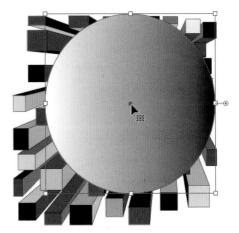

FIGURE 12-32:
Preparing a gradient-filled shape and an illustration for an opacity mask.

- When you apply an opacity mask, the Clip check box in the Transparency palette is selected by default. Leave it selected.

- If you select the Invert Mask check box, you reverse the effect that dark and light colors have on the underlying image.

- If you reduce the opacity of the masking object, the resulting mask is more transparent.

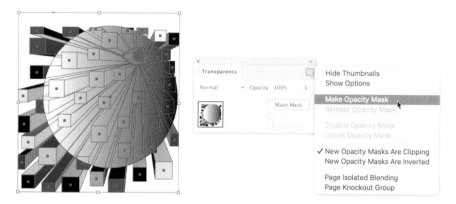

FIGURE 12-33:
Applying an
opacity mask.

5. **View and tweak the results.**

a. *Click outside the masked set to reveal the results of the opacity mask.*

b. *To unlink the opacity mask from the underlying image, click the Link button in the Transparency palette — it's visible when an opacity mask is selected.*

c. *With the opacity mask unlinked from the underlying image, you can move either the underlying (masked) image or the opacity mask to change the area that is revealed through the mask, as shown in Figure 12-34.*

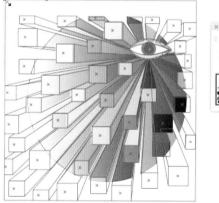
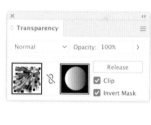

FIGURE 12-34:
Adjusting the
area of an
opacity mask.

WARNING

If you are designing a commercial print project and using Transparency, consult with your printer on what kind of settings they require to reproduce your project as designed.

The opacity mask uses the intensity of the grayscale value of the masking object (not the actual colors) to apply a gradient-like filter over the underlying object, combining transparency and gradients to produce some interesting possibilities in your design journey, such as my result in Figure 12-35.

FIGURE 12-35:
The result of an opacity mask.

IN THIS CHAPTER

» Applying pattern swatches to paths and shapes

» Applying patterns to strokes and text

» Creating your own patterns

» Scaling and position patterns within graphics

» Layering multiple patterns

Chapter **13**

Designing with Patterns

Pattern fills are discrete artwork than can be applied to fills and strokes in an almost unimaginable range of ways, including but far from limited to

» Fabric and fashion design

» Typographic effects

» Stroke patterns for dynamic effect

» A design treatment for graphics

I use these examples in the chapter to introduce you to how to apply patterns from Illustrator's impressive presets. I also show you how to create and apply your own custom patterns.

Patterns, explored in this chapter, have a cousin in Illustrator: pattern *brushes,* which also can be deployed to design and apply repeating artwork, as I explain in Chapter 11. When do you use which? The short story is, if you want to design a pattern that repeats along a stroke, including on the borders of a shape (such as a rectangular shape that serves as a picture frame), I usually advise starting with a pattern brush. But if you want to fill a shape, use a pattern swatch.

Applying Patterns

Illustrator's multiple sets of patterns are a valuable design resource. If you find one that works for your illustration, there's no sense reinventing the wheel. Exploring available preset patterns is also an excellent way to begin to acclimate yourself to deploying any pattern — preset or homemade.

Pattern swatches are stashed in, accessed from, and organized within the Swatches panel, which they share with color swatches. And like color swatches, pattern swatches can be applied to not just the fill but also the stroke of an object. If you're not comfortable using and organizing content in the Swatches panel, I suggest popping over to the section in Chapter 11 on managing color swatches.

To access Pattern libraries, choose Window ⟹ Swatch Libraries ⟹ Patterns. A submenu displays three groupings of pattern swatch libraries: Basic Graphics, Decorative, and Nature, as shown in Figure 13-1, and each of those submenus reveals additional sets of patterns.

FIGURE 13-1:
Illustrator's pattern swatches libraries.

Applying a pattern to a fill

Let's begin an exploration of applying patterns to the most common way patterns are used: fills. Most common? Wait! (I hear you thinking), aren't patterns always applied to fills? No, patterns can be applied also to strokes.

Pattern swatches can be applied to closed paths (the first anchor is also the last), or open paths (the first and last anchors differ). And pattern swatches can be applied to Live Paint faces or edges. (See Chapter 11 for an explanation of how to use Live Paint to intuitively add color to objects formed by intersecting paths.)

Use the following steps to apply a preset pattern to a shape or a path (open or closed).

1. **Draw or select a path or a shape.**

 Any path or shape is fine, but if you're using these steps as a learning example, choose a simple shape so you can focus on exploring how patterns work.

2. **Make sure the fill icon is active in the Tools panel.**

 Remember, you can apply pattern swatches to fills or strokes, so be sure the fill icon is selected.

3. **Open a swatch pattern library.**

 Choose Window ⇨ Swatch Libraries ⇨ Patterns and then select a submenu and a library within that submenu. In Figure 13-2, I'm opening the Basic Graphics_ Textures library.

FIGURE 13-2:
Opening a
swatch pattern
library.

4. **Click a pattern in the swatch library to apply it to the selected object, as illustrated in Figure 13-3.**

 To aid in quickly browsing through multiple pattern swatch libraries, use the left and right triangles just to the right of the Swatches Library menu icon, at the bottom of the Swatches panel.

 Pattern swatches (and all swatches) that you apply to objects in your document are added to the Swatches panel. All patterns added to the Swatches panel will be saved with the document. In Figure 13-4, you can see several patterns that have been applied in the document listed in the Swatches panel.

FIGURE 13-3:
Applying
pattern
swatches to
a selected
object.

FIGURE 13-4:
Several applied
patterns.

Applying patterns to strokes

Applying a pattern fill to a stroke is a quick, easy, and underrated way to apply patterns to create cool outlines for objects such as picture frames, map borders, and even freehand drawings.

Why *underrated?* Because the standard workflow for creating and applying a design for something like a picture frame is to create and use a pattern brush (as described in Chapter 9). Defining a pattern brush, when you need one, is not a waste of time, mind you! Pattern brushes should be created and deployed when you need complex stroke patterns that include separate artwork for corners and paths.

But if all you need is a single pattern applied to a stroke, you can do that easily and effectively with a pattern swatch.

The process of applying a pattern to a stroke is similar to applying a pattern to a fill. The big difference is that you need to make sure Stroke is active in the Tools panel before you try to apply the pattern to a stroke, as shown in Figure 13-5.

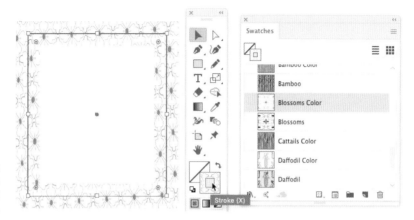

FIGURE 13-5:
A pattern swatch applied to a stroke.

Applying patterns to text

Another underrated technique, in my opinion, is applying patterns to text. I see many of my students labor to create artistic text with tools such as the Pen, the Pencil, or the Blob Brush when they could streamline their workflow by at least roughing out their artistic text with pattern fills.

Normally you apply a pattern to the fill of a selected text, not the stroke. In fact, you might find it helpful to apply a solid color to a text stroke to set off text to which a pattern fill has been applied so that the text is a bit more readable, as shown in Figure 13-6.

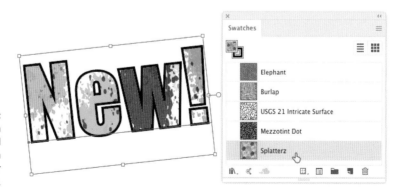

FIGURE 13-6:
A pattern swatch applied to text, with a solid color stroke.

Creating Your Own Patterns

It's easy to make your own pattern fills. And, after you do that, Illustrator offers a massive set of options for configuring how that fill is displayed. This massive set of options is used mainly by fabric designers and other creatives who need micro-control over how a pattern is displayed on a mockup of an article of clothing.

In this section, I introduce you to the technique for defining pattern options, but I focus on more widely applicable techniques for defining the relationship between a fill pattern and an object using the Scale tool.

Let's start with the easy part: The following steps are used to create a pattern from artwork.

1. **Select the artwork you want to use as a pattern.**

 You can use shapes, symbols, or embedded raster images (such as artwork you created in Photoshop).

 What you can't do is create a pattern from an object to which a pattern has been applied. If you want to use an object to which a pattern fill has been applied, first expand the object (choose Object ⇨ Expand).

2. **Drag the artwork into the Swatches panel (as shown in Figure 13-7) and name it.**

 After you drag artwork into the Swatches panel, the default pattern name is New Pattern Swatch (followed by a number). Select Swatch Options from the panel menu to enter a new name.

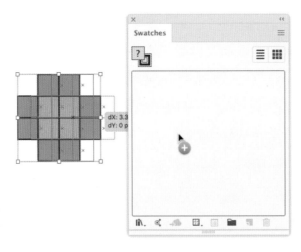

FIGURE 13-7:
Adding a custom pattern to the Swatches panel.

3. **Test your pattern swatch on a stroke or fill.**

 With your new pattern swatch selected in the Swatches panel and the Fill box selected in the Tools panel, draw a path or shape and observe how the pattern is applied, as shown in Figure 13-8.

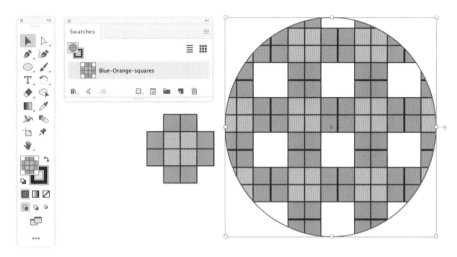

FIGURE 13-8:
Testing a custom pattern swatch.

After you use artwork to define a pattern swatch, the original artwork will not turn into a path filled by the pattern swatch. It remains a graphic object that does not have any pattern fill applied.

Transforming Patterns

When you apply patterns to objects, you can use the Scale tool to scale the pattern, with or without scaling the object. And you can scale an object with or without scaling the pattern. The same is true for applying rotation to a pattern.

Confusing? Let me illustrate and it will make sense. But before we dive in, a cautionary note: When you rescale or rotate a pattern interactively using any of the techniques in this section, the changes you make to the pattern design stick to the next object you create.

Scaling a pattern and object together

Let's start with the easiest, most intuitive, and most widely applied way to scale an object with a pattern fill. Follow these steps to scale a pattern and an object to which the pattern is applied together:

1. **Select the object to be rescaled.**

2. **Keep the object you are rescaling selected, and open the Scale dialog.**

 Double-click the Scale tool in Tools panel. The Scale tool is part of the Rotate tool flyout in the Tools panel. You can also activate it by pressing S.

3. **In the Scale dialog, enter the scale percentage you want to apply.**

 a. *Select the Preview check box so you can interactively see the effect of scaling changes.*

 b. *If you want to maintain the height-to-width aspect ratio in your object, leave the Uniform option selected and enter a single percent value in the Scale box.*

 c. *If you want to distort the height-to-width aspect ratio in your object, choose the Non-Uniform option and enter separate percent values for Horizontal and Vertical scaling.*

 d. *Leave both Transform Objects and Transform Patterns selected.*

 The Scale Corners and Scale Strokes and Effects check boxes are not specifically applicable to scaling patterns, with one exception. If you've applied a pattern fill to a stroke, you can apply the scaling you've defined for that fill by selecting the Scale Strokes and Effects check box.

4. **When the preview matches your desired result, click OK to apply the rescaling, as shown in Figure 13-9.**

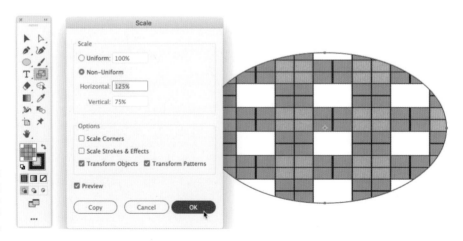

FIGURE 13-9: Rescaling a pattern and object together.

Scaling patterns and objects separately

What if you don't want to change the size of an object, but you do want to adjust how the pattern fills the object?

The process is the same as the one I just mapped out for rescaling patterns and objects together, except if you want to scale only the object (and leave the pattern the same size), deselect the Transform Patterns check box when you apply new scaling, as shown in Figure 13-10.

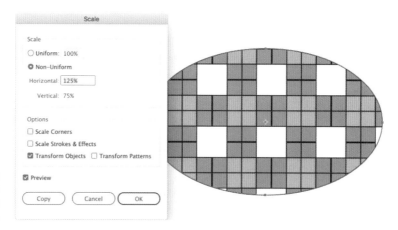

FIGURE 13-10:
Rescaling an object but not the pattern.

If you want to just rescale a pattern fill within an object (and leave the object the same size), deselect the Transform Objects check box and select the Transform Patterns check box when you apply new scaling, as shown in Figure 13-11.

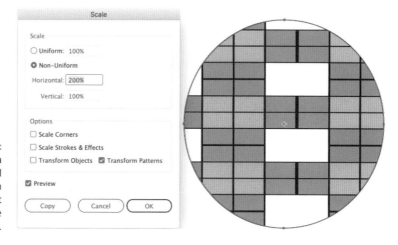

FIGURE 13-11:
Rescaling a pattern fill within an object without changing the object.

Rotating and moving patterns

You can achieve some interesting effects by rotating a pattern within the object to which the pattern has been applied. Follow these steps to rotate a pattern within an object:

1. **Select the object with the pattern fill.**

2. **Keep the object with the pattern fill selected, and open the Rotate dialog.**

 Double-click the Rotate tool in the toolbox to open the Rotate dialog box. Select the Rotate tool from the Tools panel, or just press R to make the tool active.

3. **Enter a rotation angle for the pattern.**

 a. *Select the Preview check box if it is not selected so you can interactively see the effect of rotating the pattern.*

 b. *Leave Transform Patterns selected.* The Rotate dialog can be used to rotate any object. If that were the objective here, you could select the Transform Objects check box.

 c. *Experiment with different rotation angles until you achieve the effect you want.*

4. **When you have defined a rotation angle for the pattern, click OK, as shown in Figure 13-12.**

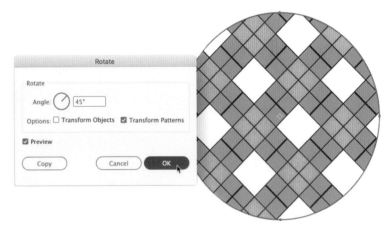

FIGURE 13-12:
Rotating a pattern within an object.

Moving a pattern within a shape

You also can move a pattern within a selected object. Use this technique to fine-tune how a pattern fits into a shape. The process feels a bit unintuitive, but I walk through exactly how to do this. Note that this process can be used not just to move a pattern within a shape but also to scale or rotate the pattern.

To move a pattern within a shape, follow these steps:

1. **Select the object with the pattern fill.**

2. **Move the pattern fill using the Selection tool with the grave accent key.**

 The grave accent key is usually paired with the tilde key on your keyboard.

 With the grave accent key depressed, click and drag the pattern with the Selection tool. An outline of the new position of the fill is displayed as you drag, as shown in Figure 13-13.

3. **When you properly locate the pattern within the object, just release the grave accent key.**

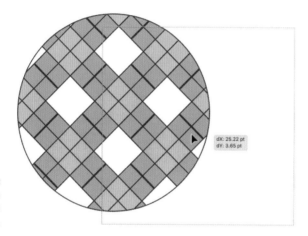

FIGURE 13-13:
Moving a
pattern within
an object.

Stacking patterns

You can create complex fills by stacking two or more patterns. You can stack patterns over patterns, or you can create a pattern fill and stack it on top of a solid color (or gradient) fill. To stack patterns, you need to first have at least two pattern swatches ready to use. The most efficient way to do that is to have them in the Swatches panel before you start stacking pattern fills.

With your pattern swatches ready to use, you layer swatch patterns in the Appearance panel with the following steps:

1. **With the pattern swatches you want in the Swatches panel, select a path to which the fills will be applied.**

2. **With the path to which the first pattern swatch will be applied selected, add the swatch to the Appearance panel:**

 a. *Choose Window ⇨ Appearance to display the Appearance panel.*

 b. *Select the Fill row in the Appearance panel.*

 c. *Click the first pattern fill for this path in the Swatches panel, as shown in Figure 13-14.*

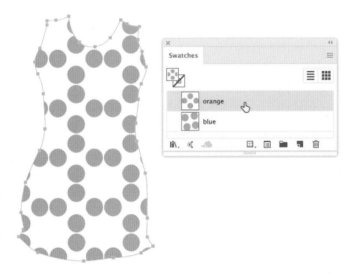

FIGURE 13-14:
Beginning to
stack pattern
fills in the
Appearance
panel.

3. **Add a second pattern.**

 a. *On the Appearance panel menu, choose Add New Fill.*

 b. *Select the new second row in the Appearance panel and click the second pattern swatch in the Swatches panel, as shown in Figure 13-15.*

4. **Restack the patterns.**

 Click and drag in the Appearance panel to change the stacking order of the fills, as shown in Figure 13-16.

Now that you know how to stack and reorder pattern fills in the Appearance panel, you can mix up complex and dynamic fills.

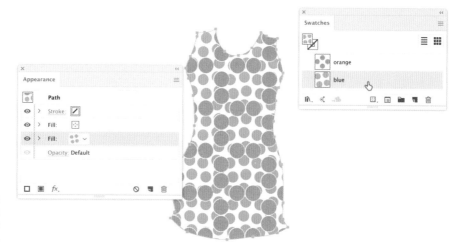

FIGURE 13-15:
Adding a
second pattern
to an object.

FIGURE 13-16:
Restacking
patterns.

Defining Pattern Options

You can use the techniques covered so far in this chapter to create and manipulate patterns with a significant amount of control and detail. In addition to what I focus on here, you can create patterns from scratch also by entering pattern mode (choose Object ⇨ Pattern Make), with or without artwork selected.

But before wrapping up this exploration of designing with patterns, I want to briefly introduce you to an almost unlimited array of even more detailed options for defining how patterns are displayed. These options are available in pattern edit mode.

To fine-tune pattern options for a specific pattern, just double-click the pattern in the Swatches panel to open pattern edit mode. Here you can both adjust and preview how patterns will be displayed, as shown in Figure 13-17.

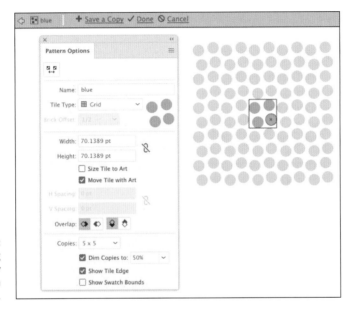

FIGURE 13-17:
Defining
pattern display
in pattern
edit mode.

Some of the options in pattern edit mode are intuitive, such as Name. Others, not so much. Here are some key options:

>> **Tile Type:** Defines how the pattern will repeat:

- *Grid* tiling results in the center of each tile being horizontally and vertically aligned to the center of the adjacent tiles.

- *Brick by Row* tiles are rectangular in shape and arranged in rows. Centers of tiles in rows are horizontally aligned. Centers of tiles in alternate columns are vertically aligned.

- *Brick by Column* tiles are rectangular in shape and arranged in columns. Centers of tiles in columns are vertically aligned. Centers of tiles in alternate columns are horizontally aligned.

- *Hex by Column* tiles are hexagonal in shape and arranged in columns. Centers of tiles in the columns are vertically aligned. Centers of tiles in alternate columns are horizontally aligned.

- *Hex by Row* tiles are hexagonal in shape and arranged in rows. Centers of tiles in the rows are horizontally aligned. Centers of tiles in alternate rows are vertically aligned.

>> **Brick Offset:** Applies to only Brick options:

- *Brick by Row* defines by how much tile width the centers of tiles in adjacent rows are out of vertical alignment.

- *Brick by Column* defines by how much tile height the centers of tiles in adjacent columns are out of horizontal alignment.

>> **Size Tile to Art:** When deselected, allows you to define the overall height and width of the tile. Select values that are larger or smaller than the height and width of the artwork. Values larger than the size of the artwork cause the tile to grow larger than the artwork and insert empty space between tiles. Values smaller than the size of the artwork cause artwork in adjacent tiles to overlap.

When this option is selected, shrinks the size of the tile to the size of the artwork being used to create the pattern.

>> **Move Tile with Art:** Ensures that moving the artwork causes the tile to move as well.

>> **Overlap:** Defines how tiles will stack front-to-back when they overlap.

>> **Copies:** Defines how many copies of the tile are displayed when the repeating pattern is previewed in Edit Pattern mode. The following additional options are available:

- *Dim Copies* sets the percentage of opacity for the display of the copies. (At 10 percent, copies of the pattern are almost completely transparent; at 90 percent, copies are almost completely opaque.)

- *Show Tile Edge* displays a box around the actual tile (not the preview copies).

- *Show Swatch Bounds* displays a unit portion of the pattern that is repeated to create the pattern.

>> **Exit Pattern Edit mode and save your changes.**

If you just want to apply the changes to the pattern, choose Done. If you want to keep your original, choose Save a Copy in the breadcrumb menu at the top of pattern edit mode and assign a new name.

Clearly, you have many options in pattern edit mode for defining how patterns will fill paths. The nicest thing about working in pattern options mode is that it provides an interactive preview of how your pattern will look in different scenarios. Instead of trying to memorize what each option does, you can experiment and see the results in real time before you accept changes to the pattern definition.

TIP

My last word of advice in defining pattern options is to avail yourself of the Save a Copy option in pattern options mode so you can always revert to your original pattern if you decide the edits you've made aren't working out the way you want.

IN THIS CHAPTER

» **Understanding raster and vector effects**

» **Defining and applying effects**

» **Managing effects with the Appearance panel**

» **Applying 3D effects**

» **Saving graphic styles**

Chapter **14**

Styling with Effects

The Effect menu in Illustrator opens the door to an incongruous plethora of wild, crazy, and only vaguely related techniques. These features can be roughly divided into effects (intuitive enough) and filters. In this chapter, I break down what effects are, what filters are, how they're different, and when you use which.

I also show you how to apply some of the most useful and widely applicable effects, such as drop shadows, 3D extrusions (converting a rectangle into a cube), and fun distortions (such as puckering paths). And I walk you through a substantial project that involves combining a rotated path with mapped artwork.

Navigating the Universe of Effects

Some effects are specific and not what you would normally think of as an effect, such as crop marks for printers, and the convert to shape feature, which turns any selected object into a rectangle or an ellipse.

Many effects duplicate features you can apply in other ways, such as Pathfinder effects, which more or less duplicate Pathfinder tools. In Chapter 4, I explain how to use Pathfinder tools and their relationship to Pathfinder effects.

In this section, I guide you through the different sets of effects and deconstruct how they work.

Getting your money's worth from effects

In this section, I will try to order the chaos of the Effect menu. In general, effects have two things in common:

>> They do *not* change the paths in a selected object.

>> They do a bunch of things at once that you could accomplish without using an effect, but the process would take a lot longer.

For example, in Figure 14-1, I applied a single effect to generate the 3D bar from the square next to it.

Note the green bounding box that appears with the selection. That actually *is* the object. The extrusion is simply an effect *applied to the appearance of the square.* It's as if I put on a Bat-man suit to make myself *look* like a body builder with six-pack abs. It would just be me under that suit, but I'd *appear* to look like Batman.

To emphasize the point, in Figure 14-2, I copied the extruded square and am editing the *actual path* (by using the double-sided arrow to pull on a side of the square). The effect is adjusting accordingly.

FIGURE 14-1:
An extruded square.

FIGURE 14-2:
Editing the
path of an
object to which
an effect has
been applied.

Now we get to the second characteristic of effects: They are productivity tools. Imagine creating all the extruded rectangles in the illustration in Figure 14-3 by hand versus generating extrusions and then tweaking and combining both the extruded object and the effect.

Again, all the paths and fills in Figure 14-3 *could* have been created with the Pen tool (which I cover in Chapter 7) and basic stroke and fill styling. But that would be much more tedious and time consuming than applying an effect.

FIGURE 14-3:
Generating all these extrusions saves time.

After you get your head around these two aspects of effects, you'll be able to make sense of the mix of options on the Effect menu and get your money's worth out of what effects have to offer.

Using Photoshop effects with care

The Effect menu includes a large subsection of Photoshop effects. Photoshop is Illustrator's raster-editing cousin (that is, primarily bitmap and non-vector). In fact, raster editing is almost synonymous with Photoshop, as in "that fast-food hamburger must have been Photoshopped to make it look that good."

As a general rule, raster editing — and raster effects — are best left to Photoshop. When you apply Photoshop (*raster*) effects to objects, you essentially rasterize them. The applied Photoshop effects will not have all the magic of vectors. They won't be infinitely scalable. They will bulk up file size. They won't be as easily integrated into digital projects such as infographics, interactive graphics, animation, or zoomable artwork.

Am I saying avoid Photoshop effects when working in Illustrator? Kind of, but not totally. You will inevitably be involved in hybrid illustration projects that necessarily combine raster artwork (such as photos) and vector graphics. And there are scenarios, particularly if you are preparing artwork for fixed-size print reproduction (such as a poster or a magazine ad), where you can safely and sanely apply raster effects to Illustrator artwork because the project is *not* going to be rescaled. Where that is the case, you can choose Effect ⇨ Document Raster Effects Settings and define a resolution compatible with your print projects. For more on defining resolution for raster print output, see Chapter 2.

As a general rule, you should use Photoshop effects in Illustrator only when you are preparing a project for a fixed-size print output.

Appreciating SVG filters

Scalable Vector Graphics (SVG) is a powerful format for sharing Illustrator-built vector graphics in digital output. It provides an alternative set of results to those available in the Effects set of options on the Effect menu, but it can be exported in ways that mesh powerfully with digital interactive and animated design.

SVG filters are accessible from the Effect menu. I'm not devoting space in this chapter to SVG filters, but that's *not* because they are not important. Just the opposite. Because SVG output and SVG filters are such a critical path on which Illustrator and vector design in general are evolving, an entire chapter, Chapter 18, is devoted to them.

Choosing and Applying Effects

Having sifted through the three kinds of options on the Effect menu (effects, Photoshop effects, and SVG filters), let's quickly survey all the effects options on the Effect menu. Then I'll zoom in on a few widely applicable effects and, in the process, demonstrate widely applicable techniques for employing any effect.

The following list provides a quick guide to what's what on the Effect menu:

>> **3D** accesses the most powerful tools on the Effect menu to apply a range of 3D effects. I focus on these effects shortly.

>> **Convert to Shape** converts any object to a rectangle or an ellipse.

>> **Crop Marks** applies crop marks around selected objects for handing off to printers.

>> **Distort and Transform** accesses a set of quick transforms you can apply to paths, such as pucker (shown in Figure 14-4) and bloat.

>> **Pathfinder** effects basically mirror the features available in the Pathfinder panel, except they apply transformations as effects rather than changes to the anchors and paths in an object. I walk through Pathfinder tools, when to use them, and how they relate to Pathfinder effects in Chapter 4.

>> **Rasterize** converts selected objects to rasters but retains the original path that you can use if your printer requires raster (not vector) graphics.

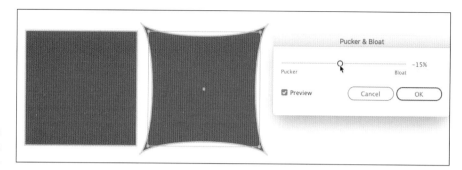

FIGURE 14-4:
Generating a
pucker effect.

>> **Stylize** applies drop shadows and other frequently needed transformations in outlines around paths.

>> **SVG Filters** are effects that are specific to SVG files. They preserve vector properties in screen display. I walk through SVG filters, their role, and how to use them in Chapter 18.

>> **Warp** effects apply arcs (shown in Figure 14-5), arches, bulges, waving flags, and other distortions of shapes.

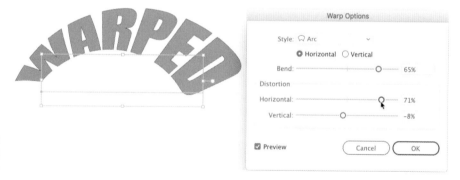

FIGURE 14-5:
Experimenting
with warps.

I've identified a few keys to working with effects so far. But if you'll hang with me a moment, I want to reinforce them because they are key to not getting lost, overwhelmed, or eating too much chocolate while experimenting with effects:

>> There's nothing you can do with an effect that you can't do "by hand," using tools such as the Pen tool, fill and stroke properties, or drawing tools. But effects *save time.*

>> Effects do not change the underlying path of an object, which means you can edit the underlying path or get rid of the effect if you want.

» You will experience a lot of trial-and-error in generating effects. Rely on the Preview check box in the dialog that appears as you define an effect to see how it works.

» The appearance of an object to which an effect has been applied is a result of both how the effect is defined *and* how you edit the path of the original object.

» Okay, here's something I haven't clued you in on yet, but it's important: If you want to change an effect, *don't* do it through the Effect menu. Choosing to apply the effect again from the menu will stack another instance of the effect on a selected object, creating a mess. Instead, edit effects through the Appearance panel. I show you how to do that next.

» Effects can be applied to objects, groups, or layers.

Managing Effects

The more powerful effects are applied with dialogs that display a Preview check box. Use that check box to see how an effect will change the appearance of the object(s) to which it is being applied. I illustrate a couple of those dialogs in Figures 14-4 and 14-5 (for the Pucker & Bloat tool and Warp tool, respectively).

After you generate and apply an effect, you'll likely want to tweak it. I walk you through how effects can be added, deleted, restacked, and tweaked by using the Appearance panel.

And you might want to *expand* the effect. I emphasize that when you apply an effect, you don't change the underlying path of objects to which the effect has been applied. But sometimes you need to apply an effect to an object's path to expand your ability to tweak the graphic. I walk through how to expand an effect.

Finally, after you go through all the blood, sweat, and tears (that was a metaphor, I hope) of creating just the right combination of effects and settings, you might want to save that set of changes. You do this by saving a graphic style, and I show you how that process works as well.

Using the Appearance panel

You can edit effects through either the Properties panel or the Appearance panel. View the Properties panel by choosing Window ⇨ Properties, and view the Appearance panel by choosing Window ⇨ Appearance.

If you have a single effect applied to an object, the Properties panel can handle that, as shown in Figure 14-6.

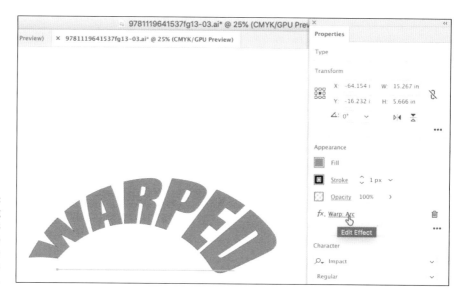

However, as soon as you stack a second effect on an object — and that's not a rare occurrence — you'll get no more help from the Properties panel than an info icon directing you to the Appearance panel, as shown in Figure 14-7.

That's why, despite the general utility of the Properties panel, I head straight for the Appearance panel when I need to edit an effect.

Examining and editing effects

The Appearance panel displays all the effects applied to the selected objects, as shown in Figure 14-8, allowing you to manage sets of effects. You can use the eye icon to toggle between displaying and hiding effects.

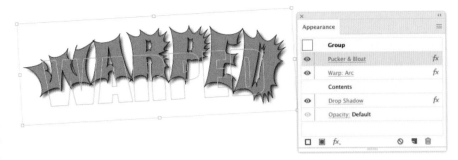

FIGURE 14-8:
Identifying
multiple
effects in the
Appearance
panel.

To edit a particular effect, click the effect, as shown in Figure 14-9. The options panel for that effect appears, and you can edit how the effect displays.

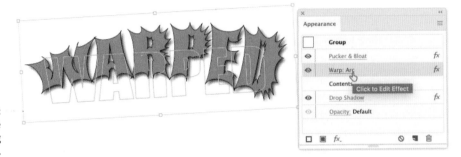

FIGURE 14-9:
Launching the
options dialog
for a warp.

Ordering effects

The Appearance panel displays effects for a selection more or less in the order in which you applied them to the artwork. Sometimes the stacking order of effects doesn't really matter, but sometimes it does. For example, in Figure 14-10, the drop shadow is higher in the list of effects than the pucker & bloat effect, so the drop shadow is applied to the stroke of the ellipse but not to the result of the pucker and bloat effect.

In Figure 14-11, I've dragged the drop shadow effect to move it on top of the pucker and bloat effect. Now the drop shadow is applied to the pucker and bloat effect instead of the original path.

Expanding effects

Often, after saving yourself a ton of valuable time by generating effects, you need to convert them into editable paths to complete your project. You can do that by selecting the object(s) and choosing Object ⇨ Expand Appearance on the main Illustrator menu, as shown in Figure 14-12.

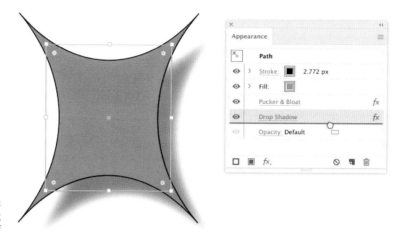

FIGURE 14-10:
Examining
the order of
effects.

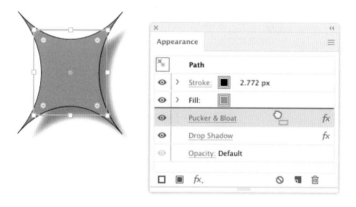

FIGURE 14-11:
Reordering
effects.

FIGURE 14-12:
Expanding the
appearance of
effects.

TIP

The main menu has an Expand option as well as the Expand Appearance option I'm selecting in Figure 14-12. The Expand option doesn't work for effects. In Figure 14-12, the Expand option appears dimmed because the selection includes effects.

When you expand objects to which effects have been applied, you end up with discrete paths that can be edited independently. In Figure 14-13, I've detached the shadow from the puckered rectangle, and I'm manipulating the puckered rectangle independent of the shadow.

Saving graphic styles

After you piece together a set of graphic styles, including effects, you can save the entire batch as a graphic style. That graphic style can then be applied to other objects.

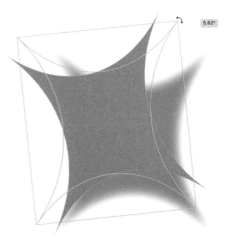

FIGURE 14-13:
Editing objects generated by expanding an effect.

You save the styles applied to any object by dragging the object to the Graphic Styles panel. Like all panels, the Graphic Styles panel is available from the Window menu. In Figure 14-14, I'm saving appearance styling that combines a pucker with a drop shadow, along with fill and stroke properties, as a graphic style. I do that by dragging the object to which this set of styles has been applied to the Graphic Styles panel.

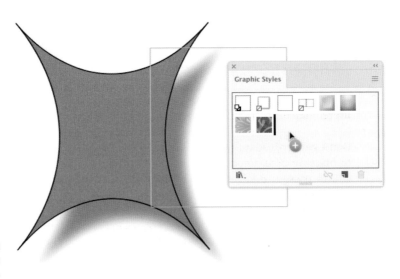

FIGURE 14-14:
Creating a graphic style.

In Figure 14-15, I'm applying that graphic style to a set of selected rectangles by clicking the graphic style in the Graphic Styles panel.

FIGURE 14-15:
Applying a
graphic style.

Generating 3D Effects and Mapping Artwork

The most powerful effects are 3D effects. You can use them to extrude shapes, as I describe earlier in the chapter. And there are much more 3D powerful effects for rotating paths and mapping symbols. Before closing this chapter, I walk through an example of how rotated paths and mapped symbols can open the door to complex designs that would take a prohibitive amount of time to create without effects.

Mapping artwork

In the following set of steps, you generate a globe from a path, and then map a literal map of the earth on that globe.

Don't get confused: I'm using the word *map* in two senses here. You find out how to place an actual map of the world on a sphere, and then rotate that sphere at will to present different sections of the planet. And I show you how to do that using a process Illustrator calls *mapping*. Applying a map to a 3D effect in Illustrator means taking an image or graphic saved as a symbol, and pasting it onto a 3D effect. If you can visualize drawing on a balloon, and then blowing up that balloon to different sizes and rotating it, you understand the concept.

The process is complicated but doesn't require special talent or skill. And after I show you how to do it, I think you'll appreciate how powerful mapping a map, or any other artwork, can be.

Using Adobe Stock images

The project I am about to walk you through uses Adobe Stock images, so this is a good opportunity for me explain how they work. Adobe Stock is a service that provides designers and businesses with access to a huge collection of royalty-free artwork, including vector graphics. Your company may have a subscription. Subscription plans priced for individual designers, small shops, and teams are also available.

In lllustrator (and other CC apps) you can drag a watermarked (preview) version of any stock image from the Libraries panel to your project. So if you don't have a subscription to Adobe Stock Images, keep your credit card in your pocket for now.

Because you will be using Adobe Stock images in the following steps to learn effects and mapping, just use a preview of the image without buying it. That preview image will have a watermark that indicates it is a sample, but that's okay. (When I am prototyping for a client, I use the preview image and wait until the client signs off on the design before purchasing the stock images.)

Exploring 3D effects and mapping

The following journey is more long and winding than most of the techniques you learn in this book, but I think you'll find it worthwhile as a substantial experience with some of Illustrator's most powerful features (effects, plus a few other techniques I throw in). And it's going to be fun!

With all those provisos, here's how to map a map of the globe onto a rotated sphere.

1. **Create and save a new file.**

 You can create this project in any size artboard and any set of document settings. Save the file as an AI file, using any filename you want (globe.ai will work just fine).

2. **Prepare a map of the world as mappable artwork by converting it to a symbol as follows:**

 a. *View the Libraries panel (choose Window ⇨ Libraries).*

 b. *In the Search box, enter* map of planet.

 c. *Use the drop-down at the top of the panel to search Adobe Stock, as shown in Figure 14-16, and note the options.*

FIGURE 14-16:
Searching Adobe Stock images.

d. Choose the world map vector abstract illustration pattern AI file and download it as a preview, as shown in Figure 14-17.

e. Drag the preview image from the Libraries panel to your workspace.

f. With the world map image selected, choose Embed Images from the Links panel, as shown in Figure 14-18.

g. Drag the embedded map of the world image from the workspace to the Symbols panel. If the panel is not visible, choose Windows ⇨ Symbols.

h. No need to worry about any of the symbol options, just name it map. The map will appear in the Symbols panel, as shown in Figure 14-19.

Only artwork placed in the Symbols panel can be mapped onto 3D effects. To learn more about how to define and use symbols, see Chapter 10.

TIP

FIGURE 14-17:
Downloading a preview version of a world map.

FIGURE 14-18:
Converting a linked image to an embedded image.

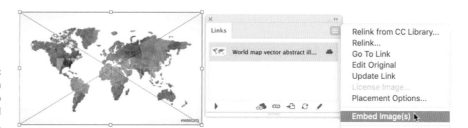

3. **Create a semi-circle with a white fill and no stroke as follows:**

a. *The easiest way is to click the Ellipse tool, hold down the Shift key, and click and drag to draw an ellipse that is constrained to a circle (constrained because you're holding down the Shift key).*

b. *Use the Toolbar or the Control panel, or the Properties panel (so many choices!) to remove any stroke from the ellipse and apply a white fill.*

FIGURE 14-19:
Viewing artwork in the Symbols panel.

c. Use the *Direct Selection* tool to select the left anchor in the ellipse, as shown in Figure 14-20, and delete that anchor by clicking the Delete key on your keyboard.

I walk through how to edit shapes, including converting a circle into a semicircle, in Chapter 4.

4. **Rotate the semicircle by using the Revolve effect:**

a. Select the semicircle and choose *Effect ⇨ 3D Revolve.*

b. Set all three Rotation angles to zero.

c. Choose the *Plastic Shading* surface and enable *Preview.* The settings and generated globe should look like Figure 14-21.

FIGURE 14-20: Creating a semicircle.

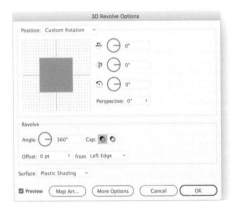

FIGURE 14-21: Generating a globe.

5. **Map the artwork of the world map:**

a. Click the *Map Art* button to enable mapping.

b. In the *Map Art* dialog, choose from the *Symbol* drop-down the map symbol you created.

c. Click the *Scale to Fit* button to size the symbol to match the globe. The settings and mapped map should look like Figure 14-22.

d. Click *OK* to apply the symbol, and click *OK* again to apply the effect.

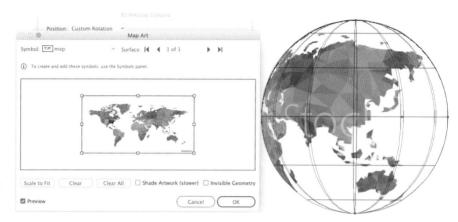

FIGURE 14-22:
Mapping a
symbol.

6. **Use the Appearance panel to edit the rotation of the 3D effect to display different sections of our planet:**

 a. *With the generated globe and map selected, click the 3D Revolve (Mapped) effect, as shown in Figure 14-23.*

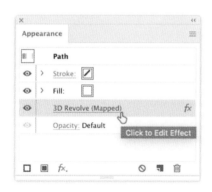

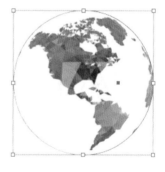

FIGURE 14-23:
Accessing a 3D
effect in the
Appearance
panel.

 b. *Select the Preview check box in the 3D Revolve Options dialog to see the effect of edits you are about to make to the revolve effect.*

 c. *Experiment with different positions from the Position drop-down, as shown in Figure 14-24.*

 d. *When you find a rotation angle you want to apply, click OK.*

The resulting globe can be easily copied and pasted, and different pasted copies can have their rotation angles edited to produce a set of globes like the one in Figure 14-25.

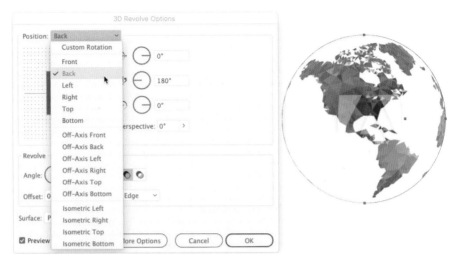

FIGURE 14-24:
Changing the
position of a
3D Revolve.

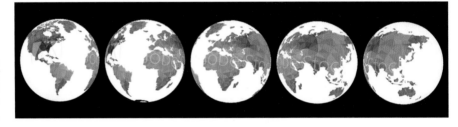

FIGURE 14-25:
Using a set of
globes created
with the 3D
Revolve effect.

As promised (warned), you just completed a substantial set of steps to experiment with the 3D Revolve effect combined with mapping. Take a deep breath and reflect on the work that would have been required to create an illustration like this *without* 3D effects!

To end the chapter, I return to the two defining things about effects:

>> Effects apply to vectors but don't change the fundamental paths of the vector. In the case of the globe experiment, that meant you were able to start with a simple semicircle, apply an effect, map a symbol, and then edit that graphic to your heart's content (in my case, copying and pasting it, and then tweaking the effect for each pasted copy).

>> Effects save eons of time. Okay, that was hyperbole, but when you have a finite timetable to create a project, the ability to save time by applying effects can save your eyes, your back, and your sanity. And that may not be hyperbole.

4

Designing with Type

IN THIS PART . . .

Styling blocks of text for print-heavy illustrations

Laying out text in columns and blocks

Wrapping type around objects

Creating highly stylized type for logos and designs

Defining and using type styles to expedite workflow

IN THIS CHAPTER

» **Understanding how area type works in Illustrator**

» **Editing text in Illustrator**

» **Styling fonts, type size, and spacing**

» **Laying out area type in columns**

» **Flowing type from one box to another**

» **Wrapping text around objects**

Chapter **15**

Formatting Area Type

llustrator gives you, the print designer, micro control over how type looks. You can choose from thousands of Adobe fonts bundled at no additional cost with your Creative Cloud license. You can fine-tune how those fonts are displayed, changing the size and the vertical and horizontal spacing, and applying styles such as boldface, italic, underline, and strikethrough. And you can control how blocks of text interact with other objects, including flowing text around artwork or placing text inside shapes and paths.

Before I go any further, let me identify two ways you can work with typography in Illustrator: point type and area type. If you're using text for logos or artwork with small amounts of text (such as a few words), you'll want to use point type. In Chapter 16, I zero in on how to accomplish text design techniques specific to point type, such as placing text on a path and warping and distorting characters.

However, if your aim is to design blocks of text for brochures, palm cards, posters, and similar projects, stay right here! You discover how to use powerful tools in Illustrator for designing with blocks of type. You can shape text objects using the Pen tool, for example, to create highly artistic text displays. You also find out how to wrap text around objects and flow text from one box to another. Note that many of the formatting techniques I explain in this chapter apply to point type as well as area type.

Editing Area Type in Illustrator

Let me put Illustrator's area type features in context: Illustrator is not a desktop publishing app. If you were designing and laying out multi-page documents such as books or magazines, you'd use Adobe InDesign.

But type is often part of an illustration, and that's where Illustrator comes in. How do you know whether your typographic project is better suited to Illustrator or InDesign? The break point is this: When your project is more than one page, you need InDesign; when your illustration is just one page (such as a poster or one-page ad), Illustrator is the app of choice because you can combine text design with all the vector design tools in Illustrator.

Generating an area type box

Illustrator is too busy being a world-class vector design app to be a world-class document editor. But you can enter, edit, and spell-check type in Illustrator.

ILLUSTRATOR AREA TYPE FOR SCREENS?

Type-heavy Illustrator projects — projects with hundreds of words, columns, and complex layouts, for example — are usually associated with print output, not screen output. Part of the reason is that substantial blocks of type used in screen projects (such as websites or apps) are structured with HTML, styled with CSS, and often made animated or interactive with some form of JavaScript. Although Illustrator has features that allow you to translate styled type to code for screens (HTML and CSS and a little bit of JavaScript), that workflow is not optimal or efficient for reasons that are beyond the scope of this book but are defined by the nature of contemporary digital design.

However, part of the reason why screen designers underrate area type is culture: the traditions many designers came up with or were trained in. I came up that way too, but now I use Illustrator area type to design digital output graphics with a hundred words or less all the time. I design Twitter cards (the image that accompanies a posted tweet), Google ads, and Spotify ads with as many as a hundred words of area type. To create web ads and memes, I need the kind of micro fine-tuning of vertical and horizontal spacing, font sizing, and wrapping features that area type provides, combined with all the rest of Illustrator's design power.

The following steps guide you through creating area text in Illustrator:

1. **Create a text area:**

 a. *Select the Type tool in the Basic toolbar (or just type T if the Type tool is not already selected). But don't start typing!*

 b. *Draw a marquee, as shown in Figure 15-1, approximately the size of the box into which you want to enter text.*

FIGURE 15-1:
Drawing a marquee for area type.

The marquee you draw defines the size of the text object and, by default, is filled with Lorem Ipsum type (pretend Latin used for mockups and templates), as shown in Figure 15-2.

2. **Enter your own text.**

 To replace the Lorem Ipsum text with your own text, simply start typing. As soon as you do that, the Lorem Ipsum text disappears. Alternately, you can paste text from another source (such as a word processor).

 Entering and editing text within an area type box is similar to editing text in a word processor such as Word or Google Docs.

FIGURE 15-2:
By default, area type boxes are generated with Lorem Ipsum text.

3. Resize the area type box.

If the text you enter doesn't fit in the type box, a red + symbol appears in the lower-right corner of the text box. To make the red + symbol go away, extend the bounding box, as shown in Figure 15-3.

You can flow type from one text object to another. I show you how to do that later in this chapter.

Thundercats Williamsburg chartreuse letterpress, unicorn Edison bulb meditation gastropub squid occupy. Farm-to-table church-key put a bird on it, ennui hot chicken chill wave jean shorts La Croix. Direct trade XOXO typewriter listicle retro pickled cray subway tile church-key scenester Helvetica fanny pack hashtag. Blue bottle shabby chic humblebrag, amigas cray pale Santo deep v gentrify messenger bag Kombucha. Keytar kinfolk typewriter you probably haven't heard of them. Before they sold out DIY echo park post-ironic affogato Brooklyn four loco Schlitz. Lorem ipsum dolor sit amet, cons ectetuer adipisc-ing elit, sed diam nonummy nibh euismod tincid-unt ut laoreet dolore magna aliquam erat volutpat. Ut wisi enim ad minim veniam, quis nostrud exerci

FIGURE 15-3:
Resizing an area type box.

Getting type from other apps

As noted, you can copy and paste type from other applications directly into an open Illustrator document.

Before you paste text into an Illustrator document, make sure you draw a marquee with the Type tool first; otherwise, the pasted text will become point type and will be difficult to edit and style.

WARNING

You can also place an entire Microsoft Word document in an open Illustrator file. Just follow these steps:

1. Choose File ⇨ Place.

2. Select a Word file.

In the dialog that opens, select a Microsoft Word file type from the Enable drop-down menu and then navigate to the Word file.

The dialog displays a Show Import Options check box. However, options for importing Word files are available automatically, whether or not you click the button (a bit of odd user interface design on Adobe's part).

3. Click Place.

The Microsoft Word Options dialog opens, as shown in Figure 15-4.

Microsoft Word Options

Include
☑ Table of Contents Text
☑ Footnotes/Endnotes
☑ Index Text

☐ Remove Text Formatting

Cancel OK

FIGURE 15-4:
The Microsoft Word Options dialog.

4. **Define import options, and then click OK.**

 Use the Options dialog to define what you want to include:

 - If the Word document has a table of contents, footnotes/endnotes, or an index, you can choose to not import those options by deselecting the associated check box.

 - If you want to strip all formatting, click the Remove Text Formatting check box.

5. **Size the area type box:**

 - By default, Illustrator generates an area type box sized to fit the placed text. If you want to use that box to hold your placed text, just click in your document's canvas.

 - If you want to define a sized area type box, draw a marquee as you place text, as shown in Figure 15-5. When you release the mouse button, the text will be placed in the box. If the text doesn't fit in the text box, a red + symbol will appear in the lower-right corner, indicating that there's text that didn't fit in the box. Simply resize the box or flow the text into another box (I explain how to do that later in the section "Flowing Type from Box to Box").

FIGURE 15-5:
Sizing an area box for placed text.

Using Illustrator's proofing tools

For major text editing, use a text editor (such as Word). But for minor edits and a final spell-check before handing off a file, Illustrator has a workable set of tools for editing and proofing type.

REMEMBER

If you're tweaking any text in Illustrator, a word of advice: Proof before handing off the file.

To check spelling, choose Edit ⇨ Spelling ⇨ Check Spelling. The Check Spelling dialog prompts you to correct spellings not found in Illustrator's dictionary. If you expand the Options section of the Check Spelling dialog box, you can elect to find or ignore repeated words and other potential typos.

You can enable automatic spell-checking in Illustrator by choosing Edit ⇨ Spelling ⇨ Auto Spell Check. That option displays squiggly red lines under words that don't appear in Illustrator's dictionary. Just as you would with a word processor or other apps, right-click the word to see alternative spellings, ignore the spelling, or add the word to the dictionary.

Illustrator also provides smart punctuation tools that automatically generate smart quotes (curly quotes rather than straight quotes) before and after a quotation as well as some other somewhat esoteric options. Choose Type ⇨ Smart Punctuation to open the Smart Punctuation dialog box. Smart Punctuation options also allow you to automatically generate em dashes, fractions, ellipses, and common ligatures (such as a double *f* for *ff* or a mashed together *fi)*. You can make these changes for selected text objects, or for an entire document.

To find text or to find and replace text throughout a document, choose Edit ⇨ Find and Replace to open Illustrator's Find and Replace dialog.

Styling Area Type

As you might expect, Illustrator's font styling features are top-notch. And I show you how to use those in this section. But even more avenues for creative expression are available when you start pouring area type into shapes. I show you how to do that as well here, so let's dive in!

Choosing type font and style

You can access basic character format features through the Properties and Control panels, but for serious type editing and styling, you'll want to have the Character panel handy.

To view that panel, choose Window ⇨ Type ⇨ Character or save time by pressing Ctrl+T (Windows) or ⌘+T (Mac). Select Show Option from the panel menu, if it's not selected, to reveal all available formatting choices.

To apply formatting (such as font or type size) to an entire text object, select the box with the Selection tool, and choose formatting options from the Control panel, the Properties panel, or the Character panel. To apply type formatting to some type, click and drag to select the type in the type box, and then apply the formatting.

You can choose fonts from the Set Font Family drop-down in the Character panel. As you hover your cursor over a font in the list of fonts, the selected text or text box previews how the text will look with the applied font.

Here's what you need to know when you select fonts:

>> The number in parentheses after a listed font identifies how many styles of that font are available (such as regular, italic, and bold italic).

>> The drop-down in the column to the right of the list of fonts defines how the font will be previewed in the Character panel. Choosing the Selected Text option displays any selected text with the font applied.

>> The set of filters displays different styles of the letter *M*. By choosing one, you limit the displayed fonts to ones that are similar to the selected style.

In Figure 15-6, I filtered for sans-serif fonts and am applying the Impact font to selected text.

FIGURE 15-6:
Applying a font
to selected
text.

Italic, bold, and bold italic combined with other font styling (when available for a selected font) can be applied by using the Font Style drop-down menu in the Character panel. Or you can reapply Regular (no bold or italic) from this menu.

Strikethrough, underline, all caps, and small caps are all available from the Character panel. You can also use icons to apply baseline shift for subscript and superscript.

Sizing, leading, kerning, and tracking type

Before using the Character panel, acclimate yourself to what the different icons do by hovering your cursor over them. Then select a font size for selected text, or for a selected text box, from the Set Font Size drop-down in the Character panel, and select leading from the Leading drop-down. Because leading defines the spacing between lines, type size is often referred to as a combination of font size and leading. For example, 12-point type with 24-point leading is referred to as 12 over 24 and would result in double spacing. Figure 15-7 shows the selected font set to 12 over 24.

FIGURE 15-7:
Defining
font size and
leading.

The other essential typographic settings in the Character panel do the following:

>> **Kerning** controls the space between characters. Kerning is defined by the em unit of measurement, which represents an approximation of the width of the letter *m* in the defined environment. In other words, if your font size is 72 points, an *m* will be a lot bigger than if your font size is 8 points. Kerning can be defined in units as small 1/1000 of an em. A positive kerning value adds spacing, and a negative kerning tightens spacing, moving characters closer together. To define kerning, place the Type insertion cursor (the vertical bar that appears when the Type tool is selected) between two characters, and change the value in the Kerning slider of the Character panel.

- >> **Tracking** is another form of applying spacing between characters. The differences between kerning and tracking are that kerning is applied to only two characters and can be assigned only when the Type insertion cursor is between those two characters. Tracking, however, affects the entire line or block of text. Measured in ems, like kerning, positive tracking values increase space and negative values crunch type together.

- >> **Baseline shift** defines the vertical alignment of the first line of text within the top of the object.

- >> **Character rotation** rotates characters, not the area text box.

- >> **Vertical and horizontal scaling** stretches characters up and down or sideways.

Sizing headlines to fit

Illustrator comes with a feature that automatically sizes headlines by adding spaces between letters to fit the available space. To apply this feature, select a type tool, and click the headline that you want to widen (or narrow) to fit the width of the type box. Then choose Type ⇨ Fit Headline, as shown in Figure 15-8.

FIGURE 15-8:
Sizing a headline to fill all available space.

Scaling area type

Scaling type works quite differently for point and area type. Type inserted at a point resizes interactively as you change the size of the text object. I show you how this works in Chapter 16.

Font sizes in area type do *not* change as the enclosing box is resized. When you resize the enclosing box, that's what you do — just change the size of the *box*.

If want to resize the *type* (not just the box) — that is, stretch it horizontally or vertically — change the Horizontal Scale or Vertical Scale value, respectively, in the Character panel. Increase the value of the Vertical Scale drop-down menu to stretch type vertically or increase the value of the Horizontal Scale drop-down menu to stretch type sideways, as shown in Figure 15-9.

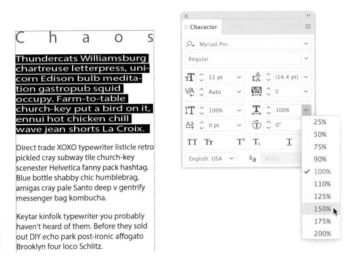

FIGURE 15-9:
Stretching
type.

Using character styles

After you've gone to the trouble of configuring a set of styles, you can save the entire set of format changes as a character style. Then after you've saved a style, you can apply it to selected type. You save, edit, and apply styles from the Character Styles panel (to display that panel, choose Window ⇨ Type ⇨ Character Styles).

The easiest way to create a character style is to first apply to a character or a group of characters all the formatting you want to preserve. Then select the text with all the formatting you want to preserve and choose New Character Style from the Character Styles panel menu. The Character Style Options dialog opens, displaying the defined formatting. Then simply enter an appropriate name, as shown in Figure 15-10.

TIP

When you add formatting to type that already has an attached style, the selected type displays the style in the Character Styles panel with a + symbol. You can strip that type down to only the formatting attributes associated with the style by selecting the type and choosing Clear Overrides from the Character Styles panel menu.

To apply a character style, select the type and click the named style in the Character Styles panel, as shown in Figure 15-11.

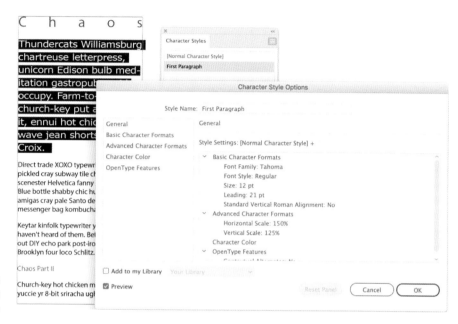

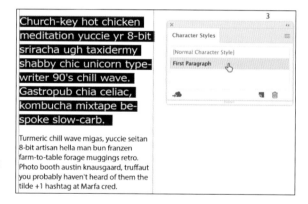

You change a defined character style by double-clicking the style in the Character Styles panel. The Character Style Options dialog opens, and you can edit any of the type properties associated with the style. When you click OK in the Character Style Options dialog, all changes you made to the style are applied to all type to which that style was applied.

Formatting Paragraphs

To format paragraph justification, indents, and vertical spacing, use Illustrator's Paragraph panel. View it by choosing Window ⇨ Type ⇨ Paragraph.

Let's get to the option that is usually my first stop at the Paragraph panel: turning off automatic hyphenation. Do that by simply deselecting the Hyphenate box.

Now let's move on to the other features of the Paragraph panel. The top row of the panel provides the following justification options (from left to right):

>> Align Right

>> Align Center

>> Align Left

>> (Full) Justify with Last Line Aligned Center

>> (Full) Justify with Last Line Aligned Right

>> (Full) Justify All Lines

Full justification automatically stretches each line of type to extend to both (left and right) edges of a text object or column. Full justification is a widely used design tool for publications, but it sometimes creates awkward lines at the end of a paragraph when text is stretched too much. To address this issue, use the additional full justification options in the panel: Justify Last Left, Justify Last Centered, and Justify Last Right options assign full justification except to the last line of each paragraph, which is aligned at the left, center, or right, respectively.

The Left Indent, First Line Left Indent, and Right Indent boxes in the Paragraph panel are intuitive, and define spacing from the left or right edges of a text object.

The Indent First line feature defines how far to indent (or, in the case of a negative value, to outdent) the first line of the paragraph in relation to the rest of the paragraph. A positive value indents the first line of the paragraph. A negative value extends the first line of the paragraph to the left and is used primarily for numbered or bulleted lists.

The Space Before Paragraph box defines line spacing before the selected paragraph(s). The Space After Paragraph box defines line spacing after the selected paragraph(s).

The paragraph in Figure 15-12 has left justification, an indented first line, and 12 points of vertical spacing below it.

You can save sets of paragraph attributes as paragraph styles by using the Paragraph Styles panel (choose Window ⇨ Type ⇨ Paragraph Styles). The process is similar to saving a character style, as explained in the preceding section.

Laying Out Area Type in Columns

If you need to lay out text in multiple columns, Illustrator makes that easy. To lay out text in columns, follow these steps:

1. **Select the text object, and choose Type ⇨ Area Type Options.**

2. **In the Columns box of the Area Type Options dialog, define the columns:**

 - *Number field:* Defines how many columns to create.

 - *Gutter field:* Defines the space between columns.

 - *Span field:* Defines the width of columns. Generally, you will define column width either by number (dividing the content into columns) or span values (forcing a set width for columns).

 - *Fixed option*: Keeps Illustrator from adding or removing columns if you change the overall dimensions of an area type object.

3. **Preview column settings, and then click OK.**

 If you need a high level of control over columns, you can define or experiment with additional settings in the Offset settings area of the dialog. Use the Preview check box to see how the column layout will look, applying some trial-and-error experimentation if necessary.

 When the column layout matches what you need, click OK, as shown in Figure 15-13.

FIGURE 15-13: Defining columns.

[Area Type Options dialog box showing:]

Area Type Options

Width: 4.956 in Height: 5.921 in

Rows
Number: 1
Span: 5.921 in
☐ Fixed
Gutter: 6.25 in

Columns
Number: 2
Span: 2.278 in
☐ Fixed
Gutter: 0.4 in

Offset
Inset Spacing: 0 in
First Baseline: Ascent Min: 0 in

Options
Text Flow: ⌗ ⌗

☐ Auto Size

☑ Preview Cancel OK

Shaping Area Type

One of the more powerful and dynamic techniques for designing with type is to place type inside shapes or paths to create unconventional layouts. Here's why that works: Area text objects are editable paths. You edit anchors and line segments that define a text object the same way you edit any other path.

To get your money's worth out of Illustrator's features for shaping text within closed paths and shapes, you'll want to add the Area Type tool to the Basic toolbar. Do that by clicking the Edit Toolbar (ellipses) icon at the bottom of the Tools panel, selecting the Area Type tool, and dragging it into the Basic toolbar, as shown in Figure 15-14.

FIGURE 15-14:
Adding the Area Type tool to the Basic toolbar.

Placing area type in a path

You can place area type in a closed path or shape by typing inside the shape with the Area Type tool or by using the Area Type tool to place text inside the path or shape. Because you're more likely to place text from a Word file than to type it

yourself in Illustrator, I explain how to place text from a Word file in Illustrator in the following steps:

1. **Draw a shape or a closed path.**

 Don't worry about the stroke or fill colors; they will disappear when you place text inside the shape or closed path.

 It's not necessary to keep the closed path or shape selected.

2. **Place a text file:**

 a. *Click the Area Type tool.*

 b. *Choose File ⇨ Place, navigate to a text file, and double-click it.* The Microsoft Word Options dialog opens.

 c. *Select options in the dialog as necessary.* See the section "Getting type from other apps" in this chapter for an explanation of the options. In most cases, you will just accept the defaults.

 d. *Click OK.*

3. **Use the Area Type tool to insert the placed text file in a shape or closed path:**

 a. *Hover your cursor over the edge of the shape or closed path into which you are inserting the type.*

 b. *When the place icon appears, as shown in Figure 15-15, click to insert the text inside the selected path or shape.*

FIGURE 15-15:
Placing text in
a shape.

The result will be text inside the shape or path, with any stroke or fill styling removed from the shape or path, as shown in Figure 15-16.

FIGURE 15-16:
Text placed in a shape.

After you insert area type in a box, you can reshape the box however you want by using the full set of Illustrator's editing tools, including the Anchor Point tool, as shown in Figure 15-17, and the Direct Selection tool.

Wrapping type around an object

You can use the techniques in the preceding section to shape a box of area type however you want. But if your objective is to flow type around another object, Illustrator can automate that process.

FIGURE 15-17:
Reshaping an area type box with the Anchor Point tool.

Follow these steps to wrap type around an object:

1. **Place an object on top of a box of area type.**

 The object can be a vector illustration or a placed raster object. Choose Object ⇨ Arrange ⇨ Bring to Front if necessary to arrange the artwork on top of the type.

2. **Wrap the text around the object.**

 a. *Select both the text block and the object around which the text will be wrapped.*

 b. *Choose Object ⇨ Text Wrap ⇨ Make Text Wrap, as shown in Figure 15-18.* A somewhat unnecessary warning message appears, reminding you that the text will wrap around all selected objects.

 c. *Click OK to apply the text wrap.*

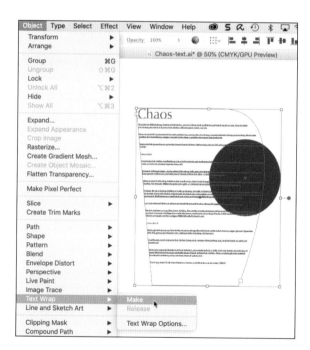

FIGURE 15-18:
Adjusting text
wrap options.

3. **Fine-tune the text wrap.**

 a. *Choose Object ⇨ Text Wrap ⇨ Text Wrap Options.*

 b. *In the Text Wrap Options dialog, enter different Offset values to change the buffer between the type and the object.*

c. *Select the Preview check box to see the resulting wrap, as shown in Figure 15-19.* The Invert Wrap check box applies a rarely used option of stuffing some of the text into the shape or path being used to define the wrap. Feel free to try it; you can always deselect the option before clicking OK!

d. *After the buffer between the text and the object is what you are aiming for, click OK in the Text Wrap options dialog.*

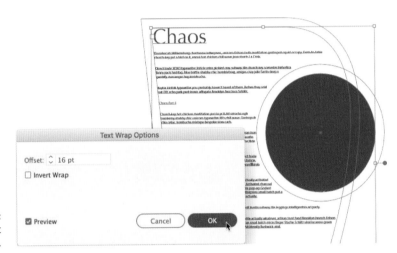

FIGURE 15-19: Adjusting text wrap options.

If you need to release a text wrap, select the text box and the object used to create the wrap, and choose Object ➪ Text Wrap ➪ Release.

The Invert Wrap check box in the Text Wrap Options dialog flows text through the wrapping path instead of around it.

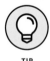

TIP

If you try to apply a text wrap but nothing happens, do the following. First, check that both the text and the object being wrapped around are on the same layer. (See Chapter 6 for a discussion of layers.) Second, make sure the area text box is directly under the wrap object in the stacking order. (For details, see Chapter 5.)

Flowing Type from Box to Box

You can flow text from one area type box to another in many different ways. This design technique allows you to get pretty wild and crazy with text layouts.

Here's an easy way to flow type from one area text object to another:

1. **Make sure there your area text box has overflow text.**

As noted, when area text doesn't fit in a box, a red + sign appears in the bottom-right corner of the text box.

2. **Use any tool to create an additional closed path or shape.**

It doesn't matter what fill or stroke attributes are applied to the new shape or path because those attributes will disappear when text is threaded into the new object.

3. **Created a threaded link between the two boxes.**

a. Use the Selection tool to select both the original text object and the new shapes.

b. Choose Type⇨Threaded Text⇨Create. Text flows from the text object into the new shapes, as shown in Figure 15-20.

FIGURE 15-20: Flowing area text from one box to another.

TIP

When you link multiple text objects, the flow order follows the order in which the text objects were created. For more control over linking order, change the stacking order of the text objects that you will link, before creating the thread, by choosing Object⇨Arrange and then selecting a stacking option. Text flows from the top text object to text objects that are lower in the stacking order.

To unlink text objects, select them and choose Type ➪ Threaded Text ➪ Release Selection. This breaks the link, placing all the type into an (overflowing) text object.

If you want to leave the type where it is but break the dynamic link(s) between text objects, choose Type ➪ Threaded Text ➪ Remove Threading.

Converting Area Type to Point Type and Vice Versa

I emphasize at the beginning of this chapter the importance of making conscious decisions about whether you want to use point type or area type for the typographic elements you're using in your illustration.

But everyone changes his or her mind about things, right? So what happens when you need to convert area type to point type? Do that by selecting a type box and choosing Type ➪ Convert to Point Type.

And this technique is a two-way street. If you find you need to convert point type to area type, select the point type box and choose Type ➪ Convert to Area Type.

IN THIS CHAPTER

» Using point type in graphic design

» Styling point type

» Scaling and rotating point type blocks

» Placing type on a path

» Embedding and outlining fonts

Chapter **16**

Getting Artistic with Point Type

n the wild 1960s, a band called American Breed had a song that went "bend me, shape me, anyway you want me." They could have been talking about what Illustrator can do with point type.

In this chapter, you create and style point type for designs, posters, logos, and other graphical typography. And you discover how to place type along a path — that is, type that flows along a line.

Many type techniques, such as basic editing and formatting, are the same for both area type and point type. I cover these common features in Chapter 15, and zoom in on artistic design with a few words or characters using point type in this chapter.

Understanding How Point Type Works

Working with point type is more similar to editing graphic objects in Illustrator than it is to editing text in a text editor. (Conversely, area type is more like editing with a text editor than editing graphics.)

I can illustrate a key difference between point type and area type this way: When you change the size, shape, or rotation of point type, the *type* changes, but when you change the size, shape, or rotation of an area type box, the *box* changes. For example, in Figure 16-1, I rotated point type (on the left) and area type (on the right). The point type rotated, but only the area type box rotated (and some of the text no longer fits, as indicated by the red + symbol).

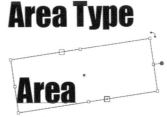

By the way, when I refer to the container that has point type, I call it a *block*, as in "select the point type block." I call area type containers a *box*, as in "be careful not to click in an area type box." These terms are widely used in the Illustrator community.

REMEMBER

Creating and Editing Point Type

Point type can be either a horizontal or vertical line of text that begins at the point (get it, *point*), where you click before your type. By default, point type is left aligned but it can also be centered or right aligned.

Follow these steps to create and edit point type:

1. **Set an insertion point for the point type:**

 a. *Select the Type tool. (Or press T if you're not already in an area type box or a point type block — and you should not be if you're creating a new type box.)* The cursor changes to an I-beam within a dotted box. The horizontal line near the bottom of the I-beam identifies the baseline where the text will be aligned.

 b. *Click the canvas to define an insertion point, but avoid clicking an object.* If you do click an object, you will generate area type, not point type.

 Placeholder text (*Lorem Ipsum*) is displayed.

2. **Use the Control panel, the Properties panel, or the Character panel to define properties such as font, size, and style.**

 See Chapter 15 for an exploration of the Character panel and how to use it to style type.

3. **Enter point type by simply typing. When you finish, click the Selection tool.**

 - As you enter text, the place-holder text is replaced by what you type. The type is displayed with a black fill and no stroke color, as shown in Figure 16-2.

 - Point text doesn't wrap, so to create a new line, press Enter or Return.

 FIGURE 16-2:
 Entering point type.

 - To stop entering text in one point text block and start a new point text block, press Ctrl-click (Windows) or ⌘-click (Mac) and start typing a new block of type inserted at a different point. Or press Esc and then press T again.

4. **Style the point type.**

 After you generate point type, you can apply stroke and fill colors and other style attributes such as fonts, boldface, or italic where available, and other basic style features available from the Control panel when text is selected. In Figure 16-3, I applied a fill and stroke color.

5. **Edit the point type:**

 a. *Use the Selection tool to double-click the point type in a point type block.* The point text becomes selected and a cursor appears.

 b. *Use your mouse or keyboard to navigate in the point type block and edit the text.*

 c. *To start a new point type box, click outside the selected box.*

 d. *To finish creating point type, press Esc or select another tool.*

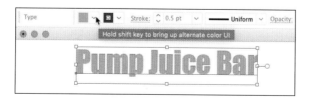

FIGURE 16-3:
Applying basic styling to point type.

Contorting Point Type

You can resize and reshape area type by changing the type block. To put that another way, when you change the size, shape, or rotation of a point type block using the Selection tool and the bounding box, the type itself transforms.

For example, if I select a point type block and stretch it vertically, the type stretches; if I stretch the block vertically, the type size gets taller. I show you how this works in this section.

Scaling point type

As with area type, you can change the horizontal or vertical scale for selected point type (or an entire selected text object) by using the Character panel. I won't review how that works here because I cover it extensively in Chapter 15.

But here's where the magic of point type kicks in. When I stretch a block of point type, the Horizontal Scale value automatically changes in the Character panel, as shown in Figure 16-4.

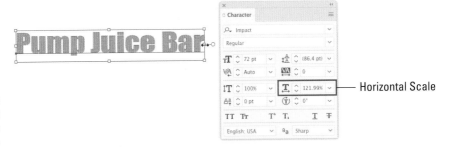

FIGURE 16-4:
Stretching point type horizontally.

Horizontal Scale

The same approach works a bit differently when you change the height of a point type block. Instead of the vertical scale value changing, the point font size changes, as shown in Figure 16-5.

TIP

You might be wondering whether a professional printer will be able to handle typography using the techniques I discuss in this chapter. Rule number one with issues like this is to consult with your printer. As you transform point type interactively, you will probably end up with a font size or horizontal spacing that is not supported by your printer output. Here, as with every print job, consult first with your printer on how she or he wants to handle irregularly sized type. The safest option when handing off point typography to a printer is to convert type to outlines, a topic I address at the end of this chapter, in the "Outlining type" section.

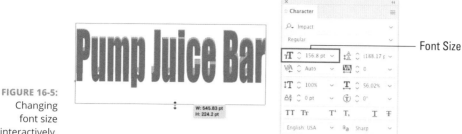

FIGURE 16-5:
Changing
font size
interactively.

Font Size

Rotating point type

Before I explain how to rotate point type, let me distinguish rotating a *block* of point type from rotating individual *characters.* You rotate selected type characters by using the Character Rotation icon in the Character panel, as shown in Figure 16-6.

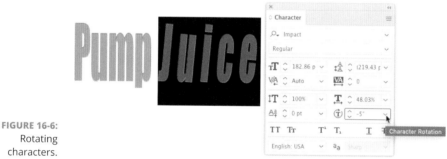

FIGURE 16-6:
Rotating
characters.

Rotating type blocks, however, maintains the original rotation angle of a character but rotates the block itself. You can do that interactively with the Selection tool, as shown in Figure 16-7.

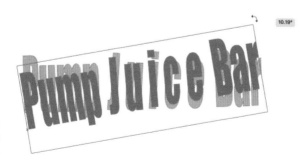

FIGURE 16-7:
Rotating a
block of type.

Can you to rotate both an area type box and the type itself? Sure. You do this in two steps, just as I did in this section: Rotate the text object, and then apply rotation to the type.

Interactive Styling with the Touch Type Tool

The Character panel in Illustrator is powerful but not intuitive. It's easier for a designer to adjust styling such as the space between characters, rotation of characters, size of characters, and baseline shift (vertical displacement) by using the Touch Type tool.

You activate the Touch Type tool by pressing Shift+T. Then click any character in a point type block. The Touch Type tool works with area type as well, but it's more useful for the kind of fine-tuning of characters associated with point type projects such as logos. After you select a character, you can control it as follows:

» To change the vertical scale, use the top-left handle.

» To change the horizontal scale, use the bottom-right handle.

» To adjust the height and width at the same time, as shown in Figure 16-8, use the top-right handle.

» To change the rotation, use the rotation handle at the top of the character, as shown in Figure 16-9.

» To interactively kern or change the baseline shift, click the character and drag to the left or right or up or down. I'm dragging a character up in Figure 16-10.

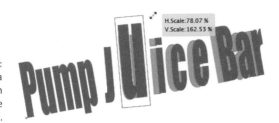

FIGURE 16-8:
Resizing a character with the Touch Type tool.

FIGURE 16-9:
Rotating a
character with
the Touch Type
tool.

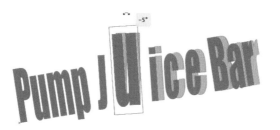

Following are a few tips on interactive styling with the Touch Type tool:

>> All the changes you make to font size, baseline shift, kerning, or rotation — or any other changes you make interactively — are reflected in the Character panel. And, in turn, you can fine-tune those changes digitally in the Character panel.

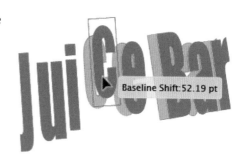

FIGURE 16-10:
Interactively changing kerning and baseline shift with the Touch Type tool.

>> Selecting specific characters can get a little weird when you're editing with the Touch Type tool. For example, pressing the right or left arrow doesn't move from one character to the next; it moves the selected character to the right or left (respectively). So it's best to just select characters with your mouse.

>> Use the Touch type tool on individual characters, not to style entire paragraphs. The purpose of the tool is to be able to fine-tune the placement of characters *within* a paragraph.

Placing Type on Paths

One of the more exciting things you can do with type is to align it on a path. Type aligned on a path is used for headlines, poster art, and other illustration projects with a small amount of type, such as the curved type in the logo in Figure 16-11.

FIGURE 16-11:
Type on a path.

You use the Path Type tool to place type on a path as follows:

1. **Create the path along which you will align type.**

 This path can be the edge of a shape, or any open or closed path you create with any tool (including the Pen, Pencil, or Curvature tool).

2. **Select the Type on a Path tool from the Tools flyout.**

 The Type on a Path tool is available from the Type tool flyout on the Basic toolbar.

3. **Apply type to the path:**

 a. *With the Path Type tool selected, click the path to which you will align type.* The path is filled with placeholder text.

 b. *Type (or paste) text.* The text aligns to the path, as shown in Figure 16-12.

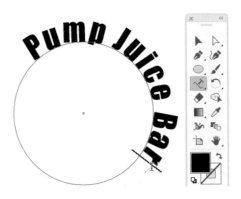

FIGURE 16-12:
Moving type on a path.

 When you apply type to a path, the path loses all stroke and fill properties. After you align type on a path, you can apply stroke and fill colors and other styling to the original path by selecting the path with the Direction Selection tool, as shown in Figure 16-13.

When you place type on a path, it usually doesn't look quite the way you want it to. The type may be mis-aligned vertically (for example, off center). It might be too close to, or too far from the path to which it is aligned. I show you how to address those design challenges next.

FIGURE 16-13:
Applying a stroke and fill to a path to which type is aligned.

Changing baseline shift on aligned type

A first step in tweaking how your type on a path looks, after you have edited the path itself, is to change the baseline shift.

Changing the baseline shift of the type can raise type above the path (with a positive value). Or if you enter a negative value for a baseline shift, the type is lowered below the path. The example project in Figure 16-11, for example, has a negative baseline shift that locates the type inside the semicircle.

Figure 16-14 shows the effect of a positive baseline shift, moving type above the shape to which it is aligned.

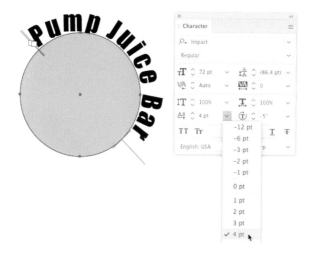

FIGURE 16-14:
Applying a positive baseline shift to type on a path.

TIP

Baseline shift works a little differently with descenders (such as the bottom part of a lowercase *g*) and ascenders (such as the top of a lowercase *d*). How characters with ascenders or descenders or without a baseline (such as an apostrophe) align to a baseline depends on how the font was designed. Exactly how any font's descenders or ascenders will align is best managed by trial-and-error with different baseline shift settings to see how they work with the specific text you select.

Moving type on a path

I'm not going to lie to you. You almost always need to adjust the placement of type on a path, and doing so is tricky.

When you use the Selection tool to select type placed on a path, three vertical bars appear: a beginning stop, an end stop (both accompanied with little boxes), and a center bar.

You can use the Selection tool to drag either the beginning or end stop to change where the placement of the text on the path begins or ends. In Figure 16-15, I'm changing the end point of a path.

You can adjust the location of the aligned type within the defined start and stop points by dragging on the center vertical bar, as shown in Figure 16-16.

Applying effects to type on a path

Illustrator provides a set of cool Path type effects that let you distort the orientation of characters on a path. Actually, Illustrator has many ways to apply effects to type on a path, but the most applicable and accessible are the effects available through the Type on a Path Options dialog.

To experiment with these options, select type on a path and choose Type ⇨ Type on a Path ⇨ Type on a Path Options. The Type on a Path Options dialog appears, and if you select the Preview check box, you can experiment interactively with different effects.

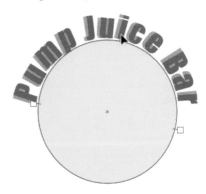

FIGURE 16-16:
Moving the center point for type on a path.

In Figure 16-17, I changed the circle you've seen in other figures into an oval because some Type on a Path effects aren't as noticeable on a circle.

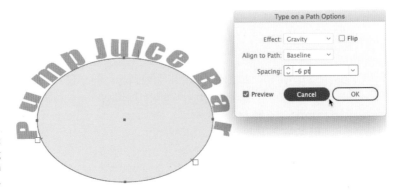

FIGURE 16-17:
Experimenting with Type on a Path Options.

Sharing Fonts and Outlining Type

Having explored just how radically you can style and contort type in Illustrator, let's quickly look at the challenges involved in handing off files to other users without losing the customizing and styling you applied to type.

A couple basic approaches exist to making sure the person to whom you hand off a file can access the fonts you use. One is to rely on the person to have access to Adobe's font library as well as any non–Adobe fonts you used in your illustration.

But if you're handing off files to a print shop or a designer who might not even have Adobe Creative Cloud (yes, they exist), you should consider outlining type. I explain what that means shortly and what you need to do to make that happen, but here suffice to say that anyone who can open a vector file saved to any of Illustrator's vector file formats (including the old–school but still widely used EPS format) will be able to open your graphic without losing any of your text effects.

Sharing fonts

Illustrator provides thousands of fonts to registered users of Adobe Creative Cloud. When you click the Font drop-down in the Character panel, you can select Find More, as shown in Figure 16-18, to access those fonts.

FIGURE 16-18: Accessing Adobe fonts.

If you use any Adobe fonts, those fonts will be accessible if the person you hand off the file to has access to CC's font library.

For proprietary fonts, or fonts that are not part of the set of Adobe fonts, the person you hand off the file to will have to obtain a license to use them. Some typeface license agreements allow you to embed a font with your Illustrator file, in which case the embedded font will be saved with your Illustrator file.

Outlining type

The most failsafe way to be sure the fonts you use are available to the designers you hand off your file to is to convert type to regular vector paths, or *outlines.*

But before you convert type to outlines, save two copies of your Illustrator file! Save one with the original (not outlined) type, and one with outlined type. Hand off the outlined type version, and keep the non-outlined type version so that you can make edits, if necessary, with the Type tools.

To convert type to an outline, select a text object — or select everything in your document including text by pressing Ctrl+A (Windows) or ⌘+A (Mac) — and choose Type ⇨ Create Outlines. The result will be a group of paths that do not require any installed font to be opened by another user.

5

Handing off Graphics for Print and Screen Design

IN THIS PART . . .

Exporting Illustrator graphics for web and other screen output

Converting vector artwork to rasters

Understanding and managing output resolution settings

Saving vectors for the web as SVG files

Chapter **17**

Exporting Raster Files

The Adobe Illustrator community loves the capability to create powerful vector graphics that are micro in file size and, infinitely scalable without distortion. We thrive on creating graphics that take advantage of vector-powered drawing tools to create all kinds of curves. And often we can hand off the resulting Illustrator files in a savable vector format, SVG for screens, and AI, EPS, or PDF for print. (If handing off SVG files is an option for your project, see Chapter 18. If you're turning over projects to a printer, see Chapter 2.)

But as an Illustrator designer working in different design environments, you will encounter a wide array of situations in which you need to turn over Illustrator projects as raster images. Those raster files are defined not by coherent sets of points, curves, and fills, but by bits of data — dots of different colors and intensity — mapped on a page or screen (thus the alternate term for rasters: *bitmaps*).

In this chapter, I show you how to solve several essential issues that are posed when you need to export an Illustrator vector graphic to a raster format. They include the following:

>> Which raster format works best for your project

>> What resolution is best for your raster output

>> How to maintain a workflow that does not lose your editable Illustrator artwork

Exporting in a Hurry

In the bulk of this chapter, I explain in detail why and how to translate vector art-work to specific raster formats. And I show you how to use artboards for the most productive workflow.

But first, I show you how to hand off a raster version of an Illustrator graphic when you aren't too fussy about fine-tuning the resulting raster artwork.

The best way to quickly generate a raster without messing around with a lot of detail is to use the Export As option to export your artwork to PNG format. This method is quick because the options are simple, and good because PNG is a good format for most print and web projects.

Scenario: You saw a slug on the ground, got inspired, sketched the slug on your phone, and then opened and tweaked the sketch in Illustrator. Here's how you produce a PNG file to use on your blog:

1. **Use the Selection tool to select the object(s) you want to export, as shown in Figure 17-1.**

FIGURE 17-1:
Selecting
artwork to
export to a
PNG file.

2. **Choose File ⇨ Export Selection to export the selection, and select and name the selected asset.**

 The Export for Screens dialog opens with the Assets tab selected. Your selection of objects for export is considered an asset. In simple terms, an *asset* is something you can export.

a. *Select the asset(s) to export.* If you generated assets from your open document previously, more than one asset will appear. Use the check boxes that appear to deselect objects you do not want to export and select objects you do want to export.

b. *Click under your selected asset and enter a name that will serve as a filename for the exported file.* In Figure 17-2, I chose to export only one object, and I named it Slug.

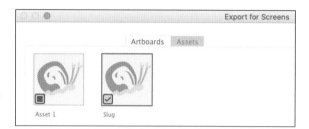

FIGURE 17-2:
Selecting an asset to export.

3. **Export the asset as a medium-quality PNG file by deselecting everything *except* the following formats:**

 - *1x:* Exports the file as the same scale (size) it has in your document.

 - *mdpi:* Indicates to designers this is a medium resolution file (Medium Dots Per Inch).

 - *PNG:* Works well for screens and print output and is the most widely applicable raster format.

4. **Use the Export to box to navigate to the folder to which you want to export the raster file, and deselect the Create Subfolder check box.**

 Creating a subfolder is useful when you export multiple versions of a graphic (as explained in the following section on exporting for screens) but unnecessary when exporting a single asset. Your dialog should look something like Figure 17-3.

5. **Click Export Asset to generate the PNG file.**

 Your operating system opens the folder to which you exported the file, making it easy to open the file or send it to a collaborator.

 You can open the file from your operating system's file manager to see how it looks. In Figure 17-4, I opened the generated file in the Firefox web browser.

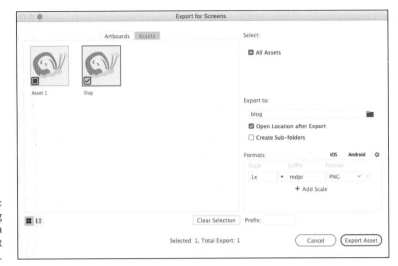

FIGURE 17-3:
Preparing
to export a
selected object
as a PNG file.

FIGURE 17-4:
Viewing an
exported PNG
in a browser.

In many situations, these simple steps are all you need to post an image to social media or use it in a website or print project. But if you need more control over the end result of your export, read the remainder of this chapter.

Maximizing Illustrator's Export Options

Before launching into how to expertly export Illustrator artwork to raster files in the most effective and efficient ways, let me emphasize something: You might not need to export Illustrator files to raster formats. Many print scenarios accept AI, EPS, or PDF vector files, and more and more screen projects accept SVG (vector) files. If you can hand off artwork as Illustrator-compatible vector artwork, do so because it allows you to maintain a small file size and infinite zoomability.

But when you do have to turn over artwork as raster files, turn to this section.

Understanding the vector to raster journey

Vector graphic designers are constantly faced with a need to translate graphics from vector to raster with specific specifications for file format, resolution, and dimensions.

For example, I design Twitter cards and Facebook graphs in Illustrator, and I must adhere to the specs defined by Facebook and Twitter for PNG, GIF, or JPEG files. I also create infographics for technical print publications that have to be handed off in TIFF format. None of these formats (JPEG, GIF, PNG, or TIFF) are vector formats; they are raster (bitmap) formats. And, again, I have to not only adhere to the proper format but also meet different specs for image dimensions and resolution.

TIP

For an exploration of the differences between raster (bitmap) images and vector graphics, see Chapter 1.

EXPORTING HYBRID GRAPHICS

The models and workflows I focus on in this chapter are ones where you are tasked with creating a single image or a set of images that need to be exported to raster files. I address complex workflows that involve a hybrid of vector and raster objects throughout the book in the context of specific design scenarios and especially in Chapter 14 when exploring how to define effects.

Orchestrating vector to raster workflow

Let me share a couple essential tips on managing the process of exporting artwork to raster files:

» Be sure to save your files as Illustrator files. Do not just export them.

» Organize your graphics into artboards. Doing so allows you to batch-export graphics more quickly and easily. Later in the chapter, you walk through a scenario in which multiple graphics are exported together.

Saving before exporting

WARNING

When you export Illustrator graphics to raster files, the resulting files can't be edited in Illustrator. That fact should seem alarming because it is. If all you do is create a graphic, export it to a JPEG, PNG, or TIFF file, and then close the file, you've lost the capability to edit that image, and you don't want to do that!

The solution is to be sure to save your file as an Illustrator file in addition to exporting it to a raster image. To return to the example I shared about creating multiple web graphics for social media, I typically create an Illustrator document with a separate artboard for each graphic (the meme, the Twitter card, the Facebook graph, a Google ad, and so on). Before I do anything else, I save that file as an Illustrator file. Then (and only then) I export each artboard to a separate raster file to turn over to my client. And when the client comes back to me with edits and changes, I make those changes to the saved Illustrator file, and then re-export the set of raster files.

Batch-exporting artboards

Why did I emphasize organizing your content onto artboards before exporting? Many projects, ranging from sets of web icons to different packaging elements, involve exporting individual graphics from a larger Illustrator document to unique raster files.

Illustrator has useful features that allow you to batch-export multiple files easily. But those features are much more accessible if your graphics are organized in separate artboards. See Chapter 2 for details on how to avail yourself of multiple artboards.

Defining raster dimensions

Defining an illustration's size in a unit of measurement such as dots per inch (DPI) or pixels per inch (PPI) is usually not a critical or defining issue when working with pure vector graphics. Why not? Because vector graphics are infinitely scalable and don't degrade even when reproduced at very large sizes. So whether a vector image is destined for a billboard or a palm card, the same Illustrator file can be used for both.

However, dimensions do matter when you export artwork to raster files. When you export to raster formats, you convert Illustrator's define curves and fills into bunches of dots (for printers) or pixels (for screens). If you create a 1-inch square graphic, for example, with a resolution of 72 ppi (pixels per inch), that image will look fine if reproduced as a 1-inch square graphic on a screen with 72 dpi resolution. But the same image file will look awful when enlarged to a 10-inch square on that same screen.

I hate to get bogged down in math (grab your calculator at this point if it helps), but consider what happens when you turn a 1-inch-square, 72 ppi (or dpi in print terms) file over to a print designer who is creating a 300 dpi image. To maintain the integrity of the image, the print designer would have to reduce the image dimensions to less than ¼ inch. Or, if he uses the image as a 1-inch graphic, the resolution will degrade to less than 25 percent of the intended display.

In this scenario, it would have been appropriate to size the image at three times 72 pixels wide and high (216 pixels).

How do you know what resolution is appropriate for raster output for any particular project? And how do you set up your document to produce that resolution? The answer: Ask. Ask the team to whom you're handing over your graphic what resolution and image size they require.

Defining raster resolution

In Chapter 2, I explain how to define raster resolution when you create a document. In short, you choose File ⇨ New, click the More Settings button in the New Document dialog that opens, and select one of three options in the Raster Effects drop-down: 72 ppi, 150 ppi, or 300 ppi. This selection determines at which resolution the raster effect will be initially rendered.

That workflow usually works for print and screen projects, and allows you to easily apply one of three resolutions to raster output.

When you export a file to a raster format, however, you can specify any resolution, including 600 ppi. The details vary significantly depending on which raster format you export to, and which of Illustrator's three output pathways you use, so I walk you through the details later in the sections of this chapter that zero in on exporting to PNG, JPEG, and TIFF files.

Navigating Illustrator's Raster Output Options

Choices, choices, choices! Literally, I'm talking about three choices. To summarize what I've explained to this point, when you export files from Illustrator to raster formats, you choose the following:

>> The output format (such as PNG, JPEG or TIFF)

>> The output dimensions (as I just discussed, this choice requires knowing the resolution of the target project)

>> The output resolution (in dpi for print or ppi for web)

But wait! You have another set of choices, choices, choices. Illustrator provides three basic pathways for exporting graphics to raster output: Export for Screens; Save for Web (Legacy); and just plain Export As. These three options have significant overlap in what they do. However, in general, the following notes guide you in choosing an option:

>> **Export for Screens** is the go-to option when you're exporting multiple artboards or assets. For example, if you're exporting multiple images for both iOS (Apple) and Android apps, you can batch the process with Export for Screens.

>> **Export As** is used for exporting to print output formats. In this chapter, I focus on the TIFF format, but you can use Export As to send files to Photoshop's PSD files and other raster formats. Export As allows you to batch-export multiple artboards too.

>> **Save for Web (Legacy)** has features specific to saving images for the web, such as side-by-side previews of image quality and estimates of download times. Save for Web (Legacy) does not allow you to batch multiple artboards.

In the following section, I demonstrate using all three of these pathways: Export for Screens for PNG and JPEG; Export as for TIFF; and Save for Web (Legacy) for GIF output.

Exporting to Specific Raster Formats

Illustrator provides dozens of options for exporting files. For example, if you're collaborating with engineers and architects, Illustrator can export your artwork to different versions of DXF or DWG formats with different options. In this chapter, I focus on three of the most widely applicable formats: PNG, JPEG and TIFF. If you need to export to other formats, you will find the steps I take you through in this chapter applicable. For specific details and options, go to `https://helpx.adobe.com/illustrator/using/exporting-artwork.html`.

To summarize the three file types I focus on here: TIFF files are for print only. JPEG files are compressed, resulting in smaller file sizes of variable quality because they lose file data as they are compressed (they are *lossy*). PNG images are not compressed, retain more data, and usually are of significantly larger file size than JPEG files. PNG format supports transparency, but JPEG does not.

Exporting PNGs

Scenario: You're tasked with exporting a set of graphics to be used in advertisements for appliances targeted for Apple mobile devices. A web or app designer requires three versions of each graphic — low-resolution, medium-resolution, and high-resolution — to implement responsive design and match image resolution to different versions and screen resolutions of mobile Apple devices. High-resolution screens will display the highest resolution images, lower-resolution screens will display medium resolution images, and older smartphones and tablets will display the low-resolution version of the images. The images should have transparent backgrounds, so the background color or pattern of the web page shows through.

To batch-export a set of graphics as multiple-resolution PNGs, follow these steps:

1. **Make sure each object is in an individual artboard, and the artboard is sized to fit the object. For the smoothest workflow, name each artboard with a name that will translate well into a web-compatible file name.**

 Avoid spaces and special characters, except the underscore and hyphen, when naming the files. I explain how to define, name, and size artboards in Chapter 2. Your canvas should look something like the one in Figure 17-5.

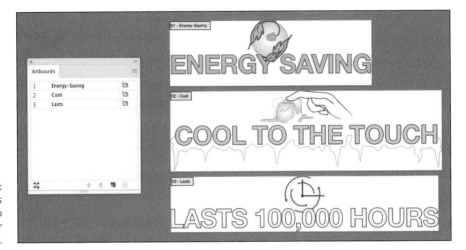

FIGURE 17-5:
Graphics
organized into
artboards for
export.

2. **Choose File ⇨ Export ⇨ Export for Screens and select the Artboards tab in the Export for Screens dialog.**

3. **In the Select section, click All.**

4. **In the Export To section of the dialog, navigate to a folder to which you will export the files.**

5. **To easily access the files after they're generated, select the Open Location after Export option.**

 This option will open your operating system's file manager with the exported files accessible.

6. **To organize all the versions of the exported files into subfolders, select the Create Sub-folders option.**

 Because I am creating three versions of each file, I am organizing them into subfolders to turn over to my web design team.

7. **Use the Add Scale button in the Formats section to add different resolution outputs.**

 In Figure 17-6, I added two additional resolutions, 2x for medium resolution screens and 3x for high resolution screens.

TIP

 The iOS (Apple mobile devices) and Android (mobile devices using the Android operating system) buttons in the Format section of the Export for Screens dialog automatically generate sets of output recommended for developers and designers targeting those respective environments.

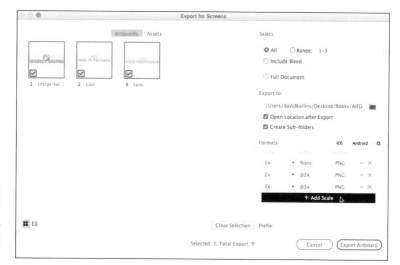

8. **To define anti-aliasing, interlacing, and transparency, click the gear icon (settings) in the Format section.**

9. **In the Format Settings dialog that opens, leave PNG set as the file format.**

- If you have type in your artwork, choosing Type Optimized (Hinted) will reduce jaggies that sometimes occur when type is converted to raster graphics.

- To have graphics fade in from lower resolution to higher resolution in screens, rather than dropping in from top to bottom, select the Interlaced check box. I strongly recommend this option for all web graphics.

- Transparent background color is the default selection, and allows the web page background to show through. Alternative options are to choose a white or black background, as shown in Figure 17-7.

10. **Click Save Settings to return to the Export for Screens dialog, and then click the Export Artboard button.**

All artboards are exported into distinct folders for the low-resolution, medium-resolution (2x), and high-resolution (3x) versions of the PNG files. The files are ready to turn over to a web or app designer.

REMEMBER

FIGURE 17-7:
Defining
settings for
export to PNG.

Optimizing JPEGS

Scenario: A client needs a file, small in dimensions and file size, to post at ETSY to promote her beautiful artwork. You will resize a large poster to a thumbnail-sized JPEG that will load quickly in any device, even with a poor Internet connection.

The Save for Web (Legacy) dialog is still here after being branded *Legacy* a few versions of Illustrator back because it's handy for specific tasks, especially fine-tuning JPEGs for export. The following steps guide you through the basic settings in that dialog:

1. **Prepare your artwork for export to JPEG by making sure the artwork you're exporting is in a single, selected artboard.**

 See details on placing artwork in an artboard and selecting an artboard in Chapter 2.

2. **Choose File ⇨ Export ⇨ Save for Web (Legacy).**

 The Save for Web dialog appears.

3. **To compare before-and-after versions of your file, choose the 2-Up tab at the top of the dialog, and experiment with different compression settings:**

 a. *To avoid exporting objects that are not part of the illustration, select the Clip to Artboard check box.*

 b. *Because you're exporting to JPEG, select JPEG from the File drop-down.*

 c. *Select the Progressive check box so the exported image fades in instead of dropping down line by line as it loads in a browser.*

 d. *In the Image Size section of the dialog, enter the dimensions of the target output.*

e. *If your image is mostly art, choose Art Optimized in the drop-down in the Image Size area of the dialog. If it's mostly Type, choose Type Optimized. If your artwork is equal parts type and art, choose None.*

f. *Because JPEG images do not export with transparent backgrounds, choose a background color from the Matte drop-down.*

g. *Use trial-and-error to see if the Browser Dither check box, which manages the transition from your artwork to the web page background, improves the appearance of the edges of your artwork.*

h. *Experiment with different quality output by using the drop-down (with options ranging from Low to Maximum) or by entering percent values in the quality slider.* As you adjust quality, note the output preview quality on the right side of the 2-Up screen and the output file size, as shown in Figure 17-8.

4. **When you arrive at the optimal relationship between export quality (which you want to maximize) and file size (which you want to minimize for faster loading), click Save.**

5. **In the dialog that opens, navigate to a folder and choose Save again.**

FIGURE 17-8: Experimenting with export quality and file size for a JPEG.

Handing off TIFF artwork to print

Scenario: You have designed a poster to be featured in a full-color commercially printed book using four-color printing. (For more on that process, see Chapter 2.) The publisher may want to have his or her own design team make some tweaks

to the file, but the team isn't Illustrator-fluent and works only in Photoshop. The publisher has specified that the file should be in desktop-publishing-friendly TIFF format. (File size is not an issue.)

The TIFF files are usually stored uncompressed, and because they aren't downloaded into screens, file size usually isn't an issue. Also, TIFF format files can store layers. TIFF images support printer-compatible CMYK.

Follow these steps to export artwork within one selected artboard to a TIFF file. (I explain how to place artwork in an artboard and select an artboard in Chapter 2.)

1. **Choose File ⇨ Export ⇨ Export As, navigate to a folder, and enter a file name in the dialog that appears.**

2. **In the Format drop-down, choose TIFF (tif).**

3. **To not include stray objects or other artboards, select Use Artboards.**

 If you have an artboard selected, 1 appears in the Range box.

4. **Click Export to display the TIFF Options dialog, and choose a color model, resolution, anti-aliasing, and other options, as shown in Figure 17-9:**

 - *Color Model:* Determines the color model of the exported file. In most cases, for commercial printing, that will be CMYK.

 - *Resolution:* Determines quality of the exported rasterized image. Higher resolution results in better quality.

 - *Anti-Aliasing:* Minimizes jagged edges in artwork but that is often not an issue for high-resolution print so unless your printer recommends this, don't select it.

 LZW Compression: Reduces file size without reducing image quality. This process is lossless.

 Embed ICC Profile: Maintains color consistency between your screen and print output.

5. **Click OK to save the file.**

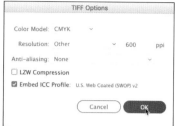

FIGURE 17-9:
Exporting
a print project
to TIFF.

Relying on Your Team

I close this chapter by repeating some essential advice: Start with output and rely on your output team. If you're working with animator or game designers, ask them what file format and resolution they need for raster artwork. The same goes for working with printers, app developers, or web designers.

Early in the process, make a connection with the team to whom you are handing off artwork. Printers often accept Illustrator files — but not always. Screen designers might accept Illustrator files, but translating an Illustrator file to a web-compatible raster isn't their job.

Avoid hand-off breakdowns by working backward from your final output, establish communication from the beginning of your design process, and communicate.

IN THIS CHAPTER

» Understanding the role of vector graphics in digital design

» Preparing Illustrator files for SVG output

» Using SVG for type

» Exporting web-ready SVG artwork

» Saving editable SVG files

» Handing off SVG code

Chapter **18**

Unleashing the Power of SVGs

The magic, the power, the challenge . . . oh, heck, the whole point of working with Adobe Illustrator is to create *scalable vector graphics.* You know what I'm talking about: lean (small file size) graphics that can be printed on a billboard (outside of Billings, or anywhere else) or on a postage stamp; graphics that can be projected on the side of a building or scaled down to display on a high-resolution watch *without degrading in quality* and *without increasing in file size.*

The pathway to presenting vector graphics from Illustrator on screens is a three-letter acronym. No, not OMG, or even WTF. That acronym is SVG. It stands (intuitively enough) for Scalable Vector Graphics. SVG is the graphic format that can be saved to Illustrator or exported to and from Illustrator. When you hand off SVG files, you preserve vector properties when your artwork is embedded in websites or other digital displays.

For a good part of the history of Illustrator, and for that matter, for most of the history of vector graphics, the power of vectors was translatable only into print projects. To the extent vector graphics could be shared online, the process required bulky proprietary plug-ins (with Flash being the most widely deployed), or access to a downloadable PDF, EPS, or AI file that couldn't be displayed in a browser. Only with the widespread adoption of SVG graphics by browsers in 2011 could designers achieve the ability to deploy vector graphics in all their power and glory in the design of screens.

Why do I bring up the ancient history of SVGs? Well, everything has within it some of what it evolved from, and Illustrator is no exception. It evolved from a print-only application, so much of the literature, experience, documentation (online and in print), and culture around Illustrator is print oriented. Creating and handing off SVG remains very underrated. To be candid, I hope this chapter helps break through that problem and helps popularize the use of SVGs. The tools and techniques are ready!

Perhaps if someone downloads this book a decade from now she will gasp in disbelief. "Really! They used to think Adobe Illustrator was mainly a tool to create graphics destined for print projects?" We'll see . . .

What we do know for certain is that today browsers and digital devices universally support SVG files. And that means that a powerful and dynamic channel now exists to embed vector images in websites and other digital output. Further, as you'll see, SVG files can be saved so that they are editable in Illustrator, creating an easily accessible web-focused workflow from Illustrator to screens.

Understanding the Role of Scalable Vector Graphics

SVG files are all over the web. They make data-driven or interactive infographics possible, including charts and illustrations that change as new data is fed into them from databases, and graphics that change depending on user interaction with a website. SVG graphics are used for zoomable maps. SVG is a key factor in digital animation. Architectural renderings and maps are done with SVG. Add to the mix icons, buttons, logos, banners, sketches, and charts.

Scalability is particularly valuable in today's multi-viewport world. A scalable SVG can display beautifully in a smartphone, or in a small corner of a web page, as shown in Figure 18-1.

When the same ad is zoomed in to a crazy 600 percent in Figure 18-2, note that there is no degradation in the curves, no jaggie steps in the curved type, no pixilation in the shapes. If you want to play with this figure yourself, by the way, it's hosted at Wikipedia commons: `https://upload.wikimedia.org/wikipedia/commons/a/aa/7_Up_Logo_Pepsi.svg`.

I mentioned that scalable vectors are a perfect fit for interactive and live-data infographics because they can expand or contract to express changes in data values (such as a change in which mobile operating system a person uses). You can see an example in Figure 18-3, where the bar and donut chart shapes are SVGs and their sizes are determined by users pressing buttons on the screen.

FIGURE 18-1:
This 7-Up ad is an SVG file.

Adobe Illustrator is, by far, the most powerful tool for creating SVG artwork and preparing SVG files and code for web designers, animators, and back-end coders.

FIGURE 18-2:
The same 7-Up ad zoomed in at 600 percent, with no distortion.

What *don't* you use SVG for? One word: photos. Several long-time friends and collaborators have made an art and a living out of vectorizing photos, so consider that a caveat. I touch on converting photos to vectors in Chapter 3, but vectorizing photos is a universe of its own. You'll find examples and tutorials of creatively turning photos into vector art if you search for *photorealistic vector art.* If you want to see an example, look at Chris Nielsen's motorcycle artwork at `https://pentoolart.com/motorcycles.html`. Chris and I collaborated on tutorials for these portraits in a book I wrote several years ago, and I can testify to the incredible number of hours that went into each of his intricately transformed photos!

FIGURE 18-3:
Data-driven
interactive SVG
images make
these graphics
work with user
input.

Defining an SVG-friendly environment

In Chapter 17, and throughout this book for that matter, I emphasize that the first rule of preparing Illustrator projects is to work backward. That is, to understand where the artwork is going to be published (in print or on screens), and getting input and advice from the folks to whom you are handing off your files on their requirements.

I'll double-down on that advice here: At the beginning of a project intended for SVG output, establish a connection with the web or digital developer with whom you are collaborating. If that's you, congratulations on being both a designer and a developer! But in any case, document the precise requirements for the file you are handing off.

What are the essentials of an SVG-compatible work environment and workflow?

>> SVG-friendly units of measurement: pixels, not points

>> RGB color modes

>> Artboards sized for scalable output

>> Minimal number of anchors to reduce file size

>> Use of symbols wherever possible

>> Use of web- or script-friendly filenames — without spaces or special characters (except a dash or an underscore), and preferably all lowercase

Defining an SVG-friendly document

You might be creating SVG artwork from scratch. Or you might be working with a project already underway and need to configure the document and settings for SVG. I walk you through both scenarios here.

To create a new document with SVG-friendly settings, follow these steps:

1. **Choose File ⇨ New. In the New Document dialog, select the Web tab, as shown in Figure 18-4.**

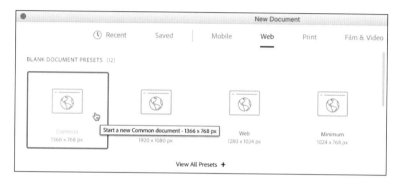

FIGURE 18-4:
Creating a
new file
with SVG-
appropriate
settings.

2. **In the Blank Document Presets section, click Common.**

The Common blank document preset (1366 x768 pixels) is a good place to start. Unlike print projects and some raster projects for screens, SVG artwork generally doesn't have a fixed size, so this large artboard will provide space to design graphics that can adapt to different sized viewports.

3. **In the Preset Details dialog that appears, assign a project name and define additional details. Then click Create.**

Here are some suggestions:

- Get in the habit of using web-compatible filenames, that is, filenames without spaces or special characters except dashes or underscores.

- Because SVGs aren't headed for a print shop, there's no need to define bleeds (leave the default settings at 0).

- You don't need to adjust the Advanced Options in the Preset Details box.

- You don't need to click More Settings unless you're including raster artwork in your project (something I address later in this chapter); screen resolution and pixel preview are not relevant to SVG output because SVG files retain the properties of vectors, which transcend pixel resolution.

Figure 18-5 shows a typical setup for an SVG project.

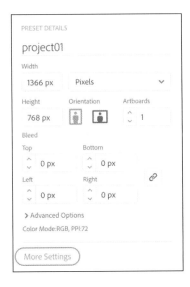

PRESET DETAILS

project01

Width
1366 px Pixels

Height Orientation Artboards
768 px 1

Bleed
Top Bottom
0 px 0 px

Left Right
0 px 0 px

> Advanced Options
Color Mode:RGB, PPI:72

More Settings

FIGURE 18-5:
Defining preset details for an SVG project.

If you're working with an existing project, you can jump into the Document Setup dialog and adjust settings. A quick way to access that dialog is to click the Document Setup button in the Control or Properties panel. That button is available when you don't have any objects selected. In the Document Setup dialog, choose the following settings:

» Units: Pixels

» Bleed: 0px for all sides

The Transparency options are not important at this stage of the process, the Overprint options are not operative in SVG output, and the options in the Type tab are not something you need to define unless you have very detailed typography requirements for text-rich documents (which is unlikely in an SVG project). The Document Setup dialog should look like the one in Figure 18-6.

I haven't discussed the role of artboards in SVG projects because they perform the same essential role with SVGs that they perform in any Illustrator project: dividing a project into discrete graphics that can be output in groups or individually. I explain how to set up and use artboards in Chapter 2.

Applying an SVG-compatible workflow

When you prepare artwork for saving as an SVG, you should use the least number of anchors possible. This practice reduces file size, so the files load faster in devices. And reducing the number of anchors (paths) makes it easier for website coders and developers to manage the content you hand off.

FIGURE 18-6:
Configuring
an existing
document for
an SVG project.

But wait! You justifiably cry out (I can't hear you, but I feel you): "Do I have to worry about paths and anchors while I draw" No, you don't. Draw away when you're designing, and reduce paths later. You find out how shortly.

I also show you how to reduce file size, sometimes radically, with the use of symbols.

Exporting versus saving

Later in the chapter, I walk through the process of saving SVG files and the different process of exporting them. But because *saving* files on the one hand and *exporting* them on the other is a major fork in SVG workflow, I want to address both options briefly early in this chapter.

If you export an Illustrator project to SVG, you create an image file that can be embedded in any web page, just like JPEGs, PNGs, and GIFs. *But you cannot edit that file in Illustrator.* So, if you are tasked with creating an SVG that will be handed off to a web designer or developer, it's probably best to simply export the SVG as a non-editable file.

In the export scenario, you definitely want to save the file as an Illustrator (AI) file, along with handing off the exported SVG image.

Alternately, you can save SVG graphics as editable files in Illustrator. Saving SVG files (as opposed to exporting them) has other advantages that I go into later in detail at the end of this chapter. But if you save files as editable SVGs, you do not need to save an Illustrator version as well.

Preparing Artwork for SVG Output

Ideally, graphics intended for SVG output will have been created with a minimum of anchors and effects and with a minimum of raster objects. As you develop your own Illustrator-to-SVG workflow and habits, you'll begin to internalize some of the demands of SVG files, and integrate those requirements more seamlessly into the design process. But as I just acknowledged, the creative process for illustrators doesn't always work that way. A traced sketch is going to have extra anchors. So too is artwork created with the Pencil tool.

So whether you are dealing with artwork created with a minimalist approach to adding paths, or you inherit a project with anchor bloat, you will want to work at reducing file size by reducing anchors (and paths), using symbols wherever possible, and minimizing the use of raster images.

Simplifying paths for screen output

The best way to see how much you can simplify paths is through trial-and-error. You do that by selecting artwork and choosing Object ⇨ Path ⇨ Simplify to display the Simplify dialog. Here you can experiment with different Curve Precision and Angle Threshold settings to see how many anchor points can be safely deleted from your artwork.

The frog in Figure 18-7, for example, was created reasonably efficiently but with some extraneous anchor points.

By using the Preview check box to see the effect of reducing points, I can assess whether or not I can sacrifice some anchor points to reduce the file size. I can also use the Show Original check box to compare the original and simplified paths. Usually, though, that clutters the screen, and I prefer to judge "before and after" simplifying by toggling the Preview option on and off.

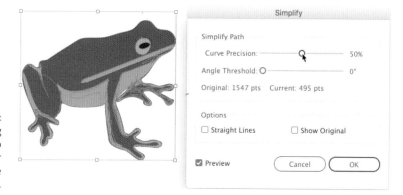

Less Curve Precision reduces the file size less but retains the integrity of shapes more. In the example in Figure 18-7, I set Curve Precision to a point where I reduced the file size to one third the original, but can still live with the accuracy. If this illustration had angles, I could have experimented with different Angle Threshold settings to see how much that would have reduced the file size without degrading the graphic.

Reducing the file size with symbols

Symbols also reduce SVG file size. For example, the file size of the graphic in Figure 18-8 is 25 percent smaller when the graphic is saved as an SVG file with the candles as symbols, compared to each candle being a discrete object.

FIGURE 18-8:
Saving this
graphic as
an SVG with
symbols
reduces the
file size by
25 percent.

I've seen and achieved even more radical reductions in file size when maximizing the use of symbols in architectural renderings (which might have dozens of trees, for example, that can be "symbolized").

I walk through how to create, deploy, and edit symbols in detail in Chapter 10. Here I'm emphasizing the specific import of using them whenever possible in artwork intended for SVGs.

Applying Transparency and Effects to SVGs

SVG graphics are rarely handed off to digital designers with backgrounds. Normally the graphics float above whatever background exists in the website, app, animation, or interactive context. If your SVG graphics are fish, you want them to swim in water without being surrounded by a white box. If they are dancers, you want them dancing against a web page background, not a visible bounding box. If they are birds, you want them flying with the sky as a background, like the bird in Figure 18-9.

FIGURE 18-9:
An SVG bird against a blue sky.

The bird in Figure 18-10 does have a background, which serves to emphasize my point that usually you don't want a background with SVGs. I explain how to avoid backgrounds shortly.

But before I get to explaining what's involved in knocking out the background behind SVG artwork, I want to focus on applying transparency to SVG graphics. I'm referring to defining the opacity of artwork using the Transparency panel. For example, I've applied 50 percent transparency

FIGURE 18-10:
An SVG bird without a transparent background; the sky does not show through.

to the yellow shape in Figure 18-11, and you can see the transparency in effect. And yes, that image *is* an SVG file, with all the lightweight, fast-loading, and infinitely scalable features built into SVG. I show you how to apply that kind of transparency as well in this section.

Outputting SVGs with transparent backgrounds

Let's return to the issue of making sure your SVGs don't export with a background.

FIGURE 18-11:
A semi-opaque SVG shape on top of a colored background.

Designers are used to thinking in terms of backgrounds that are either made transparent or remain visible. We think about knocking out a background. PNG images and GIF images work like that — you either create with a background or you choose a transparent background in a program such as Illustrator or Photoshop to knock out that background. With GIFs and PNGs, you can have one transparent color that allows the background colors or images to show through in web pages. But the logic of knocking out the background is different in an SVG file than with PNGs and GIFs. Essentially, there is no such thing as an SVG graphic that has a non-transparent background because there is no background. In other words: *By default,* SVG graphics save and export without a background.

So what's the problem? Well, it's easy to accidentally end up with a transparent background when saving or exporting SVG files! Let me illustrate: Figure 18-12 might have a white background, or it might have a transparent background. You can't tell just by looking at the Illustrator screen; you have to choose View⇨ Show Transparency Grid.

With Transparency Grid enabled, as shown in Figure 18-13, you can see that the bird has a white rectangle behind it, and that white background will "go with" the graphic if you save the file as an SVG or export it as an SVG.

Let me emphasize and shine a light on this from another angle. When I go to export this image as an SVG, the Export for Screens dialog, shown in Figure 18-14, does not have an option for selecting a transparency color.

FIGURE 18-12:
This graphic
might have
a white
background
or it might
have no
background.

FIGURE 18-13:
Viewing the
transparency
grid reveals a
white rectangle
behind the
graphic.

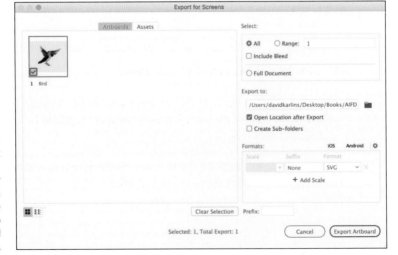

FIGURE 18-14:
You can't
choose a
transparency
color in SVG
because
there is no
background
color.

I often encounter designers who insist on putting a background rectangle behind their SVG-destined artwork so they can see how the graphic will look when backgrounded by a color in the target medium (such as a web page or app). That's okay, I caution them, as long as you remember to remove that background rectangle when you save or export the SVG. And in today's high-pressure, high-productivity, fast turnaround world, who needs one more thing to remember?

A better solution is to define a transparency "grid" with a single color that matches the environment into which the graphic will be placed. Why do I put *grid* in quotes? Because this technique cheats: With it, you define both grid colors as the same color, effectively simulating a web page or an app background color.

To use that technique to create a custom background while you develop SVG artwork, follow these steps:

1. **Choose File ⇨ Document Setup.**

2. **In the General tab, find the Transparency and Overprint Options section.**

 The changes you want are controlled in this section of the dialog.

 Don't worry about defining the grid size because you're effectively dispensing with the grid.

3. **In the Transparency Grid section of the dialog, click the first of the two grid color panels and choose a background color by using one of the various color palettes in the Colors pop-up shown in Figure 18-15.**

 None of these color palettes is particularly digital friendly, by the way. There is no palette for RGBA, hexadecimal, or other standard web color formats, but the color picker eyedropper can help you get the background color you are aiming to match.

4. **Select the second of the two grid color panels, and assign the same color to it.**

 Remember, you can use the color picker eyedropper to grab that color.

5. **Click OK in the Document Setup dialog.**

WARNING

All I've done in the previous set of steps was define how the Transparency Grid displays *when it is enabled.* So, if your Transparency Grid is not enabled, choose View ⇨ Transparency Grid.

In Figure 18-16, I selected the artboard with the graphic, and I am previewing the project against a simulated background color.

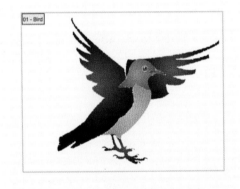

Applying transparency effects to SVG

When transparency (such as 50 percent opacity) or transparency effects such as color burn, darken, or multiply are applied to SVG graphics, those effects *retain the scalability of SVG.*

Figure 18-17 shows the same graphic — three semitransparent orange rectangles — exported as a PNG file (top) and an SVG. You can see how the PNG file degrades in quality when I zoom in on it in a browser. What you can't see is that the PNG file is almost twice as large as the SVG.

FIGURE 18-17:
Comparing
PNG output
(top) with
SVG when
transparency is
applied.

Here's a summary of the advantages to using SVG for transparency effects:

» The file size is qualitatively smaller.

» A web or app developer can tweak or edit the transparency values and assign interactivity.

» The image and the transparency will not degrade no matter how much the file is zoomed in on.

By the way, if you're curious about what the generated SVG code for this set of rectangles looks like, and how easy it is for a web or app developer to work with it, here's the code for the first of the three SVG boxes, with 60 percent opacity applied:

```
<svg id="orange-squares"
<style>.cls-1{fill:#f7931e;}.cls-1{opacity:0.6
</style
<title>orange-bars</title>
<rect class="cls-1" y="0.13" width="74" height="66.85"/>
</svg>
```

If your HTML and CSS skills allow, you can paste the `<style>` element into the `<head>` element of a web page, and the rest of the HTML into your `<body>` element, and you'll have replicated the code I created in Illustrator.

Let's walk through the process of applying transparency and transparency effects to SVG artwork step-by-step:

1. **Select the View menu and be sure that Hide Transparency Grid appears on the menu.**

 This check ensures that you're viewing the Transparency Grid. If the Transparency Grid display isn't turned on, you can't accurately see the effect of the opacity settings you apply.

2. **Select objects to apply transparency to, and choose an opacity value from the Opacity slider in the Control panel, as shown in Figure 18-18.**

 I'm using the default transparency grid for the screenshot to clearly illustrate the transparent background.

3. **Choose Window ⇨ Appearance and, in the Appearance panel, verify, edit, or hide (and show) the transparency.**

FIGURE 18-18:
Assigning transparency for SVG output.

WARNING

Do *not* apply transparency to objects intended for SVG output by using the Layers panel. Doing that applies *raster* transparency, which degrades when SVG objects are enlarged.

You can also apply Transparency effects such as color burn, darken, or multiply to SVG-destined artwork. I walk through how to apply transparency effects in detail in Chapter 12.

Applying SVG filters

Effects, like the ubiquitous drop shadow, are an essential element in every designer's toolkit. Chapter 14 explores effects in depth. Here, I focus on some specific features of special effects just for SVG files.

You may have noticed that Illustrator's Effect menu includes a substantial submenu for SVG filters. The available set of filters is expanding as Illustrator evolves to provide more support for SVG.

By the way, if you've used Illustrator for years, you might remember that the Effect menu used to list effects and filters. Filters were like effects, except they couldn't be easily edited after being applied. But SVG filters are not a revival of those types of filters; SVG filters are called *filters* because they operate through the SVG filter element in coding web pages.

Here's another cool thing about SVG filters: As you discover shortly, you can import and even create your own SVG filters.

When you apply an SVG filter, it may look similar to an non-SVG effect. For example, Figure 18-19 shows two identical squares, but the one the left has a raster drop shadow *effect* applied and the one on the right has a vector (SVG) drop shadow *filter* applied.

FIGURE 18-19:
A drop shadow
effect (left)
and SVG filter
(right).

When I select the rectangle with the SVG filter, that filter appears in the Appearance panel, as shown in Figure 18-20.

REMEMBER

The different ways that effects and SVG filters change the path of an object have subtle but real implications. Some of those implications are relevant to only web and app developers, but from your end of the workflow, the important thing to keep in mind is to *avoid mixing SVG filters and raster effects* in projects because they affect objects differently.

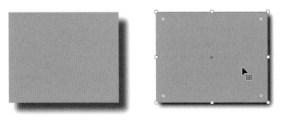

FIGURE 18-20:
A drop shadow
SVG filter,
editable in the
Appearance
panel.

By the way, I can't help sharing here that the square with the raster drop shadow in these figures is almost seven times larger than the one with the SVG filter. Just a brief public service announcement from the SVG industry on how you can lose (file) weight with SVGs.

And as you may have surmised by now, raster effects are not programmable. When you turn them over to an animator or an HTML coder, your developer teammate is not going to have the same kind of freedom to control how raster effects work in an animation or a transition.

Finally, when you apply SVG filters instead of raster effects to SVG artwork, you don't have to worry about those filters degrading when the artwork is rescaled in a browser.

Applying SVG filters

I've made the case for applying SVG filters whenever possible in SVG artwork. Let's walk through how that happens:

1. **Select the object(s) to which you are applying the filter.**

2. **Choose Effect ⇨ SVG Filters and select a filter.**

 The SVG Filters submenu has a list of filters with names that at best are only semi-intuitive (such as Al_Shadow_1, which is a drop shadow) and more often just cryptic (such as Al_Dilate_6). You'll have to experiment until you get a feel for how these filters work.

3. **With the object to which you applied the filter still selected, view the Appearance panel (choose Window ⇨ Appearance).**

4. **Hover your cursor over the applied filter and click it to reveal the Apply SVG Filter box, shown in Figure 18-21.**

 Here you can change the applied filter, and use the Preview check box to see how the filter will look. You can also select and delete an SVG filter in the Appearance panel, as shown in Figure 18-22.

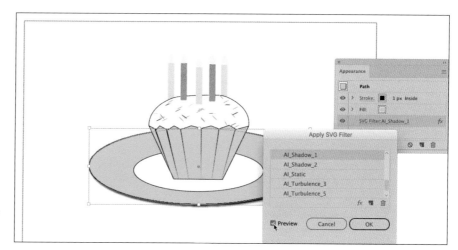

FIGURE 18-21:
Editing SVG
filters.

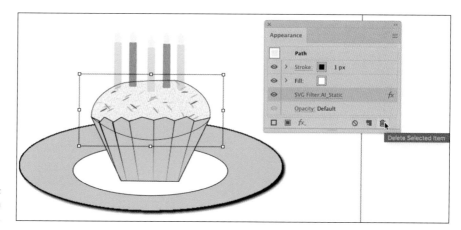

FIGURE 18-22:
Deleting an
SVG filter.

Importing SVG filters

Illustrator's set of filters is useful but hardly pushes the limits of what you can do with SVG filters. If you code in HTML, you'll find an accessible tutorial for creating your own SVG filters at w3schools: `www.w3schools.com/graphics/svg_filters_intro.asp`.

You can also purchase additional sets of filters online, and even find some nice sets of SVG free SVG filters. Check out the ones at `www.creatingo.com/import-and-use-svg-filters-in-adobe-illustrator.html`. To install this set of filters or other filters, follow these steps:

1. **Choose Effect ⇨ SVG Filters ⇨ Import SVG Filter.**

2. **In the dialog that opens, navigate to and double-click the SVG filters file you downloaded.**

 The file will probably be an SVG file.

3. **Choose Effect ⇨ SVG Filters to apply new filters to selected objects.**

 After you import new filters, they appear on the SVG Filters submenu.

Creating SVGs with Scalable, Searchable Type

SVG type provides the same valuable features found in all aspects of SVG: scalability, editability in Illustrator, and native support in all browsers. Those features in and of themselves argue for exporting your graphic content that contains type in SVG format when it's targeted for digital development.

Even beyond the advantages you incur when you use SVG for graphics in general, some special features are available when you have type in those graphics.

Exploiting the value of scalable, searchable type

As you might have noted, I'm excited about the fact that SVG type, when opened in a browser window, is searchable with the browser. Normally those browser search tools work with only HTML type.

And SVG type is not only searchable; users can find text on a page, copy and paste, and look up content. For example, if a visitor to a juice bar is interested in whether or not the kale shakes have lemon juice, he can search the SVG file for that text, as shown in Figure 18-23.

Or for that matter, if a user isn't sure what the heck kale is, he can select the text and search for a definition, as shown in Figure 18-24.

FIGURE 18-23:
Searching an
SVG graphic for
text in Chrome.

FIGURE 18-24:
Selecting type
in an SVG
graphic in a
browser.

To dial back a bit, you *can* export Illustrator graphics that include type for screens as PNGs, GIFs, or JPEGs. But they won't be scalable, and they won't retain the kind of type functionality that I demonstrated in the previous two figures.

Optimizing type functionality by saving SVGs

I'll return shortly to when and how to save SVG files and export to SVG. But while we're on the topic of SVG type, you need to know that to make the SVG type behave in the way I demonstrate in Figures 18-23 and 18-24, you must *save* your graphic as an SVG. And you must use specific settings so that the type acts the way it is supposed to when the SVG image is viewed in a browser.

To save type within an image as SVG type, follow these steps:

1. **With your graphic ready to hand off to a web developer, choose File ⇨ Save As. Navigate to the folder where you want to save the file and enter a filename.**

 If you need help navigating options for saving files, see Chapter 2.

 Keep filenames web compatible, which means use lowercase letters and numbers, do not use special characters (except the dash and underscore), and definitely do not use spaces.

 If you're resaving a file you've already saved to another format, you can keep your filename and location, and move on to Step 2.

2. **In the format drop-down in the Save dialog, choose SVG and click Save.**

 The SVG Options dialog opens.

3. **Leave the SVG Profiles set to SVG 1.1 (the current version, supported by all browsers).**

 The other options are not critical to what we are doing here, but briefly they are as follows:

 - *Subsetting option:* Leave Subsetting set to None. The other options aren't operative for SVG type for web.

 - *Image Location options:* These options are applicable only if you have embedded or linked (or both) artwork in your Illustrator file. These options are explained in Chapter 3.

 - *CSS Properties options:* I describe the CSS Properties options later in this chapter, but the short explanation is that they are determined by the needs of the developer to whom you are handing off the files. When you're saving type as SVG, you can use any of the CSS Properties options.

4. **In the lower section of the Advanced Options dialog, *deselect* the Output Fewer <tspan> Elements and Use <textPath> Element for Text on Path.**

 Note that these options are *selected* by default. This section of your SVG Options dialog should look like Figure 18-25.

FIGURE 18-25:
Saving an
SVG graphic
to preserve
special type
features.

Deselecting these options might increase your file size slightly, but by deselecting them, you preserve how text looks and the properties I've been bragging about in this section (searchability, copy-and-paste, look up in browser, and other features, depending on the browsing environment).

The Responsive check box is selected by default. This setting is not critical to preserving the special attributes of SVG type. Here, as with most options, your choice depends on the needs of your web developer. When in doubt, leaving the Responsive option selected is a widely applicable output option.

5. **Click OK in the SVG Options dialog to save the file as an embeddable SVG.**

A few notes on SVG type:

≫ As of this writing, support for all features of SVG type is a work in progress. The basic features I've walked through here work in any browser, but support for different fonts might require some tweaking of code by your web developer partner.

≫ I walk through advanced options for turning SVG files, including SVG code, over to developers later in this chapter.

>> Are you wondering whether those cool select, edit, and search features of SVG text apply to text on a curve? The answer is revealed in Figure 18-26. Spoiler: Yes!

The text-on-a-path technique used for the type in Figure 18-26 is explained in Chapter 16.

FIGURE 18-26:
Selecting text
on a path in
an SVG file in
Safari browser.

Adding code snippets to SVG graphics

Illustrator will never be anyone's top-rated code editor, but it does include a cool little feature for associating code with elements of an SVG file. Let's take a quick look at how to add a snippet of code when you want to add a link to part of an SVG graphic. The steps below walk through assigning JavaScript to an object that will make that object function like a link.

1. **With an object selected, view the SVG Interactivity panel.**

 You can display this panel if it is not active by choosing Window↪SVG Interactivity.

2. **Leave the Event set to the default, Onclick.**

 This JavaScript command performs a function (make something happen) when a user clicks the selected object in a web page.

3. **In the JavaScript box, use this syntax to define a link target:**

```
window.open("[URL]");
```

So, for example, if you were linking to the Wikipedia page on kale, the full line of code would be what I have in Figure 18-27:

```
window.open("https://en.wikipedia.org/wiki/Kale");
```

4. **Save the Illustrator file as an SVG file.**

FIGURE 18-27:
Attaching a
snippet of
JavaScript to an
SVG file to
create a
clickable link in
the graphic.

The file is ready to turn over to your web developer. (Or if that's your other role, you can change hats and pick up the file in your favorite code editor to integrate it into a web project.)

Alternatively, you can simply embed the saved SVG file in a web page. The link won't be elegant (until a web designer tweaks the generated CSS, it won't include a typical link icon when hovered over, for example). But it will work, and it will definitely be serviceable for prototyping and testing before the web page is finalized.

Don't try using Illustrator's slice technique for saving SVG files. The technology behind slices is raster-based and doesn't mesh with vector based output.

Exporting or Saving SVGs

You can save SVG graphics as SVG files, or you can export them as SVG files. I want to walk through when you might want to *save* a file as SVG, and when you should *export* a file as an SVG.

Here's a short summary of the differences between exporting and saving SVGs:

>> Saving a project as an SVG allows you to avail yourself of the option of saving a file that can be edited in Illustrator.

>> Exporting SVG to a screen creates a file that can be embedded in websites but is not editable in Illustrator. If you are exporting a file to SVG, you will almost always also want to save the file as an editable format (most rationally, either SVG or AI).

>> Exporting provides some nice, accessible tools for managing various artboards and previewing output. It also produces a file that can be handed to a web designer and embedded in web pages.

>> A saved SVG file can also be handed over to web designers. It can be shared with developers as SVG code, which radically rationalizes Illustrator-to-animation and Illustrator-to-interactivity coding. Your developers will hug you (maybe just virtually) if you hand them SVG code.

With that as an overview, the next section describes different options for saving or exporting SVG graphics.

Exporting SVGs for screens

WARNING

This might seem like a redundant warning, but better safe than sorry: I repeatedly see designers trying to export SVG files with a background object. Ouch! Doing so wrecks the default transparent backgrounds that normally export with SVGs and produces files that web developers won't like. So, add this to your checklist: Before exporting SVGs, choose View ⇨ Show Transparency Grid, and make sure that the checkerboard grid is visible. I'll sleep better now that I've cautioned you about that.

It's also helpful to organize your project into artboards *before* you start exporting to SVG. I describe how to organize files into artboards and assets (and why) in Chapter 2. And I walk through the specific options available for saving for screens in Chapter 17.

Here, I share some advice specific to exporting to SVG. You start by choosing File ⇨ Export for Screens to open the Export for Screens dialog:

>> When you export artboards, assets, or entire files, choose SVG as the Formats section, as shown in Figure 18-28.

>> Click the boxes in the bottom left of assets or artboards (depending on how you choose to export objects) to include (or not include) them in the batch export. All the available assets are selected in Figure 18-28.

» When you export as SVG, selecting the Create Subfolders check box in the Export for Screens dialog is usually unnecessary. The Create Subfolders option is for organizing different resolutions of raster output, and SVG output is vector output.

» The Open Location after Export check box opens your operating system's file manager with the target folder selected. That's handy!

» Finally, if the coders with whom you're collaborating provide you with specs for what kind of CSS to generate (internal, inline, or presentation attributes), ask you to convert type to outlines, or instruct you to embed or link raster artwork, or give you instructions on generating IDs (useful for coding), you can access those advanced options by clicking the gear (settings) icon in the Export for Screens dialog.

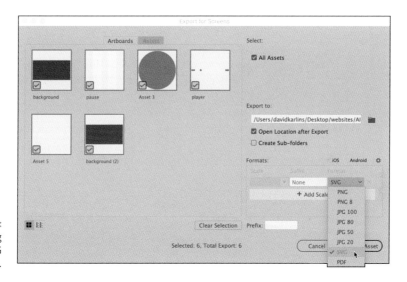

FIGURE 18-28:
Exporting assets as SVG files.

Beyond these tips, the process of exporting artwork to SVGs is basically the same as it is for exporting to any other format for screens, as discussed in Chapter 17.

Managing raster objects in SVGs

The challenge of meshing raster objects into Illustrator projects occurs itself in all kinds of scenarios and workflows, and creating SVG files is no exception.

Kind of.

The general rule in Illustrator is to avoid raster artwork as much as possible (because rasters undercut the value of vector–based artwork), and this rule is even

more important when saving or exporting to SVG. An SVG graphic without rasters is infinitely scalable, tiny in file size, and programmable or stylable by web and app developers. SVGs lose that power to the extent that rasters are embedded within them.

That said, if you *must* include raster images, follow these tips:

>> Embed raster files; don't link them. Linked files are difficult for web developers to handle.

>> Use SVG filters, not raster effects.

Saving SVGs for digital development

You save SVG files, rather than export them, for two basic reasons:

>> To be able to edit them in Illustrator

>> To access advanced features in SVG files such as the text features explored earlier in this chapter

With those two basic defining points, here are some tips on saving SVGs.

TIP

Start the process by choosing File ↪ Save (or Save As if you're resaving a file) and then choosing SVG from the Format menu. It's unlikely you will want to save as an SVGZ file. SVGZ files are compressed and do not display in browsers.

TIP

The second tip is to select a target folder, and click Save to open the SVG Options dialog. In the SVG Options dialog:

>> Always choose SVG 1.1 in the SVG Profiles drop-down. The other versions are applicable only to no-longer-relevant versions of mobile devices.

>> If you have embedded or linked images in your SVG file, you should probably choose Embed from the Image Locations drop-down. Check with your web developer first.

>> Select Preserve Illustrator Editing Capabilities to make the file editable in Illustrator. This option increases file size but allows you to work with a single SVG file that you can edit and update, and share with web developers.

Consult with your web developer on how to define CSS properties. Essentially, they allow you to generate CSS with your file that defines properties in the following ways:

>> **Presentation Attributes** embeds styling in SVG code. Use this if you are not collaborating with a web or app developer.

>> The two **Style Attributes** options rely on CSS to manage styling where possible. Consult with your web developer on which options he or she prefers.

>> **Style Elements** generates class style selectors for styling. Here again, consult with your web or app developer on his or her preference.

>> The **Include Unused Styles** option generates code that likely increases the SVG file size without adding functional value. But here again, check with your web developer if appropriate, to see if he or she prefers this option.

Finally, at the bottom of the SVG Options dialog are two valuable options:

>> The **SVG Code** button displays the generated XML file in your operating system's text editor, as shown in Figure 18-29. You can copy and paste that code or save it to hand off to a developer.

>> The **view in browser** icon (I made that name up, it looks like a globe, as shown in Figure 18-29) previews your SVG file in a browser.

After you've made appropriate selections in the SVG Options dialog, click OK to save your file.

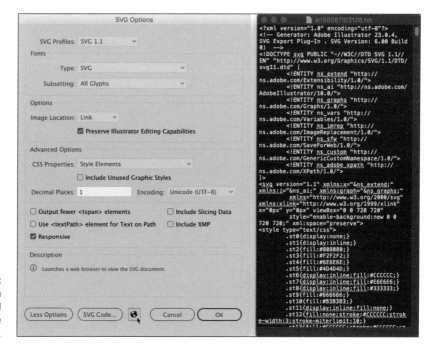

FIGURE 18-29:
Saving an SVG file and extracting the SVG code.

6

The Part of Tens

Chapter **19**

Top Ten Illustrator Resources

I n this short chapter, I present a curated list of my favorite Illustrator resources. Some of them are reference sources where you can look up the most detailed steps for any procedure. Some are here to expand your artistic horizons. Others are specific appendages to this book, especially the link to the website I set up where you can meet designers who contributed artwork and ideas, and stay tuned in to corrections and updates as I post them.

This Book's Unofficial Website

davidkarlins.com/illustrator

Here are the five reasons to visit this book's semi-official website and follow it on social media:

» You'll get updates, corrections, and errata as they are appear.

» You'll meet the dozen or so colleagues and students of mine who contributed artwork I used as examples in this book, and get access to their portfolios and other resources.

- >> I share links to other valuable Illustrator resources.

- >> The website is the best way to contact me with questions related to the book.

- >> This is a reference book, not a tutorial. But on the website, I make available many of the Illustrator files I used from others, as well as files I created to use as examples in this book, as shown in Figure 19-1.

FIGURE 19-1:
Accessing files
used in this
book.

Adobe Illustrator Official Documentation

https://helpx.adobe.com/illustrator/user-guide.html

In this age of piecemeal and unreliable data, the official Adobe Illustrator online documentation is remarkably organized, coherent, and easy to search. I'm convinced you need a book like this one (to be more specific, *this* book) to make sense of and navigate through Illustrator's massive set of features. But when it comes time to look up micro-details or get more comprehensive documentation for a feature this book doesn't have space to explore in infinite detail, the Adobe Illustrator site should be your first stop.

Using Illustrator to Create SVG for the Web

https://www.lynda.com/course-tutorials/SVG-Graphics-Web-Illustrator/724814-2.html

This book has a substantial section on creating SVG graphics in Illustrator for screens. But I could have written a book about just that topic. If you have access to LinkedIn Learning courses, and are working with, or interested in diving more deeply into, creating SVG files for digital designers, animators, and programmers, I think you'll find my course "SVG Graphics for the Web with Illustrator" (shown in Figure 19-2) valuable. (To subscribe to LinkedIn Learning courses, check with your employer, school, or public library — individuals can also subscribe.)

FIGURE 19-2: Exploring advanced applications of creating SVG graphics and text in Illustrator.

A Unique Resource for Artistic Fashion Designers

https://www.amazon.com/gp/offer-listing/1929685769/

Many years ago, I had the unusual and eye-opening experience of translating a book on fashion design using Adobe Illustrator from Korean into English. I don't

speak Korean, but I relied on online translation tools and the more defining fact that deconstructing Illustrator files doesn't depend on the language you speak. Illustrator design is a border-crossing, global language.

Producing the English language of this book, *Illustrator 10: Mastering Artistic Design* by Sae Nan Chong and Hyun Sook Seo, exposed me to fashion design techniques that I found innovative, creative, and applicable far beyond fashion design. The techniques rely on basic tools in Illustrator, especially the Pen tool and brushes, so they remain timely and effective. The book is old-school: printed in beautiful color with a DVD. Plenty of used copies are available online (make sure you get the DVD).

Going Crazy with Illustrator

https://www.amazon.com/Adobe-Illustrator-CS2-Gone-Wild/dp/0764598597

Several years ago I had the opportunity to exercise some of my wild and craziest ideas about what you can do with Illustrator. I collaborated with Bay Area Illustrator guru Bruce K. Hopkins who, among others, contributed some of his projects to the mix. The book, unfortunately titled *Illustrator Gone Wild*, contains tips and creative techniques that you can use in a wide range of projects. See Figure 19-3.

FIGURE 19-3:
A tutorial project from *Illustrator Gone Wild.*

Style Tile Templates

https://speckyboy.com/styleguide-toolbox/

If you're prototyping apps or websites in Illustrator, *style tiles* (which collect color, fonts, essential branding artwork, and navigation icons) are a critical part of contemporary digital design workflow.

One good resource is the flexible Illustrator template (AIT) file from speckyboy, shown in Figure 19-4.

FIGURE 19-4:
A style tile template.

Follow Jean-Claude Tremblay @jctremblay

https://twitter.com/jctremblay

Jean-Claude Tremblay is the technical editor of this book. His contributions to the book's accuracy and value are incalculable. Jean-Claude is a major player in the Illustrator world and his bilingual (French and English) Twitter feed, shown in Figure 19-5, is arguably the most informed, candid, and useful source of independent information on Adobe Illustrator and more.

Technical Drawing in Illustrator

https://www.youtube.com/watch?v=EjQFTBIDDsc

As an adjunct professor of engineering, and having intersected over the years with many technical illustrators, I'm always searching for teaching materials specific to the challenges engineers face when using Adobe Illustrator. One of the most useful of my findings is the video "Technical Drawing in Illustrator," posted (free) at YouTube by Catsy.

Online Tutorials from Adobe

https://helpx.adobe.com/illustrator/tutorials.html

In addition to the comprehensive online documentation I noted earlier in this list, Adobe has a nice set of beginner- and experienced-level tutorials for Illustrator. The most valuable of the videos and tutorials are aimed at beginners, and walk through basic techniques for drawing and coloring artwork. The tutorials are free and a nice complement to the material in this book.

Illustrator CC Digital Classroom

www.wiley.com/en-us/Illustrator+CC+Digital+Classroom-p-9781118639924

My personal favorite tutorial book for Adobe Illustrator is *Illustrator CC Digital Classroom* by Jennifer Smith, my colleague at Wiley and AGI Training. I've used *Illustrator CC Digital Classroom* and other materials by Jennifer Smith to train hundreds of students at AGI's facility in Manhattan.

Chapter **20**

Top Ten Productivity Tips

I llustrator users have their favorite sets of shortcuts, tips, tricks, timesavers, and techniques for producing better output faster. I have mine, and more importantly, so do other full-time Illustrator designers I've met over the decades. Here, I share a few of the ones I've found most valuable.

In the credit-where-credit-is-due department, the book's tech editor, Jean-Claude Tremblay, suggested several tips in this chapter.

Generate Layers

Illustrator enables you to automatically generate layers from objects in a document. This feature is useful when you need to hand over layers to an animator.

You generate layers from objects in a document by choosing Release to Layers from the Layers panel. The panel menu has two Release to Layers options: Build and Sequence. The differences are easier to show than tell. Figure 20-1 shows what happens when I generate layers using the Build option — the resulting layers start with the object lowest in the back-to-front arrangement, and build additional objects with each layer.

When I use the Release to Layers (Sequence) option, each object gets its own layer, as shown in Figure 20-2.

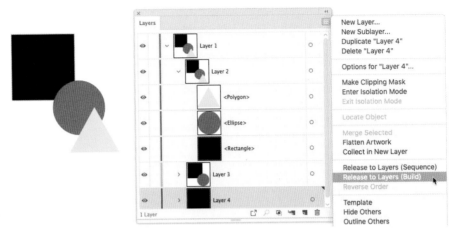

FIGURE 20-1:
Building layers.

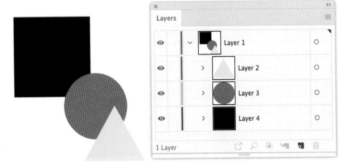

FIGURE 20-2:
Sequencing
layers.

Use Shapes for Guides

In Chapter 4, I show you how to draw isometric shapes and how to use perspective grids to draw objects with vanishing points off in the distance. Here's an additional technique you can use to make it easier (and faster) to draw isometric shapes: Rotate a shape and use that to create a guide.

To transform an object into a guide, select the object and choose View ⇨ Guides ⇨ Make, as shown in Figure 20-3.

After you generate guides, you can use them to more quickly draw objects at any angle, as shown in Figure 20-4.

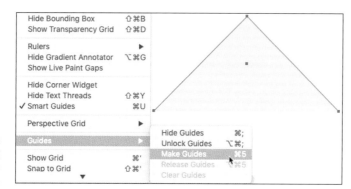

FIGURE 20-3:
Generating guides from an object.

FIGURE 20-4:
Using guides generated from a triangle.

By the way, you can customize the color of guides. I changed the color from the default cyan (which might not reproduce well in the book) to black. To change the color of guides, choose Edit ⇨ Preferences (Windows) or Illustrator ⇨ Preferences (Mac), and then choose Guides & Grid from the submenu. Options appear for changing the color and style of guides (or grids).

Generate Guides from Rulers

Guides help align objects, size objects, or locate objects quickly and precisely. Guides are especially handy for interior design, scaled drawings (such as maps), and technical illustrations.

You can generate guides quickly by dragging horizontal or vertical rules onto the canvas. That's not big news to those who have been using Illustrator for a while, but here are a couple tips you might not be aware of:

>> If you hold down the Alt key (Windows) or ⌘ key (Mac) while you drag a horizontal ruler onto the canvas, you toggle to generating a vertical guide. And vice versa: If you drag a vertical ruler onto the canvas and hold down the Alt or ⌘ key, you generate a horizontal guide.

>> If you hold down the Shift key while you drag a rule onto the canvas, you constrain the location of the resulting guide to the nearest grid subdivision.

By the way, if you drag the upper-left corner, where the left and top rulers intersect, you can reset the starting values for rulers to zero at the point you drag them to, as shown in Figure 20-5.

FIGURE 20-5: Setting a new starting point for horizontal and vertical rulers.

Place Multiple Files

If you work with illustrations that involve a lot of placed objects, you can streamline your workflow by importing them in an Illustrator document all at once, instead of one at a time.

Choose File ⇨ Place, and in the file dialog opened by your operating system, use Shift-click or Ctrl-click (Windows) or ⌘-click (Mac) to select all the files you want to place.

After you click in your Illustrator document and place the first image, your cursor reloads to place the second image, then the third, and so on. You can cycle through imported images by using the arrow keys on your keyboard to choose which one to place. As you drop one image after another into your document, the number of remaining images to place is displayed, as shown in Figure 20-6.

FIGURE 20-6:
Counting files being placed in a document.

Import Photoshop Files

When you place Photoshop files in an Illustrator document, you can use import options to fine-tune how layers, color, and text are handled during the placement process.

To access Photoshop import options, choose File ⇨ Place, and then navigate to and click a Photoshop file. The file dialog displays a Show Import Options check box. If you select that check box before clicking Place in the dialog, the Photoshop Import Options dialog appears, as shown in Figure 20-7.

The Photoshop Import Options dialog lets you choose whether to convert Photoshop layers to objects or flatten them into a single image, and — if you elect to maintain layers — whether to import hidden layers. In Figure 20-7, my graphic doesn't match the color mode of my Illustrator file and I'm being warned that this will affect transparency effects assigned to layers.

FIGURE 20-7:
Photoshop import options.

To access these features, be sure to link placed Photoshop files instead of embedding them. I explain the difference and how to manage linked and embedded files in Chapter 3.

Edit Placed Objects

Here's another tip to help manage linked Photoshop files placed in Illustrator. You can quickly and easily edit those placed files in Photoshop by using the Edit Original button in the Control panel, as shown in Figure 20-8.

FIGURE 20-8:
Launching Photoshop to edit a linked image.

This feature works only if you've linked the placed image. It doesn't work if you've embedded the placed image. But, if you did embed the file while placing it, you can use the Unembed button in the Control panel to convert your placed image to a linked image. I explain how to manage linked and embedded placed files in Chapter 3.

Import Word Files

Illustrator's word-processing features continue to improve. Thankfully for those of us who have the spelling skills of a third grader, we now have red squiggly underlining to indicate words that don't show up in the dictionary.

That said, you'll improve your workflow by doing as much of your text editing as possible in Microsoft Word or another application that exports to the .docx format.

If you choose File ➪ Place, navigate to a Word file, and click Place, the Microsoft Word Options dialog appears, as shown in Figure 20-9.

Microsoft Word Options

Include

☑ Table of Contents Text

☑ Footnotes/Endnotes

☑ Index Text

☐ Remove Text Formatting

Cancel OK

FIGURE 20-9:
Importing a
Word file.

Handy options in that dialog allow you to elect whether or not to include table of contents, footnotes and endnotes, and index text. And the Remove Text Formatting option strips all styling from the content before you dump it into Illustrator.

Crop a Placed Image

Those of us who have been using Illustrator for decades managed to survive without the capability to crop images, crazy as that sounds. Now, to crop an image, you just select the image, click the Crop Image button in the Control panel, define a crop area, and click Apply, as shown in Figure 20-10.

FIGURE 20-10:
Cropping an
image.

The capability to crop images in Illustrator may not be news to you, but here's a tip you probably were not aware of: When you crop an image, you can set the image's resolution. Note in Figure 20-10 that I've set the resolution to 72 ppi (appropriate for normal resolution web images).

I explain how to define raster image resolution in more depth in Chapter 17.

Play Actions

You can use the Actions panel (Window ⇨ Actions) to record, play, edit, or delete sets of actions. But even without spending time recording actions, you can expedite many frequently performed tasks using the built-in set of actions in the panel.

For example, if you want to export a file as a medium-quality JPEG, choose that option in the set of preset actions, and click the play icon, as shown in Figure 20-11.

You can take actions to another level by combining them. For example, if I want to export an image to three different raster formats, all I have to do is select three actions (for GIF, JPEG, and PNG), and click the play icon, as shown in Figure 20-12.

Each action plays in sequence, while I kick back, have a healthy (or unhealthy) snack, and watch Illustrator process all three of my raster images.

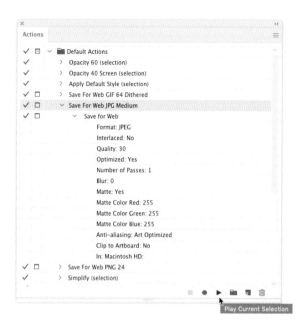

FIGURE 20-11:
Using a preset
action to save
a file as a JPEG.

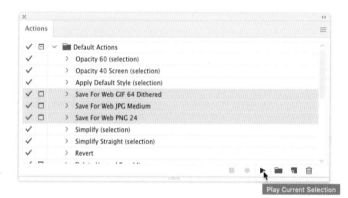

FIGURE 20-12:
Playing a set of
actions.

Use Shortcut Keys

My final productivity tip is so basic it might escape your radar: Use shortcut keys. Illustrator has over 400 keyboard shortcuts for everything from choosing tools to zooming in and out.

You'll find the whole set at `https://helpx.adobe.com/illustrator/using/default-keyboard-shortcuts.html`. The time you invest in reading through the list and highlighting the keystrokes you need will pay off quickly in time saved.

Index

A

Access Brush Libraries icon, 136
accessing
 panels, 11–12
 Pattern libraries, 222
 presets, 17
actions, playing, 352–353
actual path, 238
Add Anchor Point tool, 111
adding
 anchors, 111–112
 code snippets to SVG graphics, 328–329
 colors to Swatches panel, 186–187
 symbols to documents, 159–162
 tools to Basic toolbar, 10
additive color, 16
additive process, 172
adjusting
 appearance of objects in layers, 99
 baseline shift on aligned type, 282–283
 display of swatches, 187–188
 properties for artboards, 22–23
 settings, 19
Adobe Color
 styling with themes, 182–185
 website, 182
Adobe Creative Cloud, 285
Adobe Illustrator Draw, importing sketches from, 37–38
Adobe PDF file format, 27
Adobe Stock Images, 248

Advanced toolbar, 10
AI file format, 27
Align panel, 85–87
aligned type, changing baseline shift on, 282–283
aligning
 objects, 82–87
 with SmartGuides, 85
Alt key, 55, 56, 113
Anchor Point tool
 about, 103
 adding anchors, 111–112
 deleting anchors, 111–112
 editing curves with, 107–109
anchors
 adding, 111–112
 deleting, 111–112
 editing, 104–107
 moving, 104–105
 selecting, 72–73, 104–105
animating, with Puppet Warp tool, 129–131
Appearance panel, 242–244
applying
 art brushes, 146–148
 brushes to paths, 136–148
 color
 from Control panel, 179–180
 to Live Paint edges, 191
 from Properties panel, 179–180
 from Tools panel, 177–178
 effects
 about, 240–242
 to SVGs, 314–324
 to type on paths, 284
 gradients

 about, 200–201
 to strokes, 201
 from swatch library, 200–201
 isometric effects to shapes, 66–68
 layers in the real-world, 99–100
 patterns
 about, 222–225
 to fills, 223–224
 to strokes, 224–225
 to text, 225
 shape properties from Control Panel, 52–54
 SVG filters, 321–324
 SVG-compatible workflows, 310–311
 transparency
 about, 214–220
 effects to SVG, 318–320
 to SVGs, 314–324
apps, getting type from, 258–259
Area Type Options dialog, 267–268
Area Type tool, 268–270
area types
 about, 255
 converting to/from point type, 274
 editing, 256–260
 generating boxes, 256–258
 laying out in columns, 267–268
 placing in paths, 268–270
 scaling, 263–264
 for screens, 256
 shaping, 268–272
 styling, 260–265

arranging
 content on layers, 96–97
 effects, 244
 objects
 about, 87
 in layers, 92–95
 panels, 11–12
Art Brush Options dialog, 147–148
art brushes
 about, 138
 applying, 146–148
 designing, 146–148
Artboard Options dialog, 21
Artboard tool, 20–21
artboards
 batch-exporting, 294
 changing properties for, 22–23
 defined, 15
 defining, 20–23
 deploying, 20–27
 moving, 21–22
 resizing, 21–22
 size of, 18–19
 using for multidimensional projects, 23–27
 using for output, 29
artistic fashion designers, 339–340
artwork
 about, 31
 mapping, 247
 placing, 32–37
 preparing for SVG output, 312–314
aspect ratio, 207
assets, using for output, 29
asterisk cursor, 120

B

Backspace key, 71
baseline shift

about, 263
 changing on aligned type, 282–283
Basic toolbar
 about, 10
 showing, 71
batch-exporting artboards, 294
Bleed option, 19
Blend tool, 213
blending modes, 215–217
blends
 about, 212
 removing, 213
 setting options, 213
 working with, 213–214
Blob Brush tool, drawing filled paths with, 124–126
Blob Brush Tool Options dialog, 125–126
Brick Offset option, 235
Bristle Brush library, 139–141
Bristle Brush Options dialog, 142–143
bristle brushes
 about, 138
 editing, 139–144
brush libraries, navigating, 137–138
brushes
 about, 133–135
 applying to paths, 136–148
 bristle
 about, 138
 editing, 139–144
 calligraphic
 about, 138
 creating, 144–146
 copying, 141–144
 creating, 139–155
 editing, 141–144
 painting with, 133–155
 pattern

about, 138
 creating, 151–155
 using with drawing tablets, 155
Brushes panel, 136–137, 138
building
 area type boxes, 256–258
 brushes, 139–155
 calligraphic brushes, 144–146
 combination anchors with Pen tool, 109–111
 complex shapes, 58–63
 compound paths, 58–59
 curved anchors with Pen tool, 109–111
 documents, 16–19
 dynamic symbols, 163–164
 ellipses, 48
 freeform line gradients, 210–211
 graphics with basic shapes, 44–52
 guides from rulers, 347–348
 layers, 345–346
 line segments, 50–51
 Live Paint groups, 188–195
 pattern brushes, 151–155
 patterns, 226–227
 point type, 276–277
 polygons, 49–50
 rectangles, 46–48
 shapes
 about, 45–46
 with Shape Builder tool, 127–129
 with Shaper tool, 127–129
 stars, 49–50
 straight anchors with Pen tool, 109–111
 SVG for the web, 339
 SVGs with scalable, searchable type, 324–329
 template layers, 90–92
 waveforms, 114–116

C

Calligraphic Brush Options dialog, 145–146

calligraphic brushes
 about, 138
 creating, 144–146

canvas, 20

cataloging line/shape tools, 51

Center icon, 54

changing
 appearance of objects in layers, 99
 baseline shift on aligned type, 282–283
 display of swatches, 187–188
 properties for artboards, 22–23
 settings, 19

Character panel, 262–263, 280

character rotation, 263

Character Style Options dialog, 264–265

character styles, 264–265

cheat sheet (website), 3

Check Spelling dialog, 260

checking spelling, 260

Chong, Sae Nan (author)
 Illustrator 10: Mastering Artistic Design, 340

choosing
 anchors, 72–73, 104–105
 between Control and Properties panel, 13
 effects, 240–242
 within groups, 73
 objects, 69–77
 paths, 55, 72–73
 RGB color for screens, 175–176
 shape anchors, 55
 shapes, 54–55
 with tools, 70–75
 type font/style, 260–262

clicking, Shape tool and, 46–51

clipping masks
 with opacity masks, 218–220
 using, 35–37

closed paths, converting open paths to/from, 106–107

close-path cursor, 120

CMYK color, 16, 173

code snippets, adding to SVG graphics, 328–329

collapsing panels, 12

color
 about, 171
 adding to Swatches panel, 186–187
 additive, 16
 applying
 from Control panel, 179–180
 to Live Paint edges, 191
 from Properties panel, 179–180
 from Tools panel, 177–178
 CMYK, 16, 173
 configuring grayscale, 177
 defining for print, 172–175
 Live Paint faces, 190
 managing of strokes/fills, 177–180
 merging with gradients, 198–211
 Pantone, 174–175
 print, 16, 172–177
 RGB, 16, 175–176
 screen, 172–177
 spot, 174–175
 subtractive, 16
 web safe, 16, 176

Color blending effect, 217

Color Burn blending effect, 216

Color Dodge blending effect, 216

Color Guide Options dialog, 182

Color Guide panel, 180–182

Color Guides, 180–185

color mode, 18–19

Color panel, 178

color swatches
 changing display of, 187–188
 managing, 185–188

Color Themes, 180–185

columns, laying out area type in, 267–268

combination anchors, creating with Pen tool, 109–111

combining shapes
 about, 59–63
 with Shape Builder tool, 128–129

communicating with printers, 30

complex shapes, building, 58–63

compound paths, creating, 58–59

configuring grayscale, 177

constrained straight-segments cursor, 120

content, organizing on layers, 96–97

context-sensitive, 12

contorting point type, 278–280

Control panel
 applying
 color from, 179–180
 shape properties from, 52–54
 changing artboard properties with, 22–23
 using, 12–14

controlling
 color of strokes/fills, 177–180
 color swatches, 185–188
 effects, 242–247
 linked files, 33
 Live Paint faces/edges, 192–195
 opacity, 215
 raster objects in SVGs, 331–332
 sets of sprayed symbols, 168
 symbols, 162

Convert to Shape (Effect menu), 240

converting
area type to/from point type, 274
open paths to/from closed paths, 106–107
type to an outline, 286

Copies option, 235

copying
brushes, 141–144
shapes, 54–55

Create New button, 17

creating
area type boxes, 256–258
brushes, 139–155
calligraphic brushes, 144–146
combination anchors with Pen tool, 109–111
complex shapes, 58–63
compound paths, 58–59
curved anchors with Pen tool, 109–111
documents, 16–19
dynamic symbols, 163–164
ellipses, 48
freeform line gradients, 210–211
graphics with basic shapes, 44–52
guides from rulers, 347–348
layers, 345–346
line segments, 50–51
Live Paint groups, 188–195
pattern brushes, 151–155
patterns, 226–227
point type, 276–277
polygons, 49–50
rectangles, 46–48
shapes
about, 45–46
with Shape Builder tool, 127–129

with Shaper tool, 127–129
stars, 49–50
straight anchors with Pen tool, 109–111
SVG for the web, 339
SVGs with scalable, searchable type, 324–329
template layers, 90–92
waveforms, 114–116

Crop Marks (Effect menu), 240

cropping
placed images, 351–352
rasters, 35

Cubism, 43

cursor states (Pencil tool), 120

Curvature tool
about, 113
drawing curves, 122–124
editing curves, 122–124

curved anchors, creating with Pen tool, 109–111

curves
drawing with Curvature tool, 122–124
editing
with Anchor Point tool, 107–109
with Curvature tool, 122–124

customizing toolbars, 10

D

Darken blending effect, 216

Define Perspective Grid dialog, 65

Define Perspective Grid options dialog, 65

defining
artboards, 20–23
color for print, 172–175
raster dimensions, 295
raster resolution, 295–296

SVG-friendly environment, 308–311
transparency, 215–217

Delete Anchor Point tool, 111

Delete Brush icon, 137

Delete button, 136

Delete key, 58, 71

deleting
anchors, 111–112
blends, 213

deploying artboards, 20–27

designing art brushes, 146–148

dialogs
Area Type Options, 267–268
Art Brush Options, 147–148
Artboard Options, 21
Blob Brush Tool Options, 125–126
Bristle Brush Options, 142–143
Calligraphic Brush Options, 145–146
Character Style Options, 264–265
Check Spelling, 260
Color Guide Options, 182
Define Perspective Grid, 65
Define Perspective Grid options, 65
Document Setup, 310
Eraser Tool Options, 127
Format Settings, 299
Gap Options, 192–193
Line Segment Tool Options, 50
Microsoft Word Options, 34–35, 351
New Brush, 149
New Document, 17–18
New Swatch, 186
Options, 28, 259
Paintbrush Tool Options, 135
Path Options, 284
Pencil Tool Options, 122

Photoshop Import Options, 349

Rectangle, 46–48

Save for Web (Legacy), 300–301

Scale, 228

Scatter Brush Option, 149–150

Smart Punctuation, 260

Symbolism Options, 167

3D Extrude & Bevel Options, 67

Difference blending effect, 216

digital development, saving SVGs for, 332–333

dimensions, 16–17

Direct Selection tool

 building complex shapes, 58

 drawing shapes with perspective, 66

 moving anchors, 105

 rotating selected shapes, 56

 rounding rectangles, 57

 selecting

 anchors, 72–73, 104, 106

 objects, 70–75

 paths, 55, 72–73

Distort and Transform (Effect menu), 240

Divide icon, 59

Divide tool, 63

docking panels, 11

Document Setup dialog, 310

documents

 adding symbols to, 159–162

 creating, 16–19

 preparing for four-color printing, 173–174

 setting options for, 18

drawing

 curves with Curvature tool, 122–124

 filled paths with Blob Brush tool, 124–126

marquee, 72

with Pen tool, 109–116

with Pencil tool, 118–121

shapes

 interactively, 51–52

 with perspective, 63–66

technical, 342

drawing tablets, using brushes with, 155

drop shadow effect, 244

dynamic symbols

 about, 161, 163

 creating, 163–164

 instances, 164–166

E

editing

 anchors, 104–107

 area types, 256–260

 bristle brushes, 139–144

 brushes, 141–144

 curves

 with Anchor Point tool, 107–109

 with Curvature tool, 122–124

 effects, 243–244

 Live Paint edges, 190–191

 Live Paint groups, 193–194

 objects

 as groups, 78–79

 within groups, 79–81

 placed objects, 350

 point type, 276–277

Effect menu, 238–239, 240–241

effects

 about, 237

 applying

 about, 240–242

 to SVGs, 314–324

 to type on paths, 284

 choosing, 240–242

drop shadow, 244

editing, 243–244

Effect menu, 238–239, 240–241

expanding, 244–246

managing, 242–247

ordering, 244

Photoshop, 239–240

ellipses, generating, 48

embedding

 files, 32–34

 linked files, 33–34

enabling

 automatic spell-checking, 260

 Illustrator, 8–9

 Touch Type tool, 280

EPS file format, 27

Eraser tool, 127

Eraser Tool Options dialog, 127

erasing, with Eraser tool, 127

Exclusion blending effect, 217

expanding effects, 244–246

Export As option, 296

Export for Screens option, 296

exporting

 about, 27

 files, 29

 hybrid graphics, 293

 options for, 293–296

 PNGs, 297–300

 quickly, 290–292

 raster files, 289–303

 saving before, 294

 saving *vs.*, 311–312

 to specific raster formats, 297–303

 SVGs, 329–333

 SVGs for screens, 330–331

 TIFFs, 301–303

Eyedropper tool, 186

F

Fidelity settings, 122
files
 Adobe PDF, 27
 AI, 27
 embedding, 32–34
 EPS, 27
 exporting, 29
 linked, 32–34
 Photoshop, 349–350
 placing multiple, 348–349
 raster
 cropping, 35
 exporting, 289–303
 managing objects in SVGs, 331–332
 tracing images, 38–41
 reducing size with symbols, 313–314
 saving, 27–29
 SVG/SVG (Compressed), 27
 TIFF
 about, 293
 exporting, 301–303
 Word, 351
filled paths, drawing with Blob Brush tool, 124–126
fills
 applying
 patterns to, 223–224
 transparency, 215
 managing color of, 177–180
filters, Scalable Vector Graphics (SVG), 240, 321–324
flowing type between boxes, 272–274
fonts
 sharing, 285
 type, 260–262
Format Settings dialog, 299
formats, file, 27–28
formatting paragraphs, 266–267

four-color printing, preparing documents for, 173–174
freeform gradients
 about, 198
 using, 209–211

G

Gap Options dialog, 192–193
gaps, setting, 192–193
generating
 area type boxes, 256–258
 brushes, 139–155
 calligraphic brushes, 144–146
 combination anchors with Pen tool, 109–111
 complex shapes, 58–63
 compound paths, 58–59
 curved anchors with Pen tool, 109–111
 documents, 16–19
 dynamic symbols, 163–164
 ellipses, 48
 freeform line gradients, 210–211
 graphics with basic shapes, 44–52
 guides from rulers, 347–348
 layers, 345–346
 line segments, 50–51
 Live Paint groups, 188–195
 pattern brushes, 151–155
 patterns, 226–227
 point type, 276–277
 polygons, 49–50
 rectangles, 46–48
 shapes
 about, 45–46
 with Shape Builder tool, 127–129
 with Shaper tool, 127–129
 stars, 49–50

straight anchors with Pen tool, 109–111
SVG for the web, 339
SVGs with scalable, searchable type, 324–329
template layers, 90–92
waveforms, 114–116
Global Edit icon, 76
Global Edit mode, 75–77
Gradient Annotator, 208–209
Gradient Mesh tool, 210
Gradient panel, 203
gradients
 applying
 about, 200–201
 to strokes, 201
 from swatch library, 200–201
 freeform
 about, 198
 using, 209–211
 linear
 about, 198
 using, 201–206
 merging colors with, 198–211
 radial
 about, 198
 using, 207–208
 transforming with Gradient Annotator, 208–209
 types of, 198
graphic styles, saving, 246–247
Graphic Styles panel, 246
graphics, 44–52. *See also* lines; shapes
grayscale, configuring, 177
grids, locating objects with, 82–85
Group Selection tool, 70, 73, 79–80
grouping
 objects, 77–81
 panels, 12

groups
 editing
 objects as, 78–79
 objects within, 79–81
 isolating, 80–81
 selecting objects within, 73
guides
 defined, 82
 generating from rulers, 347–348
 locating objects with, 82–85
 using shapes for, 346–347

H

handles, on anchors, 107
Hard Light blending effect, 216
harmony rules, 180
headlines, sizing, 263
Height option, 19
hiding panels, 11
Hopkins, Bruce K, (author)
 Illustrator Gone Wild, 340
horizontal scaling, 263
Hue blending effect, 217
hybrid graphics, exporting, 293

I

icons
 Access Brush Libraries, 136
 Center, 54
 Delete Brush, 137
 Divide, 59
 explained, 2–3
 Global Edit, 76
 Libraries Panel, 136
 Link Corner Radius Values, 48
 New Artboard, 21
 New Brush, 137
 New Swatch, 186
 Options of Selected
 Objects, 137
 Out of Gamut, 178
 Remember, 2
 Remove Brush Stroke, 136
 Tip, 2
 view in browser, 333
 Warning, 3
Illustrator, 8–9. *See also specific topics*
Illustrator 10: Mastering Artistic Design (Chong and Seo), 340
Illustrator CC Digital Classroom (Smith), 343
Illustrator Gone Wild (Hopkins and Karlins), 340
Image Trace panel, 39–41
importing
 Photoshop files, 349–350
 sketches from Adobe
 Illustrator Draw, 37–38
 SVG filters, 323–324
 Word files, 351
indentation, 266
instances, for dynamic symbols, 164–166
interface
 about, 7–8
 accessing panels, 11–12
 arranging panels, 11–12
 Control panel, 12–14
 customizing toolbars, 10
 launching Illustrator, 8–9
 Properties panel, 12–14
Internet resources
 Adobe Color, 182
 Adobe products, 38
 cheat sheet, 3
 Cubism, 43
 exporting, 297
 motorcycle artwork, 307
 official documentation, 338
 online tutorials, 342
 shortcut keys, 353
 SVG filters, 324
 for this book, 337–338
 UpPrinting.com, 30
isolating
 groups, 80–81
 objects, 77–81
isometric effects, applying to
 shapes, 66–68

J

JPEGs, optimizing, 300–301
justification, 266

K

Karlins, David (author)
 Illustrator Gone Wild, 340
kerning, 262

L

Lasso tool, 70, 73–74
lassoing objects, 73–74
launching
 automatic spell-checking, 260
 Illustrator, 8–9
 Touch Type tool, 280
layers
 about, 89–90
 applying in the real-world, 99–100
 changing appearance of
 objects in, 99
 generating, 345–346
 organizing
 content on layers, 96–97
 documents with, 89–100
 objects in, 92–95
 renaming, 91
 styling with, 97–99
 targeting, 98
 template, 90–92

Layers panel
 about, 79
 arranging objects in, 97
 locating objects in, 96
laying out area type in columns, 267–268
Learn tab, 9
Libraries Panel icon, 136
Lighten blending effect, 216
Line Segment tool, 50
Line Segment Tool Options dialog, 50
line segments, generating, 50–51
line spacing, 266
linear gradients
 about, 198
 using, 201–206
lines, 43–44
Link Corner Radius Values icon, 48
linked files
 about, 32–34
 embedding, 33–34
 managing, 33
Links panel, 33–34
Live Paint
 controlling
 edges, 192–195
 faces, 192–195
 creating groups, 188–195
 editing groups, 193–194
 merging groups, 188–195
Live Paint Selection tool, 70, 190–191
locating objects, 82–85, 96
lossy, 297
Luminosity blending effect, 217

M

Macs, saving profiles on, 18
Magic Wand tool, 70–71, 74–75

magnetic boundaries, 82
Make Mask button, 218
managing
 color of strokes/fills, 177–180
 color swatches, 185–188
 effects, 242–247
 linked files, 33
 Live Paint faces/edges, 192–195
 opacity, 215
 raster objects in SVGs, 331–332
 sets of sprayed symbols, 168
 symbols, 162
mapping
 artwork, 247
 3D effects, 248–252
marquees
 defined, 54
 drawing, 72
masks, clipping
 with opacity masks, 218–220
 using, 35–37
measurement, units of, 16
measuring, with rulers, 82–83
merging
 colors with gradients, 198–211
 Live Paint groups, 188–195
Microsoft Word Options dialog, 34–35, 351
modes
 blending, 215–217
 color, 18–19
 Global Edit, 75–77
 Pencil tool, 120–121
modifying
 appearance of objects in layers, 99
 baseline shift on aligned type, 282–283
 display of swatches, 187–188
 properties for artboards, 22–23

settings, 19
Move Tile with Art option, 235
moving
 anchors, 104–105
 artboards, 21–22
 patterns
 about, 230
 within shapes, 230–231
 shapes, 54–55
 type on paths, 283–284
multidimensional projects, using artboards for, 23–27
Multiply blending effect, 216
multi-segment path, 50

N

Name option, 18
navigating brush libraries, 137–138
New Artboard icon, 21
New Brush dialog, 149
New Brush icon, 137
New Document dialog, 17–18
New Swatch dialog, 186
New Swatch icon, 186
Nielsen, Chris, 307
Normal blending effect, 216
Number of artboards option, 19

O

objects
 about, 197–198
 aligning, 82–87
 changing appearance of in layers, 99
 editing
 as groups, 78–79
 within groups, 79–81
 placed, 350
 grouping, 77–81
 isolating, 77–81

locating
about, 82–85
in Layers panel, 96
merging colors with gradients, 198–211
organizing
about, 87
in layers, 92–95
in Layers panel, 97
overlapping, 215
scaling
separately patterns and, 229
together patterns and, 228
selecting, 69–77
spacing, 82–87
wrapping type around, 270–272
Ochavo, Lydia, 30
official documentation, 338
online tutorials, 342
opacity, managing, 215
Opacity link, 53
opacity masks, clipping with, 218–220
Open button, 9
open paths, converting to/from closed paths, 106–107
optimizing
JPEGs, 300–301
type functionality, 326–328
Option key, 55, 56, 113
options
blends, 213
Control panel, 13–14
exporting, 293–296
for patterns, 233–238
Pencil tool, 121
Properties panel, 13–14
raster output, 296–297
setting for documents, 18
Symbol Sprayer tool, 167
Options dialog, 28, 259

Options of Selected Objects icon, 137
organizing
content on layers, 96–97
effects, 244
objects
about, 87
in layers, 92–95
panels, 11–12
orientation, of blends, 213
origin point, 47
Out of Gamut icon, 178
outlining type, 286
outputting SVGs with transparent backgrounds, 315–318
Overlap option, 235
overlapping objects, 215
Overlay blending effect, 216

P

Paintbrush tool, 135
Paintbrush Tool Options dialog, 135
painting, with brushes, 133–155
panels
accessing, 11–12
Control
applying color from, 179–180
applying shape properties from, 52–54
changing artboard properties with, 22–23
using, 12–14
Layers
about, 79
arranging objects in, 97
locating objects in, 96
Properties
applying color from, 179–180
changing artboard properties with, 22–23

using, 12–14
viewing, 242
Pantone color, 174–175
Paragraph panel, 266–267
paragraphs, formatting, 266–267
Path Options dialog, 284
Path Type tool, 281–284
path-continuation cursor, 120
Pathfinder
about, 59–63
option (Effect menu), 240
paths
actual, 238
applying
brushes to, 136–148
effects to type on, 284
converting open to/from closed, 106–107
moving type on, 283–284
placing
area type in, 268–270
text in, 34–35
type on, 281–284
selecting, 55, 72–73
simplifying for screen output, 312–313
pattern brushes
about, 138
creating, 151–155
Pattern libraries, accessing, 222
patterns
about, 221
applying
about, 222–225
to fills, 223–224
to strokes, 224–225
to text, 225
creating, 226–227
moving
about, 230
within shapes, 230–231

patterns *(continued)*
 options for, 233–238
 rotating, 230
 scaling
 separately objects and, 229
 together objects and, 228
 stacking, 231–233
 transforming, 227–233
Pen tool
 about, 50, 103
 drawing with, 109–116
 shortcuts, 112–113
 waveforms, 113–116
Pencil tool
 about, 113
 drawing with, 118–121
 modes, 120–121
 setting
 options, 121
 pencil curve smoothness,
 118–119
Pencil Tool Options dialog, 122
perspective, drawing shapes
 with, 63–66
Perspective Grid Selection tool,
 63–66
Perspective Grid tool, 63–66
Perspective Selection tool, 71
Photoshop effects, 239–240
Photoshop files, importing,
 349–350
Photoshop Import Options
 dialog, 349
pixels, 16
placed images, cropping,
 351–352
placing
 area type in paths, 268–270
 artwork, 32–37
 multiple files, 348–349
 text in shapes/paths, 34–35

type on paths, 281–284
playing actions, 352–353
PNGs, exporting, 297–300
point type
 about, 275
 contorting, 278–280
 converting area type to/
 from, 274
 creating, 276–277
 editing, 276–277
 how it works, 275–276
 rotating, 279–280
 scaling, 278–279
Polygon tool, 49
polygons, generating, 49–50
preparing
 artwork for SVG output,
 312–314
 documents for four-color
 printing, 173–174
preset symbols, 158
presets, using, 17–18
Preview option, 19
print color
 about, 16
 screen color *vs.*, 172–177
printing
 about, 27
 communicating with
 printer, 30
productivity, tips for, 345–353
Profile option, 18
profiles, saving, 18
proofing tools, 259–260
properties
 artboard, 22–23
 shape, 52–54
Properties panel
 applying color from, 179–180
 changing artboard properties
 with, 22–23

using, 12–14
viewing, 242
Puppet Warp tool, animating
 with, 129–131

R
radial gradients
 about, 198
 using, 207–208
raster dimensions, 295
Raster Effects option, 19
raster files
 cropping, 35
 exporting, 289–303
 managing objects in SVGs,
 331–332
 tracing images, 38–41
raster formats, exporting to
 specific, 297–303
raster graphics, 293
raster output options, 296–297
raster resolution, 18–19,
 295–296
Rasterize (Effect menu), 240
Recent tab, 18
Rectangle dialog, 46–48
rectangles
 generating, 46–48
 rounding, 48, 57–58
reducing file size with symbols,
 313–314
Release to Layers option,
 345–346
Remember icon, 2
Remove Brush Stroke icon, 136
removing
 anchors, 111–112
 blends, 213
renaming layers, 91
rescaling shapes, 55–56
reshaping shapes, 54–58

resizing artboards, 21–22
resources, 337–343
resources, Internet
 Adobe Color, 182
 Adobe products, 38
 cheat sheet, 3
 Cubism, 43
 exporting, 297
 motorcycle artwork, 307
 official documentation, 338
 online tutorials, 342
 shortcut keys, 353
 SVG filters, 324
 for this book, 337–338
 UpPrinting.com, 30
Revolve effect, 250
RGB color, 16, 175–176
Rotate tool, 230
rotating
 patterns, 230
 point type, 279–280
 shapes, 56–57
Rounded Rectangle tool, 57
rounding rectangles, 48, 57–58
rulers
 generating guides from, 347–348
 locating objects with, 82–85
 measuring with, 82–83

S

Saturation blending effect, 217
Save a Copy option, 236
Save for Web (Legacy) dialog, 300–301
Save for Web (Legacy) option, 296
Saved tab, 18
saving
 about, 27
 before exporting, 294

exporting *vs.*, 311–312
files, 27–29
graphic styles, 246–247
profiles, 18
SVGs, 329–333
SVGs for digital development, 332–333
Scalable Vector Graphics (SVGs)
 about, 305–306
 adding code snippets to, 328–329
 applying
 effects to, 314–324
 transparency effects to, 318–320
 transparency to, 314–324
 creating
 with scalable, searchable type, 324–329
 for the web, 339
 defining SVG-friendly environment, 308–311
 exporting, 329–333
 managing raster objects in, 331–332
 outputting with transparent backgrounds, 315–318
 preparing artwork for output, 312–314
 role of, 306–312
 saving, 329–333
 saving for digital development, 332–333
Scalable Vector Graphics (SVG) filters
 about, 240
 applying, 321–324
 importing, 323–324
Scale dialog, 228
Scale tool, 227
scaling
 area type, 263–264
 patterns

 and object simultaneously, 229
 and objects together, 228
 point type, 278–279
Scatter Brush Option dialog, 149–150
scatter brushes, 138, 149–150
Screen blending effect, 216
screen color
 choosing RGB for, 175–176
 print color *vs.*, 172–177
screens
 area types for, 256
 exporting SVGs for, 330–331
 simplifying paths for output, 312–313
segment, 50
Select menu, 70, 75–77
Select Object, 75
selecting
 anchors, 72–73, 104–105
 between Control and Properties panel, 13
 effects, 240–242
 within groups, 73
 objects, 69–77
 paths, 55, 72–73
 RGB color for screens, 175–176
 shape anchors, 55
 shapes, 54–55
 with tools, 70–75
 type font/style, 260–262
Selection tool
 about, 66
 dragging text, 284
 moving patterns within shapes, 231
 rotating shapes, 56
 selecting
 objects, 70–75, 71–72
 shapes using, 54
 type placed on paths, 283

Seo, Hyun Sook (author)
Illustrator 10: Mastering Artistic Design, 340
setting(s)
blend options, 213
changing, 19
gaps, 192–193
options for documents, 18
pencil curve smoothness, 118–119
Pencil tool options, 121
Symbol Sprayer tool options, 167
shape anchors, selecting, 55
Shape Builder tool
combining shapes with, 128–129
creating shapes, 127–129
Shape link, 54
Shape tool, 46–51
Shaper tool
about, 48
creating shapes, 127–129
shapes. *See also specific shapes*
about, 43–44
applying
isometric effects to, 66–68
properties from Control Panel, 52–54
building graphics with basic, 44–52
combining
about, 59–63
with Shape Builder tool, 128–129
copying, 54–55
creating
with Shape Builder tool, 127–129
with Shaper tool, 127–129
drawing

interactively, 51–52
with perspective, 63–66
generating, 45–46
moving
about, 54–55
patterns within, 230–231
placing text in, 34–35
rescaling, 55–56
reshaping, 54–58
rotating, 56–57
selecting, 54–55
using for guides, 346–347
shaping area types, 268–272
sharing fonts, 285
Shift key, 55, 56
shortcut keys, 353
shortcuts (Pen tool), 112–113
showing Basic toolbar, 71
simplifying paths for screen output, 312–313
Size option, 19
Size Tile to Art option, 235
sizing headlines, 263
sketches, importing from Adobe Illustrator Draw, 37–38
Smart Guides
about, 56
aligning with, 85
Smart Punctuation dialog, 260
Smith, Jennifer (author)
Illustrator CC Digital Classroom, 343
Smooth blends, 212
Smooth tool, 122
Soft Light blending effect, 216
spacing
blends, 213
objects, 82–87
spell check, 260
Spicoli, Jeff, 61

spot color, 174–175
spraying symbols, 166–168
stacking patterns, 231–233
Star tool, 49
stars, generating, 49–50
Start a New File Fast section, 9
static symbols, 161
Step blends, 212
straight anchors, creating with Pen tool, 109–111
straight-segments cursor, 120
Stroke link, 53
strokes
applying
gradients to, 201
patterns to, 224–225
transparency, 215
managing color of, 177–180
style, font, 260–262
style tiles, 341
styling
with Adobe color themes, 182–185
area types, 260–265
with layers, 97–99
with Touch Type tool, 280–281
Stylize (Effect menu), 241
subtractive color, 16
subtractive process, 172
SVG Code button, 333
SVG Filters (Effect menu), 241
SVG (Scalable Vector Graphics) filters
about, 240
applying, 321–324
importing, 323–324
SVG-compatible workflows, applying, 310–311
SVGs (Scalable Vector Graphics)
about, 305–306

adding code snippets to, 328–329

applying

effects to, 314–324

transparency effects to, 318–320

transparency to, 314–324

creating

with scalable, searchable type, 324–329

for the web, 339

defining SVG-friendly environment, 308–311

exporting, 329–333

managing raster objects in, 331–332

outputting with transparent backgrounds, 315–318

preparing artwork for otuput, 312–314

role of, 306–312

saving, 329–333

saving for digital development, 332–333

SVG/SVG (Compressed) file format, 27

swatch library, applying gradients from, 200–201

Swatches panel, 185–188

Symbol Sprayer tool, 166–168

Symbolism Options dialog, 167

symbols

about, 157

adding to documents, 159–162

dynamic

about, 161, 163

creating, 163–164

instances, 164–166

managing, 162

managing sets of sprayed, 168

preset, 158

rationalizing workflow with, 158–162

reducing file size with, 313–314

spraying, 166–168

static, 161

Symbols panel, 159–162

T

Tab key, 11

targeting layers, 98

technical drawing, 342

template layers, 90–92

text

applying patterns to, 225

placing in shapes/paths, 34–35

3D (Effect menu), 240

3D effects, mapping, 248–252

3D Extrude & Bevel Options dialog, 67

TIFF files

about, 293

exporting, 301–303

Tile Type option, 234–235

Tip icon, 2

toggling toolbars, 10

toolbars

Basic

about, 10

showing, 71

customizing, 10

tools

Add Anchor Point, 111

Anchor Point

about, 103

adding anchors, 111–112

deleting anchors, 111–112

editing curves with, 107–109

Area Type, 268–270

Artboard, 20–21

Blend, 213

Blob Brush, 124–126

Curvature

about, 113

drawing curves, 122–124

editing curves, 122–124

Delete Anchor Point, 111

Direct Selection

building complex shapes, 58

drawing shapes with perspective, 66

moving anchors, 105

rotating selected shapes, 56

rounding rectangles, 57

selecting anchors, 72–73, 104, 106

selecting objects, 70–75

selecting paths, 55, 72–73

Divide, 63

Eraser, 127

Eyedropper, 186

Gradient Mesh, 210

Group Selection, 70, 73, 79–80

Lasso, 70, 73–74

Line Segment, 50

Live Paint Selection, 70, 190–191

Magic Wand, 70–71, 74–75

Paintbrush, 135

Path Type, 281–284

Pen

about, 50, 103

drawing with, 109–116

shortcuts, 112–113

waveforms, 113–116

Pencil

about, 113

drawing with, 118–121

tools (continued)
 modes, 120–121
 setting options, 121
 setting pencil curve
 smoothness, 118–119
 Perspective Grid, 63–66
 Perspective Grid Selection,
 63–66
 Perspective Selection, 71
 Polygon, 49
 Puppet Warp, 129–131
 Rotate, 230
 Rounded Rectangle, 57
 Scale, 227
 selecting objects with, 70–75
 Selection
 about, 66
 dragging text, 284
 moving patterns within
 shapes, 231
 rotating shapes, 56
 selecting objects, 70–75,
 71–72
 selecting shapes using, 54
 selecting type placed on
 paths, 283
 Shape, 46–51
 Shape Builder
 combining shapes with,
 128–129
 creating shapes, 127–129
 Shaper
 about, 48
 creating shapes, 127–129
 Smooth, 122
 Star, 49
 Symbol Sprayer, 166–168
 Touch Type
 activating, 280
 styling with, 280–281

Type, 258
Unite, 63
Tools panel, applying color from,
 177–178
Touch Type tool
 activating, 280
 styling with, 280–281
tracing raster images, 38–41
tracking, 263
Transform link, 54
transforming
 gradients with Gradient
 Annotator, 208–209
 patterns, 227–233
transparency
 applying
 about, 214–220
 to SVGs, 314–324
 defining, 215–217
transparency blending modes,
 215–217
transparency effects, applying to
 SVG, 318–320
Transparency Grid, 315–318
Tremblay, Jean-Claude (editor),
 341–342
tutorials, online, 342
Type tool, 258
type(s)
 applying effects to on
 paths, 284
 area
 about, 255
 converting to/from point
 type, 274
 editing, 256–260
 generating boxes, 256–258
 laying out in columns,
 267–268
 placing in paths, 268–270

scaling, 263–264
for screens, 256
shaping, 268–272
styling, 260–265
choosing font/style, 260–262
converting to an outline, 286
creating SVGs with Scalable,
 searchable, 324–329
flowing between boxes,
 272–274
moving on paths, 283–284
optimizing functionality of,
 326–328
outlining, 286
placing on paths, 281–284
point
 about, 275
 contorting, 278–280
 converting area type to/
 from, 274
 creating, 276–277
 editing, 276–277
 how it works, 275–276
 rotating, 279–280
 scaling, 278–279
 wrapping around objects,
 270–272

U
Unite tool, 63
units of measurement, 16
Units option, 19
UpPrinting.com (website), 30

V
vector graphics, 16–17, 293
vertical scaling, 263
View all Presets link, 17

view in browser icon, 333

viewing

 Color Guide panel, 180

 Properties panel, 242

W

Wacom tablet, 37, 141

Warning icon, 3

Warp (Effect menu), 241

waveforms

 creating, 114–116

 Pen tool, 113–116

web, creating SVGs for the, 339

web safe color, 16, 176

websites

 Adobe Color, 182

 Adobe products, 38

 cheat sheet, 3

 Cubism, 43

 exporting, 297

 motorcycle artwork, 307

 official documentation, 338

 online tutorials, 342

 shortcut keys, 353

 SVG filters, 324

 for this book, 337–338

 UpPrinting.com, 30

Width option, 19

Windows, saving profiles in, 18

Word files, importing, 351

workflow, rationalizing with symbols, 158–162

workspace, 11

wrapping type around objects, 270–272

WYSIWYG design platform, 109

About the Author

David Karlins is a practitioner, professor, and student of digital design techniques and trends. He has taught Adobe Illustrator and communication at San Francisco State University, City University of New York, and New York University, and his online digital design courses are syndicated through hundreds of colleges and universities worldwide. David is the author of books on Illustrator for Adobe Press, Wiley, and other publishers and has created Illustrator training material for LinkedIn Learning.

Dedication

Dedicated to the cast of characters in Bob Dylan's "Chimes of Freedom."

Author's Acknowledgments

Contributions by colleagues and students made it possible to use a wide variety of projects in this book as examples. I gratefully acknowledge permission to deconstruct, reconstruct, and adapt work from Ellen Baryshev, Kwaniie Chan, Matthew Garzarek, Jonathan Grover, Bruce K. Hopkins, Irina Mashuryan, Migdalia Pérez, Lawrence Quist, Jeffrey Tlapale, Andy Tsoi, and Christina Young. Please check out all their work at davidkarlins.com/illustrator/topics/contributors.

I also availed myself of expert details from Lydia Ochavo of UpPrinting.com regarding handing off Illustrator files for cutting-edge print production.

In addition to contributing artwork, Matthew Garzarek served as an intern on this book and assisted in technical research, advised on content and style, and assisted in social media promotion.

Thanks to my editors, all who made this book possible and put the content over the top.

And a special thanks to my agent, Margot Hutchison.

Publisher's Acknowledgments

Executive Editor: Steve Hayes

Project Editor: Susan Pink

Copy Editor: Susan Pink

Technical Editor: Jean-Claude Tremblay

Proofreader: Debbye Butler

Editorial Assistant: Matt Lowe

Sr. Editorial Assistant: Cherie Case

Production Editor: Magesh Elangovan

Cover Image: Courtesy of Christina Young